Film Analysis Guide

Timothy R. White
Missouri State University

KENDALL/HUNT PUBLISHING COMPANY
4050 Westmark Drive Dubuque, Iowa 52002

Cover image from Photos.com

FILM ANALYSIS

FILM ANALYSIS INTRODUCTION

This text is the result of about twenty years of teaching introductory film classes. These classes have gone by a variety of names, depending on the departments in which, and the universities at which, I have taught. What they all have in common, however, is an emphasis on film analysis. It is my belief that any aspect of film study, whether history, theory or criticism, should begin with a thorough grounding in film analysis; with a firm grasp of how film works, any discussion of film's artistic or social significance will be richer.

The text is divided into two major sections. The first is devoted to film analysis proper. It begins with a discussion of film form, as well as narrative and narration. The films analyzed in this section are generally well-known; students may well be familiar with them already. These analyses will help explain exactly why they understand these films in the ways in which they do.

This section continues with analyses of films based on stylistic elements: mise-en-scène, cinematography, editing and sound. These analyses begin with an assumption that the style of filmmaking with which most students are familiar is the Classical Hollywood Cinema. These analyses, therefore, often focus on the ways in which these films conform to the classical Hollywood style, but also at times focus on the ways in which these films deviate from this familiar style editing. There is a chapter, for example, devoted to alternatives to Hollywood's continuity editing, including analyses of such well-known films as Sergei Eisenstein's *Battleship Potemkin* (1925) and *October* (1928), and Akira Kurowawa's *High and Low* (1963) and *Stray Dog* (1949), as well as the less familiar *Ohayo* (Yasujiro Ozu, 1959) and *Head* (Bob Rafelson, 1968).

The first section ends with a discussion of the ways in which the elements of film style work together to create stylistic systems within films. The analyses of films discussed here encourage students to re-examine films with which they have probably

seen, including *Schindler's List* (Steven Spielberg, 1993), *The Sixth Sense* (M. Night Shyamalan, 1999) and *Lock, Stock & Two Smoking Barrels* (Guy Ritchie, 1998).

The second section of this text allows students to use the tools learned in the first section to analyze films from a variety of modes of film narration. Obviously, the Classical Hollywood Cinema is the most dominant of these modes, so this section begins with a chapter analyzing a number of Hollywood films, mostly from Hollywood's studio era (for example, *His Girl Friday* [Howard Hawks, 1940] and *Scarface* [Howard Hawks, 1932]). Because genre was such an important aspect of the studio era, many of these films are discussed in terms on not just classical Hollywood narration, but in terms of their genres.

The next chapter deals with what is normally termed the Art Cinema, and its particular conventions of narrative and style. Most of the films analyzed are those that use these conventions in relatively obvious ways; examples include several films by Ingmar Bergman and a number of films by Luis Buñuel, 1967.

The chapter that follows analyzes films from the less-known mode of parametric cinema. Although many such films are often dealt with as art films, they are more properly discusses as belonging to a different mode entirely. The best examples of such films are *Last Year at Marienbad* (Alain Resnais, 1961) and the films of Jacques Tati.

Although documentary films are often thought to be entirely different from narrative films, they use exactly the same elements of film style as do fiction films. The particular conventions of Non-Narrative films are used to analyze a number of documentary films, including those of Michael Moore, as well as non-narrative form in Maya Deren's *A Study in Choreography for the Camera* (1945).

This section ends with a number of analyses of animated films. As with documentary films, animated films are often neglected in discussions of cinema; however, and again like documentaries, animation uses the same stylistic elements as do

live-action narrative films. In fact, because most feature-length animated films (especially those of Hollywood) use the live-action Classical Hollywood Cinema as a model, analyses of animation are especially appropriate and interesting. These analyses include Disney's *Lady and the Tramp* (Hamilton Luske, Clyde Geronimi and Wilfred Jackson, 1955), as well as more recent films as *South Park: Bigger, Longer & Uncut* (Trey Parker, 1999) and *Toy Story* (John Lasseter, 1995).

Although the textbook I have used for most of my career, a text on which many of these analyses are based and one which I highly recommend, is Kristin Thompson's and David Bordwell's Film Art. However, any number of introductory texts on film analyses can be accompanied by the analyses included in this book. Other texts in which this book can be used as an accompaniment include Thomas Schatz's Hollywood Genres and David Bordwell's Narration in the Fiction Film.

I hope this text will prove useful to the film student, no matter which text it accompanies. The student should always remember that these analyses are not the only ways in which films can be approached, but can be used as a basis, and a stimulus, for the student's own analysis.

FILM FORM

Alien (Ridley Scott, 1979)

Directed by Ridley Scott

Written by Dan O'Bannon, Thilo Newman, David Giler and Walter Hill

Cinematography by Derek Vanlint

Original music by Jerry Goldsmith

Production Design by Roger Christian, Leslie Dilley, Anton Furst, and Michael Seymour

Costume Design by John Mollo

Film Editing by Terry Rawlings and Peter Weatherley

Produced by Gordon Carroll, David Giler, Walter Hill and Thilo Newman

Produced by Brandywine Productions Ltd/20th Century Fox

Distributed by 20th Century Fox Film Corporation

Cast

Tom Skerritt…Dallas

Sigourney Weaver…Ripley

Veronica Cartwright…Lambert

Harry Dean Stanton…Brett

John Hurt…Kane

Ian Holm…Ash

Yaphet Kotto…Parker

Bolaji Badejo…"Alien"

Helen Horton…Mother (voice)

STUDY QUESTIONS

1. What are the FUNCTIONS of the elements of the film? For example, what is the function of the message for "help" received by the Nostromo? What is the function of having Ash be an android, one who works for the "Company", instead of just another human being? Ask yourself, "What is the logical justification for this element? What would be the problem if it were lacking?"

2. In what ways do we see SIMILARITY and REPETITION at work in the film? What elements (characters, events, etc.) either recur or similar elements occur? What kinds of MOTIFS did you notice, either story elements of stylistic elements?

3. How do we see DIFFERENCE and VARIATION working in the film? Which elements create PARALLELISM?

4. How does DEVELOPMENT constitute a patterning of these similar and differing elements; what is the progression from one point (the beginning) to another (the end)?

5. Does the film have a high degree of UNITY, or is there some DISUNITY?

6. What kinds of meanings do we make from the film (REFERENTIAL, EXPLICIT, IMPLICIT and/or IDEOLOGICAL or SYMPTOMATIC)?

FILM FORM in *Alien* (Ridley Scott, 1979)

I. INTRODUCTION

 A. *Alien* is often seen as combining several genres, most obviously the science fiction and horror genres

 B. Therefore, it can be seen as relying on a number of different sets of conventions belong to these different genres

 C. However, it can also be discussed in terms of its form, which is not unlike that of most classical Hollywood films

II. PERCEPTION - FIVE GENERAL PRINCIPLES

 A. FUNCTION

 1. The role of any element of the film in relation to the film as a whole

 2. Elements usually have multiple functions

 a) The message for "help" received by the Nostromo

 (1) Provides a reason for the crew on the ship to be awakened from hypersleep on their way back to Earth

 (2) Provides a reason for the ship to land on the planet where the Alien's ship is found

 b) Ash as a Company android

 (1) Because he is working for the Company and trying to protect the Alien, he provides an obstacle to achieving the goal of killing the Alien

 (2) Because he is an android, he can be "killed" and brought back to "life" to give the crew information about the company and the Alien

 B. SIMILARITY and REPETITION

 1. Certain elements (characters, events, etc.) will either recur or similar elements will occur in a film

 a) In *Alien*, we get a number of attacks from the Alien on the crew members, usually ending in death

 b) We also get a number of different escapes, including the crew's escape from the planet and Ripley's escape from the Nostromo

2. MOTIFS: Can be an element of style (color, object, place, sound [music or dialogue, camera movement, etc.]), or a story element (an action, etc.)

 a) Sounds, including breathing sounds, "wet" sound (slurping, dripping, etc.)

 b) The visual combination of organic and mechanical elements, seen in both the Alien ship and the Alien itself

 c) The background music, which blends in with the sound effects

 d) The idea of "motherhood"

 (1) The Alien eggs

 (2) The Alien ship as womb-like

 (3) The Nostromo's computer, "Mother"

 (4) Ripley's maternal protection of the cat

C. DIFFERENCE and VARIATION provide for variety, contrast and change in a film

1. Can be different degrees of the same thing; there are three forms of the Alien

 a) The "face-grabber"

 b) The "chest-burster"

 c) The adult Alien

2. Or complete oppositions, such as the organic/mechanical design of the Alien spacecraft, and the strictly industrial design of the Nostromo

3. PARALLELISM

 a) Cues the viewer to compare two or more distinct elements of a film; general similarities, not exact repetitions

 b) Example: each crew member who is killed is killed in a different manner, so we wait to find out how each will be eliminated (all are killed by the Alien except for Ash, who is killed by the crew, and Ripley, who escapes)

D. DEVELOPMENT

 1. Constitutes some patterning of similar and differing elements; there is a progression from one point (the beginning) to another (the end)

 2. In *Alien*, there are various patterns of development:

 a) It is a JOURNEY from one place (the deserted planet) to another (Earth)

 b) It is a SEARCH for the Alien and some way to kill it

 c) It is a MYSTERY; who or what is the Alien, and why does the Company want to keep him alive?

E. The principle of UNITY/DISUNITY

 1. The degree to which all of the relationships we perceive within a film are clear and economically interwoven

 2. *Alien* has little disunity; in the director's cut, however, there is a reference to the Aliens reproducing asexually, which is contradicted in later films

II. MEANING-MAKING - There are four types of meanings which we experience in films:

A. REFERENTIAL MEANING

 1. A film's reference to tangible things, events and places in the real world; we understand these because of our experiences in the real world

 2. EXAMPLE: A spaceship must escape the gravity of a planet to enter into outer space, explosions destroy structures, etc.

B. EXPLICIT MEANING

 1. The explicit meaning of the film is slightly more abstract, but is generally overtly stated by the film

 2. EXAMPLE: You must eliminate threats to survival through perseverance, courage and ingenuity

C. IMPLICIT MEANING

 1. The film's implicit meaning is not stated, but is suggested or implied by the film; when we interpret a film, we are stating its implicit meaning

2. EXAMPLE: Corporate America cares little for human beings, only profit (condemning capitalism)

D. IDEOLOGICAL MEANING

1. The ideological or symptomatic meaning of a film is the particular set of social and/or political values which we understand from the film's explicit and implicit meanings

2. EXAMPLE: Individual initiative, not group action, is able to overcome all obstacles (celebrating capitalism)

FILM FORM

The Wizard of Oz (Victor Fleming, 1939)

Directed by Victor Fleming, Norman Taurog, Richard Thorpe and King Vidor

Written by Noel Langley, Florence Ryerson and Edgar Allan Woolf

Cinematography by Harold Rosson

Original music by Harold Arlen and Herbert Stothart

Costume Design by Adrian

Film Editing by Blanche Sewell

Character Make-up by Jack Dawn

Art Direction by Cedric Gibbons

Special Effects by A. Arnold Gillespie

Color Consultation by Natalie Kalmus

Produced by Mervyn LeRoy

Produced by MGM (Metro-Goldwyn-Mayer)

Distributed by MGM (Metro-Goldwyn-Mayer)

Cast

Judy Garland…Dorothy Gale

Frank Morgan…Prof Marvel/Guardian of the Gates/Cabbie/Soldier/Wizard

Ray Bolger…Hunk Andrews/Scarecrow

Bert Lahr…Zeke/Cowardly Lion

Jack Haley…Hickory Twicker/Tin Woodman

Billie Burke…Glinda, the Good Witch

Margaret Hamilton…Miss Almira Gulch/The Wicked Witch of the West

Charley Grapewin…Uncle Henry

Clara Blandick…Aunt Em

15

STUDY QUESTIONS

1. What are the FUNCTIONS of the elements of the film? For example, what is the function of the ruby red slippers? What is the function of having each of the various characters Dorothy meets lacking some important quality? Ask yourself, "What is the logical justification for this element? What would be the problem if it were lacking?"

2. In what ways do we see SIMILARITY and REPETITION at work in the film? What elements (characters, events, etc.) either recur or similar elements occur? What kinds of MOTIFS did you notice, either story elements of stylistic elements?

3. How do we see DIFFERENCE and VARIATION working in the film? Which elements create PARALLELISM?

15

4. How does DEVELOPMENT constitute a patterning of these similar and differing elements; what is the progression from one point (the beginning) to another (the end)?

5. Does the film have a high degree of UNITY, or is there some DISUNITY?

6. What kinds of meanings do we make from the film (REFERENTIAL, EXPLICIT, IMPLICIT and/or IDEOLOGICAL or SYMPTOMATIC)?

FILM FORM in *The Wizard of Oz* (Victor Fleming, 1939)

I. INTRODUCTION

 A. *The Wizard of Oz*, largely due to its structure as a dream, is an especially interesting film to analyse formally

 B. Because it is designed for children, it is relatively easy figure out how it works

II. PERCEPTION - FIVE GENERAL PRINCIPLES

 A. FUNCTION

 1. Role of any element of the film in relation to the film as a whole

 2. Elements usually have multiple functions

 a. The ruby red slippers

 (1) Provide a reason for the Wicked Witch of the West to try to capture Dorothy

 (2) They save her from the witch

 (3) Provide the means for Dorothy to get home

 b. Qualities the characters lack

 (1) Help define their characters and connect them with the farmhands in Kansas

 (2) Give them a reason to go with Dorothy

 (3) Create obstacles that must be overcome

 (4) Provide the Witch with ways to threaten and attack them

 B. SIMILARITY and REPETITION

 1. Certain elements (characters, events, etc.) will either recur or similar elements will occur in a film

 a. In *The Wizard of Oz*, the characters we see at the beginning of the film return in Oz, and then again at the end of the film

 (1) Miss Gulch: Wicked Witch of the East, Wicked Witch of the West

 (2) Hunk: Scarecrow

 (3) Hickory: Tinman

 (4) Zeke: Cowardly Lion

 (5) Prof. Marvel: The Wizard, doorman, guard, carriage driver

 b. We are presented with a series similar meetings between Dorothy and the other characters

 2. MOTIFS

 a. Can be an element of style (color, object, place, sound [music or dialogue, camera movement, etc.])

 (1) Ruby red slippers

 (2) "We're Off to See the Wizard"

 b. Or a story element (an action, etc.)

 (1) Meeting the three characters

 (2) Dorothy meeting Miss Gulch repeatedly (as three different characters)

C. DIFFERENCE and VARIATION provide for variety, contrast and change in a film

 1. Can be different degrees of the same thing; there are good witches and bad witches

 2. Or complete oppositions, such as the black-and-white of Kansas opposed to color of Oz

 3. PARALLELISM

 a. Cues the viewer to compare 2 or more distinct elements of a film; general similarities, not exact repetitions

 b. Example: each character lacks something, but each character lacks something different

D. DEVELOPMENT constitutes some patterning of similar and differing elements; there is a progression from one point (the beginning) to another (the end)

 1. In *The Wizard of Oz*, there are various patterns of development:

a. It is a JOURNEY from one place (Kansas) to another (Oz) and back again

b. It is a SEARCH for a way home, and for the things the characters lack

c. It is a MYSTERY; who or what is the wizard?

d. It is often useful to segment a film in order to more readily see its pattern of development; *The Wizard of Oz* can be divided into nine segments (each of these may be divided into smaller segments):

 C Opening Credits

 1. At home in Kansas

 2. In Munchkinland

 3. Meeting the Scarecrow

 4. Meeting the Tinman

 5. Meeting the Cowardly Lion

 6. In the Emerald City of Oz

 7. Confrontation with the Witch

 8. Back in the Emerald City

 9. Back in Kansas

 E End Credits

E. The principle of UNITY/DISUNITY

1. The degree to which all of the relationships we perceive within a film are clear and economically interwoven

2. *The Wizard of Oz* has little disunity; only obvious example is when the witch mentions the bees, referring to a scene that was omitted

F. MEANING-MAKING - There are four types of meanings which we experience in films:

1. REFERENTIAL MEANING

 a. A film's reference to tangible things, events and places in the real world; we understand these because of our experiences in the real world

 b. EXAMPLE: A cyclone takes Dorothy to Oz, fire burns straw, tin rusts, etc.

2. EXPLICIT MEANING

 a. The explicit meaning of the film is slightly more abstract, but is overtly stated by the film

 b. EXAMPLE: "There's no place like home"

3. IMPLICIT MEANING

 a. The film's implicit meaning is not stated, but is suggested or implied by the film; when we interpret a film, we are stating its implicit meaning

 b. EXAMPLE: A girl yearns for the world of childhood, but realizes she must face adulthood

4. IDEOLOGICAL MEANING

 a. The ideological or symptomatic meaning of a film is the particular set of social and/or political values which we understand from the film's explicit and implicit meanings

 b. EXAMPLES:

 (1) "Family values" are best, especially strong in times of economic crisis (such as the Depression, when the film was made)

 (2) OR Don't rock the boat, don't expect to change things, they are good the way they are

FILM FORM

The Music Box (James Parrott, 1932)

Directed by James Parrott

Written by H.M. Walker

Cinematography by Len Powers and Walter Lundin

Original music by Harry Graham, Marvin Hatley and Leroy Shield

Film Editing by Robert C. Currier

Produced by Hal Roach

Produced by Hal Roach Studios

Distributed by MGM (Metro-Goldwyn-Mayer)

Cast

Stan Laurel…Stanley

Oliver Hardy…Ollie

Gladys Gale…Mrs. Von Schwarzenhoffen

Billy Gilbert…Prof. Von Schwarzenhoffen

Charlie Hall…Postman

STUDY QUESTIONS

1. In what ways do we see SIMILARITY and REPETITION at work in the film? What elements (characters, events, etc.) either recur or similar elements occur? What kinds of MOTIFS did you notice, either story elements of stylistic elements?

2. How do we see DIFFERENCE and VARIATION working in the film? Which elements create PARALLELISM?

3. How does DEVELOPMENT constitute a patterning of these similar and differing elements; what is the progression from one point (the beginning) to another (the end)?

4. Does the film have a high degree of UNITY, or is there some DISUNITY?

5. What kinds of meanings do we make from the film (REFERENTIAL, EXPLICIT, IMPLICIT and/or IDEOLOGICAL or SYMPTOMATIC)?

FILM FORM in *The Music Box* (James Parrott, 1932)

I. INTRODUCTION

 A. As a short film, *The Music Box* may seem to be an unlikely candidate for analysis, as it is fairly simple and straightforward

 B. However, this makes it an excellent choice for formal analysis; it is very much like a feature-length film in the way in which it operates, but in a smaller, more easily manageable size

II. PERCEPTION – FIVE GENERAL PRINCIPLES

 A. FUNCTION refers to the role of any element of a film in relation to the film as a whole

 1. Elements usually have multiple functions

 a) For example, the meeting between the Professor, Stan and Ollie on the steps serves two functions in *The Music Box*

 b) It provides another obstacle to their carrying the piano up the stairs, and it sets up the meeting at the end of the film

 2. Consider the motivation, or logical justification, for the elements of the film

 a) What is the function of Stan's long shoes?

 b) What is the function of Stan dropping the block on Ollie's head?

 B. SIMILARITY and REPETITION comprise another principle of film form

 1. Certain elements (characters, events, etc.) will either recur or similar elements will occur in a film

 a) In *The Music Box*, the repetition of the carrying of the piano up the stairs

 b) The repeated mix-ups with the hats, etc.

 2. A MOTIF is any significant repeated element in a film

 a) A stylistic element (sound, color, camera movement, object, etc.), such as the rumbling sound of the piano rolling down the stairs

 b) A story element (repeated action, etc.), such as the repeated attempts to deliver the piano

C. DIFFERENCE and VARIATION provide for variety, contrast and change in a film

 1. In *The Music Box*, Oliver Hardy and Stan Laurel themselves are contrasted: one fat and obnoxious, the other skinny and wimpy

 2. PARALLELISM cues the viewer to compare two or more distinct elements of a film

 a) Stan and Ollie dress similarly, inviting us to compare and contrast them

 b) Each trip up the stairs is interrupted by something different

D. DEVELOPMENT constitutes some patterning of similar and differing elements

 1. In *The Music Box*, the development of the film follows the efforts of Stan and Ollie to deliver the piano to the house on the hill, then to get it into the house and plug it in; eventually, they succeed

 2. SEGMENTATION of *The Music Box*: It is often useful to segment a film in order to more readily see its pattern of development

 C Opening credits

 1. The purchase of the piano

 a. We learn details about Laurel and Hardy and their new business

 b. We meet the wife

 2. Arrival at the house

 a. We meet the postman

 b. Horse joke

 3. First trip up the stairs

 a. Interrupted by the maid

 b. Sets up the meeting with the policeman

 4. Second trip up the stairs; interrupted by the policeman

5. Third trip up the stairs

 a. They meet the Professor

 b. We expect the piano to fall down the stairs again, but the joke is delayed

 c. Ollie falls into fountain

 d. After they get up to the top, the piano falls back down

6. Fourth trip up the stairs

 a. The postman returns

 b. Stan and Ollie take the piano down the stairs themselves

7. Entering the house

 a. Horse joke doesn't happen

 b. Ollie falls into fountain again

8. Installing the piano

9. Arrival of the wife

E End credits

E. The principle of UNITY/DISUNITY refers to the degree to which all of the relationships we perceive within a film are clear and economically interwoven

1. Like most Hollywood films, *The Music Box* is very unified

2. Additionally, as a short film, there is less opportunity for mistakes in narrative continuity to create disunity

III. MEANING-MAKING: There are four types of meanings that we experience in films

 A. REFERENTIAL MEANING

 1. A film's reference to tangible things, events and places in the real world

 2. For example, we understand how gravity works, so we understand why the piano keeps falling down the hill

 B. EXPLICIT MEANING

 1. Slightly more abstract, but overtly stated by the film

 2. For example, two men seek to start a business, but meet with certain obstacles

C. IMPLICIT MEANING

 1. The film's implicit meaning is not stated, but is suggested or implied by the film; when we interpret a film, we are stating its implicit meaning

 2. For example, the specific failures of Stan and Ollie with the piano are simply metaphors for their own relationships with one another and the rest of the world

D. IDEOLOGICAL or SYMPTOMATIC MEANING

 1. The set of social and/or political values that we understand from the film's explicit and implicit meanings

 2. For example, the working class can never succeed against the upper class, the police, etc.

FILM FORM

Psycho (Alfred Hitchcock, 1960)

Directed by Alfred Hitchcock

Written by Robert Bloch (novel), Joseph Stefano

Produced by Alfred Hitchcock

Produced by Shamley Productions

Distributed by Paramount Pictures

Cinematography by John L. Russell

Music by Bernard Herrmann

Costume Design by Helen Colvig

Film Editing by George Tomasini

Title Design and Pictorial Consulting by Saul Bass

Sound by William Russell and Waldon O. Watson

Cast

Anthony Perkins…Norman Bates

Vera Miles…Lila Crane

John Gavin…Sam Loomis

Martin Balsam…Milton Arbogast

John McIntire…Sheriff Chambers

Simon Oakland…Dr. Richmond

Vaughn Taylor...George Lowery

Frank Albertson...Tom Cassidy

Lurene Tuttle...Mrs. Chambers

Patricia Hitchcock...Caroline

John Anderson...California Charlie

Mort Mills...Highway Patrolman

Janet Leigh...Marion Crane

Virginia Gregg...Voice of mother

STUDY QUESTIONS

1. Think about the ways in which we are made to feel certain ways about the characters and the events using film form. How does the film invite us to compare and contrast characters, places, etc.?

2. What are the multiple functions of the various elements of the film? Think about the functions of the newspaper, the "mother" costume, etc.

3. What sorts of similarities and repetitions do we find? Repeated trips to the Bates Motel; repeated murders; repeated sinking of cars and bodies in the swamp, etc.

4. What sort of motifs do we find? References to birds; hotel rooms; families; showers; Marion in underwear, etc.

5. How does the film use parallelism to encourage us to compare and contrast? The plot presents us with stark contrasts in its settings (Phoenix, Fairvale & the Bates Motel vs. the Bates home, the hardware store, etc). Aren't we invited to compare the characters; for example, Marion & Norman? In what ways are they alike?

6. What is unusual about the progression of *Psycho*? What happens to the "star"?

7. Who is guilty in *Psycho*? Obviously, it is Norman, but what about Marion? For whom do we have more sympathy? Do we sympathize with Norman? Why? But...are we guilty also? What are the implications of all of this for watching films in general?

FILM FORM in *Psycho* (Alfred Hitchcock, 1960)

I. INTRODUCTION

 A. The **story** presented in *Psycho* is fairly simple

 B. However, the **plot** is much more complex; the way the story is told is more interesting than the story (the difference between story and plot is discussed in more detail in the next chapter)

 1. Think about the ways in which we are made to feel certain ways about the characters, the events, etc. through the use of film form

 2. The film can be seen as:

 a. Inviting us to compare & contrast characters, places, etc.; in other words, "American ways of life"

 b. Trying to implicate us in the "evil"; to make us feel guilty

II. PERCEPTION – FIVE GENERAL PRINCIPLES

 A. FUNCTION: the role of any element of the film (elements usually have multiple functions)

 1. What are the multiple functions of the newspaper?

 a. It is used to conceal the stolen money

 b. It tips off Norman to the fact that Marion is has not come from Los Angeles

 2. What are the multiple functions of the "mother" costume?

 a. It conceals Norman's identity from us

 b. It proves Norman's insanity

 B. SIMILARITY & REPETITION

 1. What sorts of similarities & repetitions do we find?

 a. Repeated trips to the Bates Motel

 b. Repeated murders

 c. Repeated sinking of cars and bodies in the swamp

 2. What sort of motifs do we find?

 a. References to birds (Marion *Crane*, Phoenix, stuffed birds, "you eat like a bird," screeching sound like a bird, etc.)

 b. Hotel rooms (where "crimes" occur)

 c. Families (some fairly normal, like Marion's, and some sort of abnormal, esp. Norman's and Carolyn's)

 d. Showers (remember the shower in the corner of the frame in Marion's apartment)

 e. Marion in underwear (which changes from white to black: implications?)

C. DIFFERENCE & VARIATION; PARALLELISM

 1. How does the film use parallelism to encourage us to compare and contrast?

 a. The plot presents us with stark contrasts in its settings

 (1) On one hand:

 (a) We get a very bland American city (Phoenix), with boring offices, hotel rooms, etc.

 (b) Fairvale and the Bates Motel are also bland & mundane ("clean bathrooms")

 (2) On the other hand, we get the Bates home

 (a) It is very old-looking, with out-dated architecture, furniture

 (b) It is a typical "haunted house:"dark and spooky, with Norman's room looking like some sort of rat's nest (cf. the motel rooms)

 (3) Think also of the hardware store

 (a) This is where the two aspects come together

 (b) It is bland, but full of sharp objects & poison

 b. We are invited to compare the characters; for example, in what ways are Marion & Norman alike?

 (1) Their names

 (2) Marion says "We all go a little mad sometimes"

 (3) They both commit crimes

 (4) Both are connected with birds (see above)

 (5) Think of the scene that begins with Norman's eye, and ends with Marion's (dead) eye

D. DEVELOPMENT: What is unusual about the progression of *Psycho*?

 1. What happens to the "star"?

 2. A film that begins as a journey (Marion going to Sam) becomes a mystery (who killed Marion?)

E. UNITY/DISUNITY

 1. As a classical Hollywood film, *Psycho* is generally very unified

 2. Are there any elements of disunity in the film?

III. THE QUESTION OF GUILT

A. Who is guilty in *Psycho*? Obviously, it is Norman, but what about Marion?

B. What is the difference between their crimes?

 1. Certainly, a matter of degree

 2. But also the difference between a premeditated crime (stealing money) and the crimes of an insane person

C. For whom do we have more sympathy?

 1. Isn't it Marion at the beginning?

 a. How is this accomplished?

 b. How is her crime "justified" to some degree?

 (1) "Illicit" sex: she is in love, and wants to get married

 (2) Stealing the money: she does it for love, and the rich man is obnoxious

 2. Do we sympathize with Norman? Why?

 a. Do we want him to get caught before we know he is guilty (for example, when he sinks the cars in the swamp)?

 b. How does the film make us sympathize with him? (POV shots, identification with him, etc.)

D. BUT...are we guilty also?

 1. Consider the scene in which Norman watches Marion undress

 2. What are we doing at the same time?

 3. Think of the eye motif; both of us are watching Marion

E. What are the implications of all of this for watching films in general?

 1. Aren't we always voyeurs?

 2. Don't we watch others (but are not seen) doing things we wouldn't watch in real life (sex, murder, all sorts of weird things)?

3. If we enjoy something like murder on the screen, are we any better than Norman?

4. Think of the next-to-last shot, of Norman looking at us; what does he see? Someone he recognizes?

NARRATIVE AND NARRATION

Citizen Kane (Orson Welles, 1941)

Directed by Orson Welles

Produced by Orson Welles

Written by Herman J. Mankiewicz, Orson Welles and John Houseman

Cinematography by Gregg Toland

Original music by Bernard Herrmann

Costume Design by Edward Stevenson

Film Editing by Mark Robson and Robert Wise

Produced by Mercury Productions/RKO Radio Pictures, Inc.

Distributed by RKO Radio Pictures Inc.

Cast

Joseph Cotton…Jedediah Leland/Newsreel Reporter

Dorothy Comingore…Susan Alexander

Agnes Moorehead…Mrs. Kane

Ruth Warrick…Emily Norton

Ray Collins…Boss Jim Gettys

Erskine Sanford…Herbert Carter/Newsreel Reporter

Everett Sloane…Bernstein

William Alland…Jerry Thompson/"News on the March" Narrator

Paul Stewart…Raymond

George Coulouris…Walter P. Thatcher

Fortunio Bonanova…Matiste

Gus Schilling…Headwaiter

Philip Van Zandt…Rawlston

Harry Shannon…Kane senior

Sonny Bupp…Kane III

Orson Welles…Charles Foster Kane

Buddy Swan…Young Charles Foster Kane

Gregg Toland…Interviewer in Newsreel

STUDY QUESTIONS

1. Both the newsreel and the character narrators provide us with a multifaceted picture of Kane, with widely different views about his character; which view of Kane should we accept?

2. We need to ask ourselves several questions that will guide us in analyzing this narrative:

 a. How do the individual characters" flashbacks present Kane, and what are their attitudes toward him?

 b. How does the film's narration present the characters and their views about Kane?

3. Although we have conflicting feelings about the veracity of the flashbacks of the characters, which portions of the narration do we believe to be "true"? Why do we take them to be "true?"

4. What is "Rosebud?"

5. How does the film really end; the plot, not the story?

NARRATIVE AND NARRATION in *Citizen Kane* (Orson Welles, 1941)

I. NARRATION AND PLOT IN *Citizen Kane*

 A. The plot of the film delegates portions of the narration to a variety of narrators

 1. Thatcher, Bernstein, etc.

 2. The newsreel portion of the film also functions as a "narrator"

 a. It provides a capsule summary of Kane's life, and also closely parallels the structure of the entire film itself

 b. However, unlike the narratives of the characters, the newsreel presents a public view of Kane instead of a private view

 3. Both the newsreel and the character narrators provide us with a multifaceted picture of Kane, with widely different views about his character

 4. The scene in the projection room

 a. Sets up the goal-oriented structure of the film (the search for "Rosebud")

 b. Provides the motivation for the series of flashbacks that follow

 B. Which view of Kane should we accept?

 1. Any conclusion about the "truth" of any of the flashbacks is an interpretation, and must be supported by an analysis of the way in which the plot presents the story

 2. We need to ask ourselves several questions that will guide us in this analysis

 a. How do the individual characters flashbacks present Kane, and what are their attitudes toward him?

 b. How does the film's narration present the characters and their views about Kane?

 3. For example, if we interpret the narration as favouring one of the narrators--Jed Leland--we may support such an interpretation by an analysis of the various flashbacks

II. ANALYSIS OF THE NARRATIVE AND NARRATION of *Citizen Kane*

 A. How do the individual characters flashbacks present Kane, and what are their attitudes toward him?

 1. THATCHER, the banker

 a. Describes a stubborn, wilful Kane, who attacks Thatcher through yellow journalism

 b. Thatcher's flashback presents an unflattering picture of Kane and concentrates on the business aspects of his life, not the personal side

 2. BERNSTEIN, Kane's business manager

 a. Describes Kane's early career as a newspaper publisher with ambition, ideals, and a great deal of success

 b. Kane emerges from this flashback as a "lovable eccentric"

 c. Bernstein's flashback omits the negative aspects of Kane's personal life, as well as his political failure, Susan's failed opera career, etc.

 d. Keep in mind that Bernstein, always a "yes man" to Kane, has become the chairman of the board of Kane's empire, and still has a great deal of respect and admiration for Kane (he has a portrait of Kane over his desk)

 3. JED LELAND

 a. Describes the public and personal failures of Kane, including his two failed marriages, his political career, Susan's career as an opera singer, etc.

 b. Omits Kane's various successes

 c. Leland, formerly Kane's best friend, ends up broke in a nursing home without any desire to continue living

 4. SUSAN ALEXANDER

 a. Her flashback shows us Kane as a man obsessed, first with her career as a singer, later with his statues and his palace (Xanadu)

 b. Omits the business aspects of his life

 c. She ends up a poor, lonely alcoholic, but still feels sorry for Kane

 5. RAYMOND, the butler at Xanadu

 a. Describes Kane as a quick-tempered eccentric, who said and did "a lot of strange things"

 b. Raymond comes to an ambiguous end, but seems to be doing fairly well financially

B. How does the film's narration present the characters and their views about Kane?

 1. The narration seems to undermine the flashbacks of Thatcher, Bernstein, and Raymond; each has something to gain or protect:

 a. Thatcher has his own public position to protect

 b. Bernstein has the Kane empire to protect

 c. Raymond seems to be willing to say anything for money

 2. Although Susan has nothing to protect, her flashback is the most subjective, with many subjective (POV) shots (on the stage at the opera, in her room as she attempts suicide, etc.)

 a. We learn more about her emotional state from her narrative than we do about Kane, and in fact we often know more about Kane than she does

 b. Thus her flashback may be lacking in credibility; We tend to distrust the testimony of emotional witnesses, especially women

 3. Leland's flashback, however, seems to be favored by the narration

 a. RANGE: Provides the greatest range of information; the most unrestricted, giving us scenes at which he couldn't have been present

 (1) We see Kane's meeting with Susan

 (2) We also see the stagehands, whom he couldn't have seen

 b. DEPTH: It seems to be the most objective, lacking the subjectivity and emotionalism of Susan's testimony; "just the facts"

 c. Jed's flashback presents the most complex view of Kane, giving us both his good and bad sides

C. Although we have conflicting feelings about the veracity of the flashbacks of the characters, we take the portions of the narration that have no narrator to be "true"

 1. These scenes include:

 a. The beginning and end of the film

 b. The scenes in the projection room

 c. The portions before and after the individual characters narratives, etc.

 2. Why do we take them to be "true?" Because their depth is objective, not subjective

III. WHAT IS "ROSEBUD?"

A. Although we learn at the end of the film that Rosebud is a sled that Kane had as a boy (and with which he attacked Thatcher), the full significance of Rosebud is left unexplained

B. As the reporter points out, no one word can explain a man's life, and in the end we are as unsure of the "real" Kane as we are about the meaning of Rosebud

C. We are left with a multiple view of Kane, similar to the multiple images we see as he walks past the mirrors in the hall at Xanadu (cf. the other multiple shots of Kane; for example, at the political rally, with Kane, Jr. and the posters)

D. The film begins and ends with a shot of a "No Trespassing" sign; it is impossible to trespass on Kane's life enough to know what kind of person he really was

IV. THE ENDING OF THE FILM

 A. How does the film really end; the plot, not the story?

 B. What is the effect of the introduction of the actors? (Cf. a curtain call at a play)

 C. Diegetic images are used nondiegetically

 D. Emphasizes the plot; calls attention to the construction of the film, reminds the audience that it is not reality, it is art; remember that film is not reality

 E. What is missing? (Orson Welles!) What is the effect? (false modesty)

NARRATIVE AND NARRATION

Psycho (Alfred Hitchcock, 1960)

Directed by Alfred Hitchcock

Written by Robert Bloch (novel), Joseph Stefano

Produced by Alfred Hitchcock

Produced by Shamley Productions

Distributed by Paramount Pictures

Cinematography by John L. Russell

Music by Bernard Herrmann

Costume Design by Helen Colvig

Film Editing by George Tomasini

Title Design and Pictorial Consulting by Saul Bass

Sound by William Russell and Waldon O. Watson

Cast

Anthony Perkins…Norman Bates

Vera Miles…Lila Crane

John Gavin…Sam Loomis

Martin Balsam…Milton Arbogast

John McIntire…Sheriff Chambers

Simon Oakland…Dr. Richmond

Vaughn Taylor...George Lowery

Frank Albertson...Tom Cassidy

Lurene Tuttle...Mrs. Chambers

Patricia Hitchcock...Caroline

John Anderson...California Charlie

Mort Mills...Highway Patrolman

Janet Leigh...Marion Crane

Virginia Gregg...Voice of mother

STUDY QUESTIONS

1. The **story** presented in *Psycho* is simple. However, the **plot** is much more complex; the way the story is told is more interesting than the story. Think about the process of the plot giving us story information, and the ways in which we are made to feel certain ways about the **characters** and the events through this process.

2. Is the narration restricted or unrestricted? Is it objective, perceptually subjective, or mentally objective?

3. How does the process of narration implicate us in the crimes committed?

NARRATIVE AND NARRATION in *Psycho* (Alfred Hitchcock, 1960)

I. INTRODUCTION

 A. The story presented in Alfred Hitchcock's 1960 film *Psycho* is fairly simple

 B. However, the plot is much more complex; the way in which the story is told is more interesting than the story

 C. Think about the ways in which we are made to feel certain ways about the characters, the events, etc.

II. ANALYSIS OF THE NARRATIVE AND NARRATION OF *PSYCHO*

 A. In general, the plot is unrestricted and objective; however, it has moments of restricted and subjective narration

 B. The film uses different degrees of range and depth to do three things:

 1. To drive the narrative successfully and interestingly

 2. To compare and contrast characters, places, etc.; in other words, "American ways of life"

 3. To implicate us in the "evil", and to make us feel guilty

 C. The plot of the film presents us with stark contrasts in its settings

 1. On one hand, we get a very bland American city (Phoenix), with boring offices, hotel rooms, etc.; Fairvale and the Bates Motel are also bland and mundane (the motel's most outstanding feature is "clean bathrooms")

 2. On the other hand, we get the Bates home, which it is very old-looking, with out-dated architecture and furniture

 a. It appears to be typical "haunted house"; it is dark and spooky

 b. Norman's room looks like some sort of rat's nest (in contrast to the very neat and clean motel rooms)

 3. Think also of the hardware store, which is where the two aspects come together; it is bland, but full of sharp, dangerous objects and poisons.

 D. Likewise, we are invited to compare the characters, especially Marion and Norman

1. In what ways are they alike? Ultimately, who is really guilty in this film?

2. Is it we who are really guilty?

 a. The film draws a parallel not just among characters, but also between the viewer and Norman

 b. Our implication in the "crime" as well as our disorientation are created through the use of range and depth of narration

III. SEGMENTATION of *Psycho*

 A. When we discussed film form, we looked at the ways in which the form of the film operates

 B. By carefully segmenting the film, we can see in more detail how the process of narration works in the film

 C. SEGMENTATION of Alfred Hitchcock's *Psycho*

 1. C Opening credits

 a. Opening scene

 (1) We immediately feel like voyeurs, watching two people, partially undressed, obviously after making love in a sleazy hotel room

 (2) When is something like this duplicated?

 b. Real estate office

 (1) How is Marion's crime justified in this scene?

 (2) Think of the references to family; these relationships are all abnormal

 c. At Marion's apartment with the money

 (1) We get some camera movements and shots that are OBVIOUSLY and SELF-CONSCIOUSLY objective, presenting a POV that is clearly the NARRATOR'S (and OURS)

(2) So, we are made to sympathize with Marion (we understand her feelings and why she feels justified in stealing the money), but we feel also feel like voyeurs once more (think of her black bra; difference and variation?)

d. In Marion's car

(1) POV? and how much do we know? (The narration is restricted; we begin to get mental subjectivity)

(2) Who does she see? Function?

e. In the car on the side of the road with the policeman

(1) We get perceptually subjective shots from both POVs

(2) But note the difference in the eyelines to maintain more perceptual subjectivity, and our sympathy, with Marion

f. Used car lot

g. Back on the road

(1) Think about what she "hears" in her mind

(2) Are these memories, her imagination, or what?

h. Bates Motel

(1) We meet Norman

(2) Why does it become restricted when Norman leaves Marion and we hear Mrs. Bates?

(3) The meal in the office

(a) Begins the motif of (dead) birds

i) Marion Crane (from Phoenix)

ii) Stuffed birds (get it?)

iii) "You eat like a bird"

(b) We get much exposition about Mrs. Bates and the past

(c) There is a strong connection made between Norman and Marion

(4) After Marion leaves the office

(a) POV? and how much do we know? What is

different?

 (b) It becomes restricted to Norman; we get Norman's POV

i. Back in Marion's room

 (1) We lose our "anchor"

 (a) The movie has been about Marion

 (b) Who is it about now?

 (c) Whose POV?

 (2) The narration, in general, becomes very unrestricted and objective; why?

 (3) How does the film implicate us in this scene? Even when Marion is being killed, there is a part of us that wants to see her body

 (4) The Symmetrical Sequence of Shots

 (a) Begins with Norman looking at Marion

 (b) We get a shot of his eye

 (c) Then a cut to the hole (a circle) in the wall (what is the hole behind?)

 (d) This is presented in a series of fairly long takes

 (e) Then we get the shower and the murder, presented in a series of short, rapidly edited shots

 (f) Ends with a shot of the drain (a circle) that dissolves to the eye of Marion

 (5) After this sequence, we get a camera movement through the room

 (a) Using the narrator's POV, it focuses on the newspaper and the window

 (b) Does this recall an earlier use of the camera?

 (c) How do we feel, especially in light of our sympathy for Marion?

j. Norman finds Marios, cleans up, and disposes of her

k. In the store

 (1) Introduces Lila Crane (will she be our anchor?) and the private investigator, Arbogast

 (2) What do we see and hear in the store?; knives, talk about poison, etc.

l. PI's search for Marion

 (1) Begins with montage sequence of search

 (2) Then at the Bates Motel

 (3) Late in the scene we get some shots from Arbogast's POV; will he be our anchor?

m. In the phone booth

n. Return to the Bates Motel

 (1) Begins unrestricted, with objective shot of Norman

 (2) Becomes restricted to Arbogast; POV shots of birds in the office, more in house

 (3) Some unrestriction right before Arbogast is killed; why?

o. Sam and Lila

p. The Sheriff's House; We receive more information about Norman and his mother

q. Back at the Bates Motel; Norman and his mother

 (1) Very restricted and objective; we think we know what's going on but we don't

 (2) Why are camera angles and positions chosen?; to withhold information

r. At the church with the sheriff

s. Lila and Sam back to the Bates Motel

 (1) Does this segment belong to a pattern?

 (2) It is the third meeting over the motel counter

 (3) What sort of progression has there been in this series?

 (4) Unrestricted and objective

 (5) Remains unrestricted; from the house to the office

(6) But has shots of and in the house from Lila's POV; perceptually subjective in those portions of the scene and objective in the office

t. At the police station

(1) Unrestricted (in the office and with Norman) and objective until almost the last shot)

(2) He looks at us; what does he see?

u. Ends with a shot of the car

2. E End credits

NARRATIVE AND NARRATION

The Usual Suspects (Bryan Singer, 1995)

Directed by Bryan Singer

Produced by Michael McDonnell and Bryan Singer

Written by Christopher McQuarrie

Original music by John Ottman

Cinematography by Newton Thomas Sigel

Film Editing by John Ottman

Produced by Blue Parrot, Gramercy, PolyGram, Bad Hat Harry and Spelling Films

Distributed by Columbia TriStar

Cast

Stephen Baldwin…Michael McManus

Gabriel Byrne…Dean Keaton

Benicio Del Toro…Fred Fenster

Kevin Pollak…Todd Hockney

Kevin Spacey…Verbal Kint

Chazz Palminteri…Dave Kujan

Pete Postlethwaite…Kobayashi

Suzy Amis…Edie Finneran

Giancarlo Esposito…Jack Baer

Dan Hedaya…Jeff Rabin

STUDY QUESTIONS

1) With this film, it is especially difficult to determine the story vs. the plot; this is because we can accurately determine the plot – the way in which the film gives us story information - but it is much more difficult to decide just what the story is; in other words, just how much of what we see is "true"? What is it that we can determine is non-diegetic material (items in the plot that is not in the story)? What is it that we can determine are implicitly presented events, those that are in the story but not in the plot? How can we be sure? How do we determine what it is that we will believe in the plot?

2) How does the film manipulate cause and effect to achieve specific effects? Are causes planted early in the film to explain later effects? Are causes withheld to create suspense? Are effects withheld to create surprise?

3) Does the film begin with some of the story already having taken place? What is the effect; does it help to create suspense and arouse curiosity? At the beginning of the film, is there an exposition, with information about events and characters before the film began?

4) What is the range of narration in this film? The depth? What are the effects of this particular kind of narration?

5) Ultimately, how is this film different from the average classical Hollywood film? In what specific ways does it conform or deviate from the classical model?

NARRATIVE AND NARRATION in *The Usual Suspects* (Bryan Singer, 1995)

I. INTRODUCTION

 A. *The Usual Suspects* is an interesting film to discuss in terms of its narrative and narration

 B. This is because it provides a narrative that is basically unreliable

 C. It is unreliable due to the range and depth of the narration, although we don't know that immediately

II. THE STORY/PLOT DISTINCTION

 A. With this film, it is especially difficult to determine the story vs. the plot

 1. This is because we can accurately determine the plot, the way in which the film gives us story information

 2. But it is much more difficult to decide what the story is; in other words, just how much of what we see is "true"

 B. What is it that we can determine is non-diegetic material; the material that is in the plot that is not in the story?

 1. Background music

 2. Credits

 3. Anything else?

 C. What is it that we can determine are implicitly presented events?

 1. What is in the story but not in the plot?

 2. We assume certain events occurred (the trip to Los Angeles, the hijacking of the truck, etc.)

 3. How can we be sure?

 D. How do we determine what it is that we will believe in the plot?

 1. Range and depth have an important effect on what we believe

 2. This is discussed in more detail below

III. CAUSAL AGENTS

 A. The agents of cause and effect are CHARACTERS (as is typical in a Hollywood film)

 1. In what ways are the characters in the film constructs, or collections of character traits?

 a) Verbal, for example, is crippled and "weak"

 b) Detective Kujan is arrogant, believes he is smarter than everyone else

 2. In what ways do they have traits needed for them to function in the narrative?

 a) Because Verbal is crippled, he is not suspected by Kujan

 b) Because of Kujan's arrogance, he is deceived by Verbal

 B. How does the film manipulate cause and effect to achieve specific effects?

 1. Are causes planted early in the film to explain later effects? For example, the crimes committed by the characters early in the film are the causes of their later arrests

 2. Are causes withheld to create suspense?

 a) This is the primary strategy of the film

 b) The cause of the incident at the pier – the explosion, the deaths of the crew and the protagonists – is not revealed until the very end of the film

 3. Are effects withheld to create surprise? For example, the effect of the truck hijacking is not revealed until Kobayashi reveals that it is one of the reasons Kaiser Soze is threatening the characters

IV. TIME and NARRATIVE

 A. Does the narrative manipulate ORDER?

 1. This is the most important manipulation of the film

 2. The film is built on a series of flashbacks, beginning the night before the interrogation of Verbal

B.	DURATION

1.	What is the SCREEN DURATION? 106 minutes

2.	What is the PLOT DURATION? About 24 hours

3.	What is the STORY DURATION?

a)	This is not easy to determine with any certainty

b)	It begins at least when we see the flashback of the young Kaiser Soze…assuming that we can believe it

C.	FREQUENCY

1.	Are there events that occur more often in the plot than they do in the story?

2.	The death of Dean Keaton occurs twice (again, assuming that we can believe what we see)

V.	SPACE and NARRATIVE

A.	What is the STORY SPACE?

1.	New York and Los Angeles (and all the space between), Hungary, etc.

2.	Again, assuming we can believe it

B.	What is the PLOT SPACE?

1.	The police stations in New York and Los Angeles

2.	The restaurant

3.	The ship, etc.

C.	What is the SCREEN SPACE? What we see in the frame at any given moment

VI.	DEVELOPMENT OF THE NARRATIVE

A.	Does the film begin with some of the story already having taken place?

1.	Yes, in fact, most of the story has already taken place

2.	What is the effect?

a)	It creates suspense and arouses our curiosity

b)	We want to know how this state of affairs – the explosion of the ship – came to be

61

B. At the beginning of the film, is there an exposition, with information about events and characters before the film began?

 1. Yes the interrogation provides a perfect opportunity for this exposition

 2. It is not until later that we begin to doubt the truthfulness of this exposition

C. How does the body of the film develop patterns?

 1. The most important pattern is a change in knowledge

 2. We learn the details (we think) as Kujan learns them, until the end when we learn the "truth" about Kaiser Soze

D. CLOSURE

 1. Is the end of a film CLOSED, with everything resolved? Or is it OPEN, with questions left unanswered?

 2. This depends on what you believe about Kaiser Soze…

VII. RANGE AND DEPTH OF NARRATION

A. What is the range of narration in this film?

 1. Is it UNRESTRICTED? Do we see, hear, and know more than any or all of the characters?

 2. Or is it RESTRICTED? Do we see, hear, and know what only one character in the film experiences?

 3. We think it is unrestricted; but by the end we assume that it is restricted to what Verbal knows (or to what Kujan knows?)

B. What is the DEPTH of narration in this film?

 1. OBJECTIVE or EXTERNAL narration?

 a) Are we confined to what the characters say and do, their external behavior?

 b) Initially, we assume that it is primarily objective, and that we are seeing what happened

 2. PERCEPTUAL SUBJECTIVITY?

 a) Does the narration give us access to what characters see and hear, through optical POV shots or sonic POV of a character?

b) We assume that some instances are perceptually subjective; for example, at the beginning of the film when we see what Verbal "sees" at the pier

3. MENTAL SUBJECTIVITY?

a) Do we "hear" a character's thoughts, see fantasies or hallucinations, etc?

b) By the end of the film, we conclude that what we have been seeing and hearing is either the reconstructed events in the mind of Verbal, or in the mind of Kujan

VIII. CONCLUSION

A. Ultimately, how is this film different from the average classical Hollywood film?

B. In what specific ways does it conform or deviate from the classical model?

1. Causal agents are individual characters (Verbal, Dean Keaton, Kujan, etc.)

2. Characters have goals based on some sort of personal desire (Kujan wants to prove that Keaton is Kaiser Soze)

3. Opposition to the goals lead to conflicts (Verbal is an obstacle to this goal, bringing them into conflict)

4. Characters change because of the conflicts (Kujan realizes that he is not as smart as he thought)

5. A strong degree of closure?

a) It depends on what you believe

b) Any lack of closure is cause by the unreliability of the narration, which is not typical of classical Hollywood cinema

MISE-EN-SCÈNE

Fear Strikes Out (Robert Mulligan, 1957)

Directed by Robert Mulligan

Written by Ted Berkman, Raphael Blau and Al Hirshberg

Produced by Alan J. Pakula

Music by Elmer Bernstein

Cinematography by Haskell B. Boggs

Editing by Aaron Stell

Produced and Distributed by Paramount Pictures

Cast

Anthony Perkins…Jimmy Piersall

Karl Malden…John Piersall

Norma Moore…Mary Piersall

Adam Williams…Dr. Brown

Perry Wilson…Mrs. John Piersall

STUDY QUESTIONS

1. A problem faced by the filmmakers was to figure out a way to make a film about something subjective – mental illness – in the visual medium of film. How do they solve this problem using mise-en-scène?

2. How do costume and make-up support the narrative? How are they motivated by the narrative? Do they function as props and motifs?

3. How does figure behavior fit in with the stylistic system of the film overall? What does it tell us about the various characters?

4. How does the narrative develop? In what ways does the mise-en-scène change as the narrative develops?

MISE-EN-SCÈNE in *Fear Strikes Out* (Robert Mulligan, 1957)

I. INTRODUCTION

 A. *Fear Strikes Out* was not a commercially successful film

 1. Not an especially attractive portrayal of our national pastime, baseball

 2. Not especially upbeat, despite the ending

 B. However, it did win critical praise, especially for the acting

 1. Many of the actors in the film were among the group of "method actors"; method acting was a popular style of acting in the 1950s

 2. Anthony Perkins especially was praised for his acting; consider that he acted in *Psycho* three years later

 C. THE PROBLEM and THE SOLUTION

 1. The Problem: how to represent mental illness and Piersall's recovery from it in visual terms

 2. The Solution: primarily through the mise-en-scène (through other elements also)

II. SETTING

 A. LOCATION SHOOTING

 1. Very little of the film was shot on location; most of the outdoor scenes were shot on lots at Paramount

 2. Some of the baseball footage (at Boston's Fenway Park, maybe elsewhere also) is stock footage; the actors weren't even there

 3. Notice that we don't see a shot of Piersall when he is at the baseball field showing both Piersall and the baseball stadium

 B. STUDIO SHOOTING: Most of the interior scenes were shot on sets constructed in the studio specifically for this film

III. COSTUME and MAKE-UP

 A. *Fear Strikes Out* is typical of many Hollywood films of the 1950s, especially those using method acting, in that it sought to make costume and make-up historically accurate (realistic) to a great degree

 B. However, costume and make-up serve various narrative functions, especially defining characters and establishing *similarities* among some of the characters, and *differences* among others

IV. FIGURE BEHAVIOR

 A. METHOD ACTING

 1. First established in the 1930s in American theater

 2. Also known as NATURALISTIC ACTING; involved the use of a psychological attitude with learned technical skill

 a. The actor sought to internalize the character

 b. The actor sought to "be" the character, feel the same emotions, etc.

 3. Its ultimate goal was greater realism in character interpretation

 4. It became popular in the 1950s in Hollywood films (especially used by Marlon Brando and James Dean); seemed suited to the kinds of psychological themes in these films (as opposed to action films, comedies, musicals, etc.)

 5. Today, it seems just as old-fashioned as the melodramatic acting in silent films; today's "realistic" acting (for example, that of Meryl Streep) will seem old-fashioned in a few years

 B. FIGURE BEHAVIOR in *Fear Strikes Out* also helps define and differentiate the characters

V. HOW DOES THE PLOT DEVELOP THE NARRATIVE THROUGH MISE-EN-SCÈNE?

 A. The major characters are divided into two groups

 1. The "NORMAL" group

 a. Mary (Mrs. Jim Piersall)

b. Dr. Brown (the psychiatrist)

c. Mr. Cronin (the manager of the Boston Red Sox)

2. The "ABNORMAL" or MENTALLY UNSTABLE group

a. Jim Piersall

b. Mr. Piersall (Jim's father)

c. Mrs. Piersall (Jim's mother)

3. These two groups form two competing "families"

B. The film seems to be unable to establish any middle ground

1. The characters and their behavior are either "Normal" or "Abnormal," either bland and boring or unusual and interesting

2. The film develops by showing us how Jim becomes more and more part of the "Abnormal" group until his breakdown, and then more like the "Normal" group

C. How do costume and figure behavior make connections and establish relationships among characters?

1. Within the "Normal" group

a. Mary is fairly average

(1) Wears little make-up

(2) Dresses in a conservative but semi-stylish way

(3) She has a conservative hair style

(4) She behaves in a "sensible manner" (cf. June Cleaver)

b. Dr. Brown

(1) He also dresses in a bland, conservative way

(2) He behaves in a conservative, boring way

(a) He always seems perfectly reasonable, never loses his temper

(b) Always talks about rational behavior

(c) He smokes a pipe to make him seem like a stereotypical psychiatrist

 c. The costume and figure behavior of both Jim's wife and Dr. Brown identify them as middle-class, but also as average, bland characters; in this film (and according to the standards of the 1950s) that means "mentally healthy"

2. Within the "Abnormal" group

 a. Mrs. Piersall (Jim's mother)

 (1) Wears unusually dowdy clothing, frumpy dresses and hats

 (2) Behaves in an odd manner; we know that something is "wrong" with her but we don't know what it is

 (3) We are told (twice) that she "had to go away" for a while; she was "sick"

 b. Mr. Piersall (Jim's father)

 (1) Wears odd-looking clothing

 (a) Like his wife, he seems to be identified as a lower class character

 (b) But also a little "off;" the baseball cap, poorly tied ties, T-shirts and sweaters, etc.

 (2) Behaves in an oddly aggressive manner

 (a) He is defensive, loses his job because of his anger and need for conflict

 (b) He pushes Jim to succeed where he failed (as a baseball player and in life in general)

 (c) He is "sick," due more to mental stress than to physical stress or illness

 c. Jim Pearsall

 (1) He wears normal clothing, but it is too big for him

 (a) Emphasizes his slender build, makes him seem even more "geeky"

 (b) Shoulder pads give his head a "sunken look," make

him seem even stranger

 (c) He looks "lost" in his own clothing

 (2) He behaves oddly, like both his mother and father (repeatedly says of both his mother and father "we're a team")

 (a) Like his father, he has fits of anger and loses his job because of it

 (b) He pushes others to perform, becomes aggressive and abusive

 (c) The scene at the train station where they both begin to break down cements this connection between the father and the son

 (d) Like his father and mother, he gets sick; like his mother, he must "go away for awhile"

 (e) Unlike his father and his mother, he recovers from his illness

D. THE RECOVERY: Jim becomes part of the Normal group

 1. Dr. Brown in some ways is like a father to Jim

 a. He takes the time to talk to him, seems interested in his family (daughter) and his life

 b. Also watches baseball with Jim, and discusses the game with him

 c. Note how the doctor's office becomes like a living room; watching a TV (in a psychiatrist's office?), Jim lying on the couch, going from patient to family member

 2. Jim becomes normal

 a. In this scene (the turning point), Jim is wearing "normal" middle class clothing: a sweater which fits him, makes him look like an average guy

 b. Jim's look of intensity becomes an easy-going smile after he begins to recover

 c. His aggressiveness is gone

 (1) He throws the ball softly; plays catch with his father not to win or practice, but for fun, and as a way to relate and communicate with his father

 (2) He admits that he might not make the Red Sox, but it's not that much of a big deal

 (3) He goes out to play baseball almost as if he has had a lobotomy, without much drive

VI. CONCLUSION

 A. *Fear Strikes Out* uses an interesting pattern of range and depth

 1. Begins mostly unrestricted and objective

 2. As Jim becomes more mentally ill, it becomes more restricted (to Jim) and subjective, first perceptually (we see what he sees, hear what he hears, etc.), then mentally (the crowd becomes louder and louder)

 3. After his breakdown, the narration becomes unrestricted and objective, and leaves him; helps reinforce his isolation

 4. With Jim's return to mental health, the narration gives us a combination of unrestricted and restricted narration, and mostly objective narrative (the Hollywood standard or "Normal" narration)

 B. This development of the narration and the use of mise-en-scène (with the other elements of film style) leaves us with an unpleasant picture of our society, in which it is impossible to be interesting and mentally healthy at the same time

MISE-EN-SCÈNE

The General (Clyde Bruckman and Buster Keaton, 1927)

Directed by Clyde Bruckman and Buster Keaton

Written by Al Boasberg, Clyde Bruckman, Charles Henry Smith and Buster Keaton

Cinematography by Bert Haines and Devereaux Jennings

Editing by Buster Keaton and Sherman Kell

Art Direction by Fred Gabourie

Produced by Joseph M. Schenck

Produced by Buster Keaton Productions

Distributed by United Artists

Cast

Marion Mack…Annabelle Lee

Charles Smith…Mr. Lee

Richard Allen…His Son

Glen Cavender…Captain Anderson

Jim Farley…General Thatcher

Frederick Vroom…Southern General

Joe Keaton…Union General

Mike Donlin…Union General

Tom Nawn…Union General

Buster Keaton…Johnnie Gray

STUDY QUESTIONS

1. Why is mise-en-scène especially important in this film? What about it makes the visual aspect more important than it might be in other kinds of movies?

2. How do settings function in the film? In what ways do they contribute to the narrative? Do they serve other purposes as well? In what ways do settings help form motifs in the film?

3. How do costume and make-up support the narrative? How are they motivated by the narrative? Do they function as props and motifs?

4. How does figure behavior fit in with the stylistic system of the film overall? What does it tell us about the various characters?

5. What is the genre of this film? In what ways does genre motivate certain kinds and uses of mise-en-scène? How does mise-en-scène help to establish the genre of the film?

MISE-EN-SCÈNE in *The General* (Keaton, 1927)

I. INTRODUCTION

 A. In any film, mise-en-scène is important; however, in a silent film (as in *The General*), it takes on even more importance, and is used even more extensively to convey story information to the viewer

 B. Let's look at the ways in which *The General* conveys story information and creates humor through the use of mise-en-scène

II. The Four Aspects of Mise-en-scène (SETTING, COSTUME, LIGHTING and FIGURE BEHAVIOR):

 A. SETTING

 1. Does the film use location shooting or studio shooting? Both...

 a. The outdoor scenes

 (1) Where is the action supposed to be taking place?

 (a) Georgia (in the southern US)

 (b) It takes place during a historical event, Gen. Sherman's march to the sea (Sherman's troops destroyed train rails and telegraph lines)

 (2) Many of the outdoor scenes, especially of the countryside, were shot on location in Wisconsin

 (3) However, the southern town was most likely recreated on a Hollywood studio lot

 b. The indoor scenes

 (1) Johnnie's girlfriend's house, the store where men are enlisting, the house at the northern encampment, etc.

(2) These were shot on sets in Hollywood (although Keaton studied photographs of the Civil War and copied them to add authenticity to the film)

2. What are the narrative functions of the settings?

 a. What about the open countryside? It emphasizes Keaton's small size, especially compared to the vast armies that surround him

 b. Narrative functions of various props

 (1) The bridge

 (a) It provides a narrative focus, a goal for the characters, for much of the film

 (b) Each side needs to reach there first in order to defeat the other side

 (2) The train engine itself

 (a) It also provides a narrative focus for much of the film

 (b) It is what Johnnie "loves," almost as much as he loves his girlfriend and the South

 (c) It provides the reason for him to go north and learn of the Yankee plans

 (d) It is a source of humor; for example, consider the scene where the mortar is going to shoot Johnnie's engine

B. COSTUME (including MAKE-UP)

1. In most cases, costume and make-up, like the settings, are historically accurate (realistic), not especially stylized; a few exceptions:

 a. Keaton's costume, which is designed to emphasize his small build

 b. His make-up, which is designed to give him a bland look and to make his features easier to see

2. Either way, both serve specific functions in the film:

a. How do they help to define characters?

 (1) Johnnie's girlfriend is defined, through costume and make-up, as the stereotypical "Southern belle"

 (2) Her father is defined as the "Southern gentleman"

 (3) Both Yankee and Rebel soldiers are defined by the colors of their uniforms

b. Other ways in which they serve as props

 (1) The uniforms provide a means for the soldiers and Johnnie to pass though enemy lines

 (2) Johnnie's Yankee uniform provides the motivation for the Rebel soldier to shoot at him

 (3) The uniform becomes an important symbol of status

C. FIGURE BEHAVIOR

1. Is the figure behavior realistic or stylized?

a. For most of the characters, it seems fairly realistic

 (1) However, remember that this is a silent film, and acting in general had to be more exaggerated in the absence of verbal language

 (2) In any case, no one in any narrative film behaves in the same way that we do in real life

b. In the case of Johnnie, and to a certain extent his girlfriend, the acting is far more stylized

 (1) What creates humor in the way in which Keaton plays Johnnie Grey?

 (a) How does he react to the world around him? (consider his nickname: Old Stoneface)

 (b) Consider the scene in which he "rides" the beam connecting the wheels of the engine: the world goes on around him, and he often has little reaction to it

 c. Other sources of humor in figure behavior?

 (1) The sword incident

 (2) Johnnie's falling over the sword

 (3) The girlfriend's putting tiny pieces of wood in the engine, sweeping the floor, etc.

D. LIGHTING

1. Obviously, lighting provides illumination so we can see the action

2. It is also used to indicate night scenes, lightning, etc. (along with the tints; how are they used?)

3. The use of lighting can best be seen through looking at some examples

MISE-EN-SCÈNE

Meet Me in St Louis (Vincente Minnelli, 1944)

Directed by Vincente Minnelli

Written by Irving Brecher and Fred F. Finklehoffe

Cinematography by George J. Folsey

Songs by Ralph Blane, Hugh Martin and Arthur Freed

Film Editing by Albert Akst

Produced by Arthur Freed

Produced and Distributed by MGM (Metro-Goldwyn-Mayer)

Cast

Judy Garland…Esther Smith

Margaret O'Brien…'Tootie' Smith

Mary Astor…Mrs. Anna Smith

Lucille Bremer…Rose Smith

Leon Ames…Mr. Alonzo Smith

Tom Drake…John Truett

Marjorie Main…Katie (the maid)

Harry Davenport…Grandpa

STUDY QUESTIONS

1. The mise-en-scène of *Meet Me in St Louis* is often regarded as relatively realistic. Is it? Do you think it was designed to accurately reflect the early 1900s?

2. What motifs can you find in the film? Are there some that seem to be especially nostalgic for the audience, as well as (or instead of) serving the narrative?

3. How does the film keep the viewer aware of what time of year it is? Why is it important that the film be set in St Louis? What does the mise-en-scène tell us about St Louis?

4. How does mise-en-scène tell us about the divisions among the Smith family? How are these divisions *visually* represented?

5. What is a possible interpretation of the ideological meaning of this film, based primarily on the mise-en-scène?

MISE-EN-SCÈNE in *Meet Me in St. Louis* (Vincente Minelli, 1944)

I. INTRODUCTION

 A. The mise-en-scène seems very realistic

 B. Actually, it is often EXPRESSIONISTIC

 1. Exaggerated and unrealistic (bright colors, unrealistic settings, unusual lighting, etc.)

 2. Mise-en-scène designed to be expressive, to create certain impressions and feelings in the audience, not to look "real"

 3. Examples

 a) The Smith house; it is larger than a real house, has more rooms and more "stuff" such as furniture, paintings, drapes, etc.

 b) Costumes; they are fancier, more elaborate and colorful than what was worn in real life

 C. *Meet Me in St. Louis* offers an impression of 1903 America that:

 1. Is not what 1903 America really was like

 a) Child labor

 b) Low wages, long hours, etc.

 2. Is nostalgic

 a) What 1944 audiences believed, or wanted to believe, America was like at the turn of the century

 b) 1944, World War II still raging in Europe, and especially in the Pacific, although the end was in sight

 3. NOSTALGIC MOTIFS

 a) FOOD

 (1) Shortages of most consumer goods in the US, especially sugar and meat

 (2) The film's mise-en-scène offers images of food; food is central to the family, and the dinner table is an important meeting place

b) LIGHT

 (1) Blackouts were common, energy was conserved; Americans missed the use of light

 (2) The film uses light (and the conspicuous consumption of light) as a motif

II. NARRATIVE STRUCTURE

 A. PLOT TIME

 1. Covers about 1 year

 a) Summer through fall, winter, and spring

 b) Shows life and continuity in family's activities, rituals, etc.

 2. Highlights special days

 a) Holidays, World's Fair, etc.

 b) Helps create sense of nostalgia, emphasizes family values (important to audiences at the time; husbands, boyfriends, fathers missing)

 B. PLOT TIME and Mise-en-scène

 1. Film shows us what time of year it is through images of holidays

 a) Decorations and activities associated with those holidays

 b) Examples:

 (1) HALLOWEEN

 (a) Lighting used to create a spooky feeling

 (b) Foreigners' house presented expressionistically, feeling of danger

 (2) CHRISTMAS: red and green in the mise-en-scène: costumes, decorations

 2. Also with what Bordwell and Thompson call "candy box" title cards

III. SETTING: From the large scale to the small scale, the film gives us a picture of family-oriented, middle America

 A. ST. LOUIS

 1. "All-American" city

 a) Average, bland

 b) Not as distinctive as Eastern, Western, or Southern city

2. Midwestern city, not too large (cf. New York)

3. Associated with middle-class, family values (unlike New York City)

4. A city between tradition and progress

 a) Ice man delivers ice, beer delivered by beer wagon

 b) Automobile also seen at beginning of the film, and the World's Fair is bringing the latest technology to town (there are both gas and electric lights; the Smiths have both tap water and a pump)

 B. NEIGHBORHOOD

1. Large, comfortable homes

2. Very white, middle-class

3. Very safe; Tootie rides around with the ice man, in no danger

 C. THE SMITH HOME

1. Extremely comfortable, warm colors and light

2. First interior shot is of the kitchen

 a) Introduces the food motif

 b) Family members usually introduced in the kitchen

3. Dining room important; becomes the meeting place for the family, again associated with food and eating

4. Three generations live together in same house; unusual even in 1944

IV. COSTUME

 A. WOMEN: Usually wear bright colors

1. Associated with particular colors; Esther usually wears blue

2. The use of bright colors

 a) Reflects their bright attitudes and personalities

 b) Helps distinguish them from one another

 c) Helps them stand out from the other (less important) characters

3. Opposite use of color in trolley car scene; dark color of Esther's dress, lighting emphasizing her red hair, placement in center of frame ensures our attention stays on her

4. At the party, women wear old-fashioned clothes, reflecting their attitudes and creating nostalgic effect ("Skip to my Lou," etc.)

B. FATHER

1. When he is first seen, he is wearing grey and carrying his briefcase

2. In sharp contrast to women, with bright colors, and John Truitt ("the boy next door") who wears white and later blue like Esther

3. However, later in the film with Esther he wears blue, and he wears blue when he changes his mind about moving to New York

V. FIGURE BEHAVIOR and THE FAMILY

A. Shots tend to show them together, often at dinner table

B. When we see Rose on the phone, family is still visible in the background

C. Father stands up, turns his back on the family

D. Shots in the dining room tend to isolate the father:

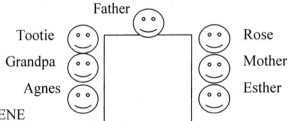

VI. CHRISTMAS SCENE

A. ESTHER'S SONG ("Have Yourself a Merry Little Christmas")

1. Actually pretty bleak

a) "Someday soon we all will be together, if the Fates allow / Until then we'll have to muddle through somehow"

b) Esther's performance seems sad, nostalgic; place it in the context of 1944

2. Causes Tootie's hysteria

a) Snow family offers visual representation of Smith family

b) Tootie symbolically destroys the family that has already been destroyed by the Father's decision; shocking, but set up by Tootie's morbidity throughout the film

B. FATHER'S DECISION

1. Begins in darkened house; reflects the darkness brought on by his decision to move to New York

2. It is the match light that seems to change his mind; the "spark" that makes his brain work

3. He then turns on the lights throughout the house, bringing joy back the Smith household

VII. FINAL SCENE; SPRING and THE WORLD'S FAIR

A. Spring had connotations of life, renewal; flowers

B. Much light; they comment on the lights at the fair

C. They are then dressed in white

VIII. INTERPRETATION

A. Does not seek to change ideology; it reinforces the ideology it assumes that the audience already accepts

B. WOMEN and THE FAMILY

1. Women are placed at the center of the family, most important

a) The plot's range tends to be restricted to what the women see and know; especially Esther (the most "perfect" of the Smith daughters)

b) Women offer stability

(1) Mother most sensible member of the family

(2) Katie is the "quarterback" of the family

C. WOMEN and THEIR PLACE IN SOCIETY

1. Marriage most important ambition for a young woman

2. Other ambitions (education) are secondary in importance

D. Film serves several social functions

1. On a simple level, offers comfort and a promise of better times to audiences on the home front

2. Speaks to the situation of the audience

a) Consisted mostly of women

b) Longed for the return of their husbands, lovers and sons

3. By reinforcing their beliefs about women and their "proper" role in society, the film:

a) Makes them feel good about traditional role of women

b) Prepares them for their return to that role

(1) They had joined the work force, made decisions on their own

 (2) Many enjoyed their new roles and jobs; had to give them up to returning GIs

 (3) Had to be made complacent (happy if possible) about a return to male dominance

c) Ultimate message of the film

 (1) Women should get married (to the boy next door), stay at home, cook, have children, etc., in order to be happy

 (2) If they do so, they will be the ones who are really in control, not the men

MISE-EN-SCÈNE

Mildred Pierce (Michael Curtiz, 1945)

Directed by Michael Curtiz

Written by Ranald MacDougall, William Faulkner and Catherine Turney

Produced by Jerry Wald

Music by Max Steiner

Cinematography by Ernest Haller

Editing by David Weisbart

Produced and Distributed by Warner Bros.

Cast

Joan Crawford…Mildred Pierce

Jack Carson…Wally Fay

Zachary Scott…Monte Beragon

Eve Arden…Ida Corwin

Ann Blyth…Veda Pierce

Bruce Bennett…Bert Pierce

Lee Patrick…Mrs. Maggie Biederhof

Jo Ann Marlowe…Kay Pierce

STUDY QUESTIONS

1. The characters are placed in various groups of similarity and opposition partly through the use of mise-en-scène; how is this done? Which characters are seen to be positive? Which are seen to be negative? How do we know? To which group does Mildred herself belong?

2. How does the narrative use mise-en-scène, as well as the other elements of film style, to create ambiguity about the status of Mildred as a character?

3. What does this film tell us about women who are successful? What does it suggest is the true meaning of success for a woman?

4. What is the genre of this film? In what ways does genre motivate certain kinds and uses of mise-en-scène? How does mise-en-scène help to establish the genre of the film?

MISE-EN-SCÈNE in *Mildred Pierce* (Michael Curtiz, 1945)

I. INTRODUCTION

 A. Mise-en-scène helps create similarities and oppositions among the characters of the film

 B. An analysis of these similarities and oppositions may contribute to one implicit meaning (or interpretation) of the film

 1. Important! Remember that any interpretation of any film is subjective, but must be based upon concrete, objective aspects of the film itself

 2. The following interpretation, although based on evidence from the film, is only one possible interpretation of the film

 3. Note also that this interpretation plays on the inherent sexism of the audience

II. Mise-en-Scène and the Characters of *Mildred Pierce*

 A. The various characters in the film may be divided into two categories for convenience

 1. "Good" characters:

 a. Bert, Mildred's ex-husband

 b. Kay, Mildred's youngest daughter

 c. Ida, Mildred's business manager

 d. Lottie, the maid

 2. "Bad" characters:

 a. Mildred

 b. Wally, the real estate agent

 c. Monte, Mildred's second husband

 d. Veda, Mildred's obnoxious older daughter

 B. These characters are placed in various groups of similarity and opposition partly through the use of mise-en-scène

 1. Kay and Bert are similar in a number of ways

a. Setting

 (1) Both are first seen outdoors in the sunshine

 (2) They are seen together at Mrs. Biederhof's house

b. Figure behavior

 (1) Both are seen engaged in wholesome activities

 (a) Kay plays football

 (b) Bert rejects alcohol and later takes a job at a plant, doing physical labor

 (2) Both tell Mildred not to encourage Veda and tell Veda not to be pretentious

 (3) Both are weak characters

 (a) Kay dies

 (b) Bert loses his job and wife

2. Ida and Lottie are similar in several respects

a. Setting

 (1) Both are seen primarily in their respective work places

 (2) Ida in the restaurant or its office, Lottie in Mildred's home

b. Costume

 (1) Both dress in a businesslike manner

 (2) Lottie in her uniform, Ida in masculine business suits

c. Figure behavior

 (1) Neither character acts in a traditionally "feminine" manner

 (a) Lottie is a sexless character (typical of African-American characters in the classical Hollywood cinema)

 (b) Ida, unsuccessful with men, acts in an unladylike manner, striking matches on the sole of her shoe and slugging whisky

(2) Neither has the ambition of Mildred or Veda, and both simply work for wages

3. Wally and Monte

 a. Are opposed to one another in costume and setting

 b. But similar in figure behavior

 (1) Both lust after women (especially for Mildred)

 (2) Appreciate female legs

 (3) Scheme for money and sex

 (4) Are heavy drinkers

4. Wally and Veda are alike in setting and behavior

 a. Setting

 (1) Both become associated with Wally's sleazy bar

 (a) Wally as the owner and Veda as a "singer"

 (b) It is where Veda announces her engagement

 (2) They are also often seen together in other settings: Mildred's house, the lawyer's office, etc.

 b. Figure behavior

 (1) Both are basically unscrupulous

 (2) They are willing to cheat those close to them for financial gain

 (3) Don't they both know about Veda's false pregnancy?

5. Veda and Monte are linked by costume, setting, and behavior

 a. Costume

 (1) Both wear expensive and fashionable clothing

 (2) Monte from the beginning, Veda as Mildred becomes successful

 b. Setting

 (1) Both are seen as most comfortable at the beach house and the Pasadena mansion

<div style="text-align: right">

(2) Also at the race track, night clubs, etc.

</div>

 c. Figure behavior

 (1) Both display exaggerated, polished, and artificial manners

 (2) Both characters also smoke, drink, take money from Mildred, scheme to make money without working, and hate the smell of grease

C. · The "good" characters of the film are not fully developed as characters and/or are seen as weak or as victims

 1. BERT

 a. Is the victim of Wally's business dealings

 b. Loses Mildred (and only wins her back through outside intervention)

 c. Is rather bland and boring

 2. KAY

 a. Dies early in the film

 b. Is reduced to a mere photograph on the piano

 3. IDA

 a. Is not really a "woman," but is just "one of the guys"

 b. She succeeds at business but not at romance

 4. LOTTIE

 a. Is only a cardboard character

 b. A standard Hollywood depiction of a black character

D. The "bad" characters are far more successful

 1. WALLY benefits from Mildred's business difficulties

 2. MONTE gets Mildred, her money, and her daughter

 3. VEDA receives money and gifts from her mother, as well as her mother's lover, Monte

E. MILDRED: The plot creates doubts in our minds about whether Mildred is a "bad" character, presenting her as ambiguous

1. VISUAL REPRESENTATION: Ambiguity reflected in the shadows that often divide her face into light and shade

2. PLOT DEVELOPMENT (through mise-en-scène, etc.) creates this ambiguity

 a. The film initially suggests that she is guilty of Monte's murder (how?)

 b. Then presents her as a caring mother, creating doubts about her guilt

 c. Gradually makes her into a harder, more "masculine" character

 (1) She begins to dress like Ida, drink, and smoke

 (2) She becomes a business success

 (3) This change makes us once more believe that she could be guilty

 d. Finally, she confesses; what is the effect of this?

3. Therefore Mildred and Veda (a very "bad" character) can be seen to be similar also

 a. Setting

 (1) Both are seen in increasingly high class settings as Mildred becomes successful

 (2) In fact, they are often framed together in the film's shots

 b. Costume: Both wear increasingly expensive and fashionable clothing, although Veda's is slinkier and sexier than is Mildred's

 c. Figure behavior

 (1) Both smoke, drink, and use their bodies and sexuality to become successful

 (2) They accuse one another of being interested only in money and success

 (3) They are both romantically interested in Monte

III. Conclusions and Interpretation

 A. The film presents Mildred as an ambiguous character

 1. She can't be a weak and good character

 a. This would result in a boring character and film

 b. She would also be unable to be a business success

 2. Likewise, she can not be a bad and successful character

 a. This would defy the Hollywood convention prohibiting the protagonist from being a bad character

 b. It would also defy the cultural and social convention prohibiting a woman from being successful and having a good sex life without a (good) man

 B. The problems that have been caused by women are solved through the intervention of strong male characters

 1. The police and the detective "save" Mildred from Veda by manipulating her into revealing the truth

 2. Recall the shots of the cops dominating and surrounding Mildred

 C. In the end, Mildred may become like Mrs. Biederhof

 1. Mrs. Biederhof, initially presented as a "bad" character (a home wrecker) "did the right thing" and got married

 2. Mildred has a bland but honest husband

 3. Having lost her business, she can stay home with no more ambition than to clean her house and make her husband happy

MISE-EN-SCÈNE

One Week (Edward F. Cline and Buster Keaton, 1920)

Directed by Edward F. Cline and Buster Keaton

Written by Edward F. Cline and Buster Keaton

Produced by Joseph M. Schenck

Cinematography by Elgin Lessley

Editing by Buster Keaton

Produced by Comique Film Corporation

Distributed by Metro Pictures

Cast

Buster Keaton…The Groom

Sybil Seely…The Bride

Joe Roberts…Piano Mover

STUDY QUESTIONS

1. Why is mise-en-scène especially important in this film? What about it makes the visual aspect more important than it might be in other kinds of movies?

2. How do settings function in the film? In what ways do they contribute to the narrative? Do they serve other purposes as well? In what ways do settings help form motifs in the film?

3. How do costume and make-up support the narrative? How are they motivated by the narrative? Do they function as props and motifs?

4. How do the various props used in the film function? How do they mark off scenes as being different from one another?

5. How does figure behavior fit in with the stylistic system of the film overall? What does it tell us about the various characters?

6. What is the genre of this film? In what ways does genre motivate certain kinds and uses of mise-en-scène? How does mise-en-scène help to establish the genre of the film?

MISE-EN-SCÈNE in *ONE WEEK* (Edward F. Cline and Buster Keaton, 1920)

I. INTRODUCTION

 A. This is a silent film; therefore, lacking sound, the other aspects of film form take on additional importance

 B. Narrative information must be conveyed through other means, especially mise-en-scène

 C. For example, the CALENDAR serves narrative functions

 1. It is part of the setting

 2. It gives us important narrative information; it articulates the days of the "one week" of the film

II. DIFFERENTIATION OF CHARACTERS; Identified as types

 A. BUSTER (the protaganist)

 1. Costume identifies him as lower middle class character

 2. Figure behavior establishes him as inept but graceful

 3. Facial expression creates humor; consider that Keaton was known as "Old Stone Face"

 B. HANK (the antagonist, or obstacle to Buster reaching his goal)

 1. Costume identifies him as lower class

 2. Figure behavior establishes his character as "bad" or negative

 C. WIFE

 1. Costume initially established as bride

 2. Then through costume and figure behavior, she is established as a stereotypical "housewife"

III. WRITTEN INFORMATION

A. In silent films, written language (letters, newspaper articles, etc.) were especially important as a means of conveying information without resorting to intertitles; seemed more natural and less intrusive

B. Examples from *One Week*

 1. The letter from Buster's uncle giving the house to the newlyweds

 2. The directions for building the house

 3. Signs for the lot number, "FOR SALE," etc.

IV. SETTING: One Week, as was typical of Hollywood filmmaking of its era, utilizes primarily studio shooting

A. LOCATION SHOOTING

 1. Some of the exteriors (for example the railroad tracks) were likely shot on location in or near Hollywood

 2. Exteriors of the house

 a) It appears that the house is "real"

 b) However, it was probably fabricated on a studio lot for the film

B. STUDIO SHOOTING

 1. The interiors were shot on a studio stage

 2. There is probably no physical connection between the exteriors and the interiors; the spatial relationship is created strictly through editing

C. THE HOUSE

 1. The house is part of the mise-en-scène

 2. It also becomes a prop; provides a focal point for the narrative

V. PROPS and REALISM

A. The house: it is humorous because it is not like a "real" house

B. The piano: humor comes from what we know of real pianos

C. The floor of the room upstairs

D. The chimney

 1. Funny because it is not realistic (should be heavy)

 2. And because we know that is not how chimneys are constructed

3. Spatial relationship between the chimney and the bathtub is impossible; this creates a joke about the construction of the house

VI. TWO SCENES and HOW THEY WORK

 A. SPINNING HOUSE SCENE

 1. This scene works because of a combination of two elements of style: mise-en-scène and cinematography

 2. It is shot on a stage in a studio, and the camera revolves

 B. TRAIN SCENE

 1. This scene also works because of the combination of mise-en-scène and cinematography

 2. DEPTH CUES

 a) The presence of depth cues is caused by the framing of the shot and the setting

 b) The lack of depth cues is also caused by framing

 c) The final joke of the scene is the result strictly of the framing of the shot, which misleads the viewer

MISE-EN-SCÈNE

North by Northwest (Alfred Hitchcock, 1959)

Directed by Alfred Hitchcock

Written by Ernest Lehman

Cinematography by Robert Burks

Music by Bernard Herrmann

Production Design by Robert F. Boyle

Film Editing by George Tomasini

Produced by Herbert Coleman

Title Design by Saul Bass

Special effects by Lee LeBlanc and A. Arnold Gillespie

Set décor by Frank R. McKelvy and Henry Grace

Hair styles by Sydney Guilaroff

Color consultation by Charles K. Hagedon

Art direction by William A. Horning and Merrill Pye

Assistant direction by Robert Saunders

Make-up by William Tuttle

Produced by MGM (Metro-Goldwyn-Mayer)

Cast

Cary Grant…Roger Thornhill

Eva Marie Saint…Eve Kendall

James Mason…Phillip Vandamm

Jessie Royce Landis…Clara Thornhill

Leo G. Carroll…The Professor

Martin Landau…Leonard

STUDY QUESTIONS

1) Think of the ways in which the following three aspects of Hitchcock's work are manifested in the mise-en-scène of *North by Northwest*

 a) Hitchcock is a director who concentrates on thrillers and mysteries; he often likes to show the danger that lies in ordinary, everyday situations and locations

 b) He also often presents a world in which there is no clear-cut difference between good and evil, but is instead ambiguous

 c) At the same time, Hitchcock made films that are also comedies in subtle ways; he enjoys playing with conventions of film and with film form

111

2) How is the film structured? How would you describe the locations in which the film takes place? Are they unusual for a film like this?

3) How are the various characters presented? What does mise-en-scene - the costumes, figure behavior, etc. - of the characters tell us about them?

4) What kind of a character is Roger O. Thornhill? What is his profession? What is his environment?

5) What kind of character is Vandamm? In what ways is he similar to and different from Roger Thornhill? In what sorts of locations do we see him?

6) What kind of character is Eve Kendall? In what ways is she similar to and different from the other characters?

7) How is Hitchcock's (rather unusual) sense of humor manifested in this film?

MISE-EN-SCÈNE in *North by Northwest* (Alfred Hitchcock, 1959)

I. INTRODUCTION

 A. We think of Hitchcock as a director who concentrates on thrillers and mysteries

 1. *North by Northwest* qualifies as both

 2. We will look at the film as a thriller that tries to show the danger that lies in the ordinary

 B. Some critics see Hitchcock as a director who likes to make films that deal with issues of morality

 1. This usually means:

 a) Not that he is presenting a clear-cut difference between good and evil, but is offering a vision of the world as ambiguous

 b) There often is not much difference between characters who identify themselves as "good" and those they regard as "evil"

 2. We could interpret *North by Northwest* in this way; both sides seem equally cynical and willing to justify just about anything to achieve their goals

 C. However, perhaps more than any other Hollywood director, Hitchcock made films that are also comedies at the same time

 1. They are comedies in very subtle ways; the humor is not usually obvious (except his own appearances in his films)

2. Hitchcock enjoys playing with conventions of film and with film form

D. In this discussion we will focus primarily on the ways in which these three aspects of Hitchcock's work are manifested in the mise-en-scène of *North by Northwest*

II. MISE-EN-SCÈNE in *NORTH BY NORTHWEST*

 A. INTRODUCTION

 1. THE STRUCTURE

 a) It is a search (for George Kaplan, who doesn't exist)

 b) But it is even more a journey, which is laid out early in the film: New York, Chicago, and Rapid City

 c) This journey will also provide the structure for this discussion; we will discuss each of these settings, along with the props, lighting, figure behaviour, costumes, etc., that make them "work"

 2. Most directors set thrillers in dark, seedy urban areas, thus relegating danger, corruption, murder, etc., to the "underworld"

 a) Hitchcock prefers to set his thriller in bright sunshine, in places that seem safe or even somewhat "sacred" (national shrines)

 b) Thus, he shows the evil that lurks all around us, not just in "dangerous" areas

 c) Compare to *Blue Velvet*, *Twin Peaks*, etc.

 B. NEW YORK CITY

 1. INTRODUCTION TO ROGER O. THORNHILL

 a) His environment consists of modern office buildings, hotels, bars; all high-class, secure places

 b) He is presented as sophisticated but essentially noncommittal, somewhat boring

 (1) He dresses fashionably but in monochrome

 (2) He is a typical Madison Avenue advertising executive

 (3) His two wives found him "dull"

 c) He is also somewhat amoral

(1) Is not above lying to get a taxi

(2) He refers to his profession as "expedient lying"

(3) He is presented as a sort of *Playboy* magazine ideal; a "ladies man," and a heavy drinker (which saves his life)

2. The Townsend home

a) The "bad guys" who kidnap Thornhill dress very much like him, in a monochrome, bland 1950s style

b) A very high-class home, everyone is polite; not the kind of place we expect spies and danger

c) Vandamm is in some ways a counterpart to Thornhill; they are not that different

(1) He is amoral (they end up sleeping with the same woman)

(2) He is a "country gentleman" to Thornhill's urban playboy

(a) He is just as sophisticated, but wears earth tones

(b) At the end of the film, when Leonard is shot, he comments that the use of real bullets is not "sporting"

3. The United Nations building

a) We think of it as a place of international "peace and understanding"

b) All of these locations present normally safe, un-confining spaces, but they offer no escape (bad guys on elevator, etc.)

4. WASHINGTON D.C.

a) The USIA, a spy organization, is presented as a bureaucratic institution in a bland office building

b) Clearly visible through the window, while they talk about letting Thornhill "take the rap" is the capitol building

c) What are the differences and similarities between the "good guys" and the "bad guys"?

117

C. THE TRAIN

 1. We have moved from dangerous "safe" spaces to a more traditionally dangerous space

 2. The train is more confining; there is no escape

 3. However, even here, the danger comes from a seemingly innocent source: Eve (note that although he is the "wanted criminal," she is the dangerous one)

 4. Eve serves as another counterpart to Thornhill

 a) She is presented as a "playgirl," looking for noncommittal sex

 b) She is an "icy blond," sophisticated and conservative (like an advertising executive)

 c) Like Thornhill, she plays two roles

 5. The sexual subtext (almost a romantic comedy) is introduced on the train

 a) What do we think they will do; what expectation is set up?

 b) The rest of the film is not just a search and a journey, but a working out of the romance; how can they get together?

D. CHICAGO

 1. The train station; we hear the destinations of the various trains, all boring Midwestern cities (Gary, Kalamazoo, Grand Rapids, etc.), while the police search for Thornhill

 2. The hotel is much like the locations in New York; the danger (Eve) is located in a normally secure, upper-class location

E. CORN FIELD IN INDIANA

 1. With Mt. Rushmore, one of the two more dangerous places in the film; both seem like they should be safe

 2. Hitchcock has mentioned that he wanted to put his hero in the most danger in the opposite of where other directors would

 a) Others would trap the hero on a street corner, on a dark night under a street lamp, with shadowy villains all hidden in alleys, etc.

 b) Hitchcock traps his hero in a corn field

<ol type="1" start="1">
In Indiana
In broad daylight
The villains are in plain sight in a crop duster, not hidden in shadows
Thornhill is not only in isolation, but is completely out of his element; he can function in cocktail lounges, but is lost in a corn field

<ol type="a" start="3">
However, Thornhill manages to outwit both the villains and the "yokels" driving off in the pickup truck with the refrigerator (creating humor)
THINK ABOUT NARRATION; What do we know that Thornhill doesn't know?
<ol type="1">
About Kaplan? (We know that he doesn't exist)
About Eve? (We know that she is a spy, she sets him up, she loves Thornhill)

<ol start="3">
THE AUCTION; We are introduced to the "MacGuffin" (the statuette with the microfilm)
THORNHILL'S TURNING POINT
<ol type="a">
When he finds out about Eve, he changes his mind about her and about helping the USIA
Someone has asked him to "do something worthwhile"
The light of the plane falls on his face; a dissolve to Mt. Rushmore (a serious statement by another director, a joke from Hitchcock)

F. RAPID CITY

<ol start="1">
Vandamm's house is a typical early 1960s "modernistic" house
<ol type="a">
Meant to appear open, bright, not dangerous
To us, it may have a kind of modernistic ugliness and coldness, and therefore is somewhat intimidating

Mt. Rushmore is a national shrine, shouldn't seem dangerous
<ol type="a">
But it becomes very dangerous and intimidating; partly due to its sheer size

 b) Seen so closely, it also appears hard and rocky, not hospitable

 c) Compare to the capitol building; in both places, sinister activities are taking place in, near, or on national shrines

3. EVE'S TURNING POINT

 a) She explains herself in the forest with Thornhill

 b) She was, in fact, an amoral "playgirl"

 c) But she was asked to do "something worthwhile"

 d) Now that both have been "redeemed," they can solve the case and join romantically

G. CLOSURE: THE TRAIN

1. Hitchcock ends the film with a great degree of closure

 a) The "bad guys" are killed or captured, Thornhill and Eve are married

2. Hitchcock has made a number of jokes in the film, especially about film clichés

 a) This includes jokes about Cary Grant himself as an actor

 (1) He is "recognized" by a number of people

 (2) There are many comments about his good looks and familiarity

 b) Doesn't the film look phoney?

 c) Hitchcock's final joke is "the train in the tunnel"

MISE-EN-SCÈNE

Our Hospitality (John G. Blystone and Buster Keaton, 1923)

Produced by Joseph M. Schenck Productions

Directed by John G. Blystone and Buster Keaton

Written by Clyde Bruckman, Jean C. Havez and Joseph A. Mitchell

Cinematography by Gordon Jennings and Elgin Lessley

Art Direction by Fred Gabourie

Costume Design by Walter J. Israel

Cast

Joe Roberts…Joseph Canfield

Ralph Bushman…Clayton Canfield

Craig Ward…Lee Canfield

Monte Collins…The Parson

Joe Keaton…Train engineer

Kitty Bradbury…Aunt Mary

Natalie Talmadge…Virginia Canfield

Buster Keaton Jr….Willie as a Baby

Buster Keaton…Willie McKay

STUDY QUESTIONS

1. Why is mise-en-scène especially important in this film? What about it makes the visual aspect more important than it might be in other kinds of movies?

2. How do settings function in the film? In what ways do they contribute to the narrative? Do they serve other purposes as well? In what ways do settings help form motifs in the film?

3. How do costume and make-up support the narrative? How are they motivated by the narrative? Do they function as props and motifs?

4. How does lighting function in the movie? How does it mark off scenes as being different from one another? Is lighting motivated by the narrative?

5. How does figure behavior fit in with the stylistic system of the film overall? What does it tell us about the various characters?

6. What is the genre of this film? In what ways does genre motivate certain kinds and uses of mise-en-scène? How does mise-en-scène help to establish the genre of the film?

MISE-EN-SCÈNE in *Our Hospitality* (John G. Blystone and Buster Keaton, 1923)

I. INTRODUCTION

 A. *Our Hospitality* is a good example of the ways in which a film uses mise-en-scène to economically advance the causal chain and create a tightly structured narrative

 B. It is a silent film; lacking sound, the other aspects of film form take on additional importance

 C. Narrative information must be conveyed through other means, especially mise-en-scène

II. SETTING

 A. Refers to the place in which the film is shot

 1. Specific settings in the film fulfill different narrative functions

 2. They are motivated by the cause and effect sequence of the narrative action

 B. Settings divide and contrast scenes

 1. Prologue scene

 2. New York

 3. Willie's return to the South (the town, his father's "estate," the dam, etc.)

 4. The areas he wanders to while trying to escape the Canfields (meadows, mountains, river banks, rapids, waterfalls, etc.)

 C. Establishes parallels and contrasts to further the narrative

 1. Willie envisions a mansion when he is told that he has inherited his father's estate, but it turns out to be a shack

 2. This is later contrasted with the Canfield house, which looks like the one Willie envisions

 3. Ironically, the Canfield house becomes the only safe place for Willie because their "hospitality" prevents the Canfields from killing him while he is in their house

 D. PROPS and MOTIFS

1. Water motif
 a) Water as rain motif
 (1) First conceals the murders in the prologue
 (2) Later gives Willie an excuse to remain at the Canfield house after supper
 b) Water as river motif (the final chase scene)
 c) Water as waterfall motif
 (1) Water from the dam creates a waterfall that conceals Willie from the Canfield boy
 (2) Waterfall in the last chase scene becomes life-threatening as Willie and Virginia are nearly swept off it
2. "Love thy Neighbor" sampler motif
 a) First seen in the prologue on the Canfields' wall, as one of the Canfields tries to prevent his brother from killing McKay
 b) Reappears after the wedding, when the elder Canfield decides to end the feud after seeing it
3. Gun rack motif
 a) The Canfields go to the gun rack to load their pistols when they discover that Willie McKay is in town
 b) Repeated returns to the gun rack as the Canfields try to kill Willie
 c) When they return home after the final chase scene, the Canfields realize that the gun rack is empty

III. COSTUME and MAKE-UP supports and is motivated by the narrative
 A. Willie McKay, the dandified city boy, is contrasted with Canfield, the Southern gentleman
 B. Costume as props
 1. Willie's suitcase and umbrella make it clear that he is a traveler
 2. The Canfields always have their pistols with them to remind us of their goal: to kill Willie and continue the feud
 3. Change of costume

 a) Willie escapes the Canfields when he disguises himself as a woman

 b) Later transfers the disguise to the horse to mislead his pursuers

IV. LIGHTING in the film serves both general and specific functions

 A. The film is largely evenly lit according to the classical Hollywood cinema's three-point lighting system

 B. Scenes are alternatively set in darkness and in daylight

 1. Feuding occurs at night

 2. Willie's return to the South and his "adventures" before supper at the Canfield's occur in daylight

 3. He goes for supper in the evening and stays the night

 4. The Canfields pursue him the next day

 5. The film ends with the wedding at night

 C. Lighting also distinguishes the "serious" scenes from the less serious ones

 1. Especially the prologue vs. the rest of the film

 2. When McKay douses the lamp in the prologue, the scene's lighting immediately changes from the three-point lighting system to stark high key lighting from the fireplace (a diegetic source of light)

V. FIGURE BEHAVIOR

 A. Figure behavior helps advance the narrative (Willie's behavior tells us how wily and resourceful he is)

 B. Placement of figures and staging in depth lets the film present two narrative lines simultaneously

 1. Canfield boys planning to kill Willie

 2. Willie overhearing, starts to run away

VI. GENRE: mise-en-scène functions not only to advance the narrative and unify the film, but also for comedy

 A. SETTING: railway tracks, train tunnel

 B. COSTUME: Willie's disguise is exposed when he turns around and we see that his skirt is partially lifted to reveal his buttocks; the same costume is used on the horse to distract the Canfields

 C. FIGURE BEHAVIOR: the elder Canfield gleefully sharpening his knife; Willie's trip down the river

D. STAGING IN DEPTH: the engineer is blissfully unaware that the train car has become separated from the engine

E. COMIC MOTIFS (theme-and-variations)

 1. People encountering the train

 a) People gather round to watch it pass

 b) The old man throws rocks at the train to get firewood

 2. Train tracks

 a) Humped, curled and rippled tracks

 b) The donkey blocking the track

 c) No track at all

 3. "Fish on a line"

 a) Willie catches a small fish

 b) Hangs by a rope to one of the Canfield boys

 c) Finally gets free from the Canfield boy but the rope is still tied to his waist

 d) Willie dangles from the same rope at the waterfall, just like the fish that he caught

CINEMATOGRAPHY

Chinatown (Roman Polanski, 1974)

Directed by Roman Polanski

Written by Robert Towne and Roman Polanski

Produced by Robert Evans

Original music by Jerry Goldsmith

Cinematography by John A. Alonzo

Film Editing by Sam O'Steen

Sound Editing by Howard Beals

Produced by Long Road, Paramount Pictures and Penthouse

Distributed by Paramount Pictures

Cast

Jack Nicholson…J. J. (Jake) Gittes

Faye Dunaway…Evelyn Cross Mulwray

John Huston…Noah Cross

Perry Lopez…Lieutenant Lou Escobar LAPD

John Hillerman…Russ Yelburton, Deputy Chief of Water Dept

Darrell Zwerling…Hollis Mulwray

Diane Ladd…Ida Sessions

Roy Jenson…Claude Mulvihill

Roman Polanski…Man with Knife

Burt Young…Curly

STUDY QUESTIONS

1. What is the difference between the look of this film and that of most other detective movies and films noir that you may be familiar with? In what ways is this film an updated version of an older genre?

2. How does the film's *style* contribute to the *narrative*? In other words, how do the stylistic elements make us feel a certain way about the story and characters? How does cinematography, especially, do this?

3. Think about the ways in which the film uses onscreen space and offscreen space. How does the film indicate actions and/or characters offscreen?

4. What is the range and depth of the narration? Is this typical of the detective movie in general? How is the narrative of this film different from those of older detective films?

CINEMATOGRAPHY in *Chinatown* (Roman Polanski, 1974)

I. INTRODUCTION

 A. *Chinatown* uses a particular film style - FILM NOIR - and belongs to a particular genre - THE HARDBOILED DETECTIVE FILM; but deviates in important ways from both of these

 B. FILM NOIR

 1. Literally, means "black film" or "dark film"

 2. A film style (NOT A GENRE) with origins in GERMAN EXPRESSIONISM

 a) German filmmakers left Nazi Germany and came to Hollywood, brought this style with them

 b) Also seen in many horror movies of 1930s and 1940s

 3. Featured:

 a) Black-and-white film stock, usually high contrast (fast)

 b) Low-key lighting, little use of fill lights, to create a dark, shadowy image

 c) Interiors cramped, dark, often dingy offices and apartments

 d) Exteriors usually shot at night (fog, wet streets, etc.) and took place in urban areas (alleys, back streets, etc.)

 C. THE HARDBOILED DETECTIVE GENRE

 1. SUBJECT MATTER, THEMES and VALUES

 a) An individual hero caught between two opposing forces

 (1) On one side is a violent, urban criminal community without morals

 (a) The detective shares their "street smarts"

 (b) But he has a moral code that they lack

 (2) On the other side is a society with values he can't understand or accept

(a) Usually committed to "doing the right thing"

(b) Does not see this commitment in society

(c) Society tends to reject his personal style (cf. "Dirty Harry" movies)

b) Genre deals with the theme of the macho code, not feminine or family values

(1) Detective operates the way he does because of professional integrity

(2) Does not care that much about love or friendship

c) It deals with value of self-reliance, not cooperation

(1) The detective succeeds due to his status as a "loner" rejecting the police and their help

(2) Compare this to the Western, in which the "good guy" works alone to save the community

2. VISUAL STYLE: hard-boiled detective film usually uses film noir style

3. NARRATIVE STYLE

a) Narration tends to be very restricted and subjective (at least perceptually, sometimes mentally)

b) Why is it restricted and subjective?

(1) So we share the investigation with the detective

(2) Helps us see this world as the detective sees it

(a) We share his "world vision"

(b) He relies on his own sense of morals

(c) He operates differently from both of the cops and the crooks, and we need to understand why

II. IN WHAT WAYS DOES *Chinatown* CONFORM and DEVIATE, and WHY?

A. *Chinatown* is a modern reworking of the hard-boiled detective film; it is a 1970s version of a 1940s genre

B. Deviates from style and subject matter of this genre in a number of ways for a number of reasons

C. NARRATIVE STYLE is typical of detective films

 1. Film's narration is very restricted to Jake Gittes

 a) We (almost) never leave Gittes; there are no scenes in which he is not present

 b) We (almost) never know more than Gittes knows

 2. Narration is also perceptually subjective

 a) We see what Jake sees, often from a strict optical POV

 (1) The shot through binoculars

 (2) The shot looking in the car mirror

 (3) The shot of him smoking in bed, watching Evelyn Mulwray

 b) We hear what he hears, but not his thoughts (which would make it mentally subjective)

 3. This high degree of restriction and subjectivity begins to fall apart at the end of the film

 a) We get a rapid succession of points of view

 b) This does two things

 (1) It creates the proper sense of confusion

 (2) Reflects Gittes's loss of control of the situation; eliminates the "anchor" we have had throughout the film

D. VISUAL STYLE

 1. The hard-boiled detective film almost always relied on the film noir visual style; it is here where *Chinatown* deviates most

 2. COLOR

 a) It uses color instead of black-and-white, high contrast film stock

 b) Interiors often are underexposed (not enough light) to increase the dark, shadowy look

 c) But the film's exteriors tend to be overexposed (too much light) to "wash out" the colors, make them seem lighter and not as rich as they normally would appear

 d) Presents a different, more modern view of southern California, in which the city is hot, dry, and fairly bland

 (1) This visually adds to the story, which is about the fight over water

 (2) Presents a less glamorous depiction of evil, which exists not in dark alleys but in public offices, etc.

3. LIGHTING

 a) Mostly rejects low-key lighting in the exteriors, with little use of fill lights (used to create a dark, shadowy image in the film noir)

 b) Again, this presents an image of evil existing in full light, not in dark, hidden areas

4. INTERIORS are not always the cramped, dark and dingy offices and apartments of film noir; they are well-lit, pleasant areas

5. EXTERIORS

 a) Are more common in this film than are interiors (unusual for the film noir)

 b) Are not the typical dark, foggy, wet streets of film noir

 c) They are open, sunny, and dry

6. EXCEPTION: The very end of the film - in Chinatown itself - is presented more like a traditional film noir

7. Compare the beginning of the film to the end

 a) The opening "Paramount symbol" and credits are in old-fashioned b-and-w; the b-and-w photographs fool us

 b) At the end of the film, we get the modern, color version of the "Paramount symbol"

E. SUBJECT MATTER, THEMES and VALUES

1. Jake Gittes is an individual hero caught between what he thinks are two opposing forces

 a) Is there a violent, urban criminal community without morals?

 (1) Who are the villains?

 (2) Does he share their "street smarts"?

 b) Who are the "good guys"?

 (1) Are there any characters who really care about right and wrong?

 (2) The police are typical

 (a) They are bumbling idiots

 (b) Jake used to be one

2. The detective is no longer seen as the "potent" powerful character of the typical detective film

 a) His nose - a phallic symbol - is injured

 b) What is his line of business?

 (1) He does divorce work

 (2) In the typical hard-boiled detective film, the detective refuses to do this sort of work (in real life it is the "bread and butter" of the business)

3. Even so, Jake operates the way he does because of professional integrity

 a) He works for money, but not in this case

 b) He does not care that much about love or friendship

4. The film deals with the value of self-reliance, not cooperation

 a) The detective succeeds due to his status as a "loner" rejecting the police and their help

 b) But does he really succeed?

 c) What will happen?

CINEMATOGRAPHY

Touch of Evil (Orson Welles, 1958)

Directed by Orson Welles

Written by Orson Welles, Paul Monash and Franklin Coen

Music by Henry Mancini

Cinematography by Russell Metty

Editing by Walter Murch, Aaron Stell, Virgil W. Vogel and Edward Cutiss

Produced by Albert Zugsmith

Produced and Distributed by Universal International Pictures

Cast

Charlton Heston…Ramon Miguel Vargas

Janet Leigh…Susan Vargas

Orson Welles…Police Captain Hank Quinlan

Joseph Calleia…Police Sergeant Pete Menzies

Akim Tamiroff…Joe Grandi

Joanna Cook Moore…Marcia Linnekar

Ray Collins…District Attorney Adair

STUDY QUESTIONS

1. How does *Touch of Evil* present a world in which it is impossible to completely separate the "good" characters from the "bad" characters? How does cinematography contribute to this aspect of the film?

2. How does cinematography affect the ways in which we see the mise-en-scène of the film?

3. Framing is important in presenting the characters in particular ways; how does this happen?

4. The long take at the beginning of the film is one of the more famous scenes in film history. What is the effect of this long take? Why is it here, and how does it function in the context of the rest of the film?

CINEMATOGRAPHY in *Touch of Evil* (Orson Welles, 1958)

I. INTRODUCTION

 A. Orson Welles's *Touch of Evil*, like *Citizen Kane*, presents the story of a character obsessed with control, but who loses this control

 B. But the film also presents an ambiguous nightmare world in which it is impossible for the "good" characters to remain completely separate from the evil of the "bad" characters

 1. Cf. *Blue Velvet*: the evil lurking in a small town, and the impossibility of avoiding it, even though we pretend to

 2. Casting is important to this presentation of a nightmare world; it all seems like a bad dream, with people and characters we have seen before in other contexts

 a) We find it difficult to forget that many of the actors are the same actors we saw in *Citizen Kane*

 b) Some of the actors (Zsa Zsa Gabor, Marlene Deitrich) are so well known that they appear to be themselves

 c) Others (especially Charlton Heston) just do not seem to be the characters they are playing

 d) Orson Welles is obviously Orson Welles; jokes about his own weight (candy bars and doughnuts), constant references to his CANE (Kane)

 3. But this nightmare world where good and evil meet is accomplished also largely through cinematography, especially such techniques as the use of high contrast film stock and the long take

II. THE TECHNIQUE OF THE FILM

 A. PHOTOGRAPHIC QUALITIES

 1. The nightmare border town world of Quinlan and Grande is articulated through the use of high contrast film stock

a) This establishes deep shadows, an extreme contrast between the light and dark areas of the image

b) This serves several functions

 (1) It creates an extremely dark image

 (a) It seems to be a world in which it is almost always night

 (b) Although it is daylight when they come back to the US, it becomes as dark as it was in Mexico

 (c) In both locations, the world of the film is one in which unknown dangers constantly lurk down alleyways, behind every corner, even around characters and in corners of rooms

 (2) The darkness also emphasizes the characters

 (a) The lighting makes them easy to see when they are in the light, and our attention is drawn to them

 (b) They seem to isolated in the dark world created by the film; alone in these islands of light

 (3) The total effect is characters, both good and bad, seeking some kind of control over an environment that can not be controlled because it can not really be completely known or seen

2. THE WIDE-ANGLE LENS

 a) The use of the wide-angle lens tends to distort the mise-en-scène, especially faces (they often move from the middle plane, where they are not distorted, to the front of the frame, where they are)

 b) Hank Quinlan, especially, is presented as a distorted character through the use of the wide-angle lens, not just on his face but on his upper body

c) The use of deep focus with the wide-angle lens helps exaggerate space and depth, and also keeps all of the characters in sharp focus, emphasizing their interconnections

B. FRAMING

 1. LOW-ANGLE, LOW HEIGHT FRAMING

 a) Welles uses a technique similar to that of Huston in *The Maltese Falcon*

 b) Quinlan is often shot from a low angle and height, making his bulk seem even greater

 c) The low angle and height adds to the distortion of the mise-en-scène, as does the use of high angle and height in other shots

 2. FRAMING OBSCURES SOME DETAILS, REVEALS OTHERS, and ESTABLISHES A NARRATOR'S POV

 a) Framing is used to add to the sense of the unknown and mystery through the use of offscreen space

 (1) EXAMPLE: the interrogation of Sanchez

 (2) EXAMPLE: Susan (Mrs. Vargas) in the motel room

 b) Framing is used to point out details

 (1) Often without the motivation of POV of a character

 (2) EXAMPLE: the "sizzling hot" poster of Zita (who was blown up in the opening shot), which is then covered with acid

 c) Framing also establishes a POV of the narrator, not a character

 (1) EXAMPLE: "Forget Anything?" on the hotel room door; he forgot his cane

 (2) Creates a sense of ambiguity concerning whose "side" the narrator is on; who are the "good guys"?

 (3) Although Vargas is the protagonist, the film presents an objective, unrestricted narration to separate us from him

C. THE LONG TAKE; According to Bordwell and Thompson, the opening shot of *Touch of Evil* "makes plain most of the features of the long take"

 1. It constitutes a sequence shot, offering an alternative to building the sequence out of many shots

 2. It stresses the cut that finally does come (to the explosion)

 3. It features constant camera movement, using a crane

 4. It has its own internal pattern of development

 a) TEMPORAL: It establishes an expectation from its first image; we expect the bomb to explode at some point

 b) SPATIAL: It establishes the geography of the scene (the border between the US and Mexico)

 c) The camera movement weaves together two separate lines of narrative cause and effect that intersect

 (1) Susan and Vargas are established as the protagonists on one side

 (2) The are drawn into the conflict involving Grande and Hank Quinlan

 d) It satisfies the expectation that it had established at the beginning

III. CONCLUSION: Ambiguity and the "Touch of Evil"

 A. How are the "good" and "bad" characters presented?

 1. BAD CHARACTERS

 a) The "bad" characters are often just as frightened as are the "good" characters

 (1) Grande seems to be a victim of Quinlan

 (a) He is afraid of Quinlan, who kills him

 (b) He appears foolish (toupee), and we feel sorry for him in some ways

 (2) Menzies, Grande's assistant and friend

 (a) He is not really evil

 (b) He admires Quinlan but is afraid of him

 (c) As Tana says, he loved Quinlan

 b) Tana and Hank Quinlan are the most interesting characters in the film

 (1) Quinlan is crude, but not entirely sympathetic

 (2) Why is he the way he is?

2. The "good" characters are boring, insipid, or preachy (or even "evil"; think of Sanchez, Lenniker's daughter, etc.)

 a) Schwartz, the cop who helps Vargas, is a boring bureaucrat

 b) Susan, Vargas' wife, is insipid, a helpless middle-class wife

 (1) She is from Philadelphia, which used to have a reputation as "upper crust," WASPy (reference to her mother)

 (2) She seems prejudiced (like Quinlan); calls the Mexican "pancho," wants to get out of Mexico

 (3) She is married to a Mexican, but is he really much of a Mexican?

 c) Vargas is preachy and bureaucratic

 (1) We keep wondering why he leaves his wife alone for so long

 (2) He cares about the "law," not about what is right or about his wife (cf. Quinlan)

 (3) We don't really care much about him

 d) Both Vargas and Susan are "goody-goodies," and seem to regard themselves as somehow better than the rest of the characters (better in a middle-class sort of way)

3. The film seems to offer no middle ground

 a) There are no "normal" characters

 b) Even the night clerk at the motel is strange

4. The film leaves us with an ambiguous feeling; we want Vargas to triumph, but we also find Quinlan very interesting, and we don't really want him to get killed

B. Consider the end of the film and its message

1. Quinlan is described as "a great detective but a lousy cop"

2. Tana's remark: "He was some kind of man. What does it matter what you say about people?" (Cf. *Citizen Kane*)

3. Quinlan, as it turns out, was right: Sanchez confesses, and is guilty, just as Quinlan believed him to be (and as he believed all the other suspects he framed to be)

4. Remember, Menzies keeps asking Vargas what he's trying to do to Quinlan

 a) Quinlan is killed by his best friend

 b) Quinlan dies in a pool of stagnant water floating with garbage

 c) Vargas drives away with his wife; he doesn't care

5. We are left with a sense of ambiguity

 a) Who is good or bad, and can we ever really know?

 b) There is good and bad in all of us

 c) Cf. *Citizen Kane*

CINEMATOGRAPHY

Raging Bull (Martin Scorsese, 1980)

Directed by Martin Scorsese

Written by Jake LaMotta, Peter Savage, Paul Schrader, Mardik Martin and Joseph Carter

Original music by Robbie Robertson

Additional music by Pietro Mascagni (from "Cavalleria Rusticana")

Cinematography by Michael Chapman

Film Editing by Thelma Schoonmaker

Art Direction by Kirk Axtell and Alan Manser

Set Decoration by Phil Abramson and Frederic C. Weiler

Costume Design by Richard Bruno

Produced by Robert Chartoff and Irwin Winkler

Produced by Chartoff-Winkler

Distributed by United Artists

Cast

Robert De Niro...Jake La Motta

Cathy Moriarty...Vickie La Motta

Joe Pesci...Joey La Motta

Frank Vincent...Salvy

Nicholas Colasanto...Tommy Como

Theresa Saldana...Lenore

Mario Gallo...Mario

Frank Adonis...Patsy

Joseph Bono...Guido

Frank Topham...Toppy

Lori Anne Flax...Irma

Charles Scorsese...Charlie (Man with Como)

Don Dunphy...Himself/Radio Announcer

Bill Hanrahan...Eddie Eagan

Rita Bennett...Emma - Miss 48's

STUDY QUESTIONS

1. How do many modern film genres deal with the issue of violence (for example, science fiction and fantasy films, or slasher and horror films)? What about newspapers? News on TV? Sports? How does *Raging Bull* deal with the issue of violence? How do mise-en-scène and cinematography function in this portrayal?

2. Does the movie celebrate boxing, Jake La Motta, and violence? Or does it have a more ambivalent attitude toward violence? What does it suggest is the real problem?

3. How does the film present boxing and violence ambivalently? In what ways is it attractive? In what ways is it repulsive?

4. Does the film suggest a relationship between sex, masochism and violence? In what ways does it do this? Does the movie suggest anything about Jake's sexual self-doubts?

5. Ultimately, how do we feel about Jake La Motta? Do you hate him? Feel sorry for him? Do you feel he is a victim of circumstances? What is the result of Scorsese's refusal to make things clear? What would have happened if Jake had reformed, and "seen the errors of his ways"? How would you feel? How would you have felt if Jake had just been a complete jerk all through the film?

CINEMATOGRAPHY in *Raging Bull* (Martin Scorsese, 1980)

I. INTRODUCTION

 A. Most films and TV shows we see either knowingly or unknowingly reinforce the ideological ideas we already accept as "natural"

 1. In Hong Kong movies, we often see strong women fighters, but they usually end up with men

 2. Or "Beverly Hills 90210" which assumes that the audience shares the characters' capitalist (but liberal humanist) ideology

 B. However, some films deliberately challenge and criticize the ideology that most of the audience accepts

 1. The films of Godard, for example, do this

 2. American documentary films about the Vietnam War in the 1960s sometimes challenge the idea that the war was right

 C. However, many of these (including the documentaries) also assume some common ideological beliefs between the filmmakers and audience

 1. In order to convince the audience that something is "wrong," they must appeal to something the audience believes is "right"

 2. For example, killing is wrong, individual rights are most important, etc.

 D. Martin Scorsese's 1980 film, *Raging Bull*, is a film that takes a more ambivalent attitude toward ideological issues

 1. It challenges the viewer to confront his/her own attitudes

 2. We will look at the film in an effort to determine its ideological position and ambivalences

 3. It accomplishes much of its exploration of American ideology through its use of cinematography

II. THE ISSUE OF VIOLENCE IN AMERICA

 A. How do many modern film genres deal with the issue of violence?

 1. SCIENCE FICTION and FANTASY FILMS: *Star Wars*? *Jurassic Park*?

 2. SLASHER and HORROR FILMS: *Friday the 13th*? *Brain Dead*?

 3. What about the newspapers? News on TV? Sports?

B. How does *Raging Bull* deal with the issue of violence?

1. Does it celebrate boxing, Jake La Motta, and violence? Or does it present La Motta as a sick, vicious killer? Or does it suggest that there is a problem with violence in the US, but that the problem lies elsewhere, not just with Jake?

2. How does the film present boxing and violence ambivalently?

 a) In what ways is it attractive?

 (1) Think of the cinematography, especially at the beginning, and the nondiegetic music; it also makes us feel Jake's solitude in the ring

 (2) What about the combination of violence and sex (when Vicki kisses his bruises and cuts)?

 b) In what ways is it repulsive?

 (1) The slow motion shots of Jake punching the "pretty" fighter

 (2) The slow motion shots of Sugar Ray Robinson punching Jake

 c) Use of documentary and "realistic" conventions:

 (1) Black and white film stock

 (2) The use of "home movies" (and note the inversion: the "home movies," which in "real life" would have probably been in b-and-w, are in color)

 (3) The use of the Steadycam, which allows close shots, tracking shots, etc., inside the ring

 (4) The use of dates to situate the events historically (and think of the title that identifies the time and place of Jake's "fight" with his brother)

3. SUBJECTIVITY and VIOLENCE

 a) The film presents much of the violence subjectively

 (1) The shots of Jake beating the "pretty boy"

 (2) Jake getting beaten by Sugar Ray Robinson

 (3) How does this subjectivity make us feel?

152

（4） Does it make the violence more or less hard to take?

（5） Does it make you feel sympathetic toward Jake?

III. THE ISSUE OF SEX and ITS RELATIONSHIP TO VIOLENCE

 A. The film suggests a relationship between sex, masochism and violence

 1. The scene when Vicki kisses Jake's bruises

 2. Jake's sexual self-torture (the teasing, then the ice water)

 3. His efforts to get Joey to hit him

 4. The invitation to Sugar Ray Robinson to beat him

 5. Jake's beating his head in the jail cell

 6. In general, Jake does things to himself, things that will make him suffer

 B. Sexual Self Doubts and Homosexuality?

 1. Again, Jake does things that make him suffer; he eats and drinks instead of making love to his wife

 2. He is unreasonably jealous of other men (he believes Vicki when she said she had sex with every other man she could find)

 3. He seems unusually interested in, almost obsessed with, the "pretty boy"; he doesn't know whether to fight him or fuck him

 4. The movie suggests, through his invitation to Sugar Ray to beat him, his embrace of his opponents, the shots of the second massaging his back, etc., that his fascination with boxing may be due to repressed sexuality

IV. CONCLUSION

 A. In the end, how do we feel about Jake La Motta?

 1. Do you hate him?

 2. Feel sorry for him?

 3. Do you feel he is a victim of circumstances?

 B. Even if we don't excuse him, how can we say that society encourages his behavior?

 1. Regarding his behavior toward Vicki and Joey's criticism of it, what does he see his brother doing?

 2. Why do all those people go to see boxing? What do they expect to see? What kind of people are they?

 3. Remember the playing of the US national anthem as the audience riots?

C. Is not Jake just an unintelligent guy who got mixed messages from the world around him?

D. What is the result of Scorsese's refusal to make things clear?

1. What would have happened if Jake had reformed, and "seen the errors of his ways?" How would you feel?

2. How would you have felt if Jake had just been completely unsympathetic all through the film?

E. In the end, what is your opinion of this film?

CINEMATOGRAPHY

Rope (Alfred Hitchcock, 1948)

Directed by Alfred Hitchcock

Written by Hume Cronyn, Patrick Hamilton and Arthur Laurents

Cinematography by William V. Skall and Joseph A. Valentine

Music by Leo F. Forbstein and Francis Poulenc (from "Perpetual Movement No. 1")

Costume Design by Adrian

Film Editing by William H. Ziegler

Produced by Sidney Bernstein and Alfred Hitchcock

Produced and Distributed by Warner Bros.

Cast

James Stewart...Rupert Cadell

John Dall...Shaw Brandon

Farley Granger...Philip

Joan Chandler...Janet Walker

Cedric Hardwicke...Mr. Kentley

Constance Collier...Mrs. Atwater

Edith Evanson...Mrs. Wilson, the Governess

Douglas Dick...Kenneth Lawrence

Dick Hogan...David Kentley

STUDY QUESTIONS

1. What is unusual about the editing of this film? In what ways does the editing affect the cinematography, esp. camera movement and offscreen space?

2. What is the relationship among plot time, story time, and screen time in this film? How does Hitchcock indicate the passage of time?

3. How does the film's *style* contribute to the *narrative*? In other words, how do the stylistic elements make us feel a certain way about the story and characters?

4. Think about the ways in which the film could have been made differently and what the difference in effect would be. Pay particular attention to the two following scenes: The one in which Brandon takes the rope into the kitchen and puts it in a drawer; and the scene after dinner, in which the housekeeper clears the dishes off the chest, carrying them from the living room to the dining room. First describe the scenes, then imagine alternatives to the ways in which Hitchcock shot them. Why did he shoot them the way he did?

5. With whom do we sympathize in the film? Why, and how does this happen?

CINEMATOGRAPHY in *Rope* (Alfred Hitchcock, 1948)

I. INTRODUCTION

 A. Hitchcock normally relied heavily on editing; he believed it is the most important aspect of film style

 B. But decided to experiment by making a film without editing

 1. Takes are almost all 10 minutes long (amount of film in one reel)

 2. The takes end with a close-up of a back, etc., and begin likewise

 3. Because he did not edit, he relied more heavily on cinematography, especially camera movement and offscreen space

 4. To achieve effects of editing, Hitchcock "maintained the rule of varying the size of the image in relation to its emotional importance within a given episode"

 C. WHAT ABOUT TIME and THE NARRATIVE?

 1. Plot time: 1 hr., 45 min. (7:30 pm to 9:15 pm)

 2. Screen time: 1 hr., 20 min.

 3. Story time: a matter of opinion

II. TECHNICAL DIFFICULTIES

 A. THE BACKGROUND

 1. To achieve effect of night falling, the lights between the window and the background were gradually dimmed

 2. The clouds

 a) Made of spun glass, hung between window and background

 b) Moved slightly from left to right between reels

 3. Background itself made in a semicircular pattern, allowing camera movement without distorted perspective

 B. CONTINUOUS CAMERA MOVEMENT and THE SET

 1. Walls mounted on rails, moved out of the way to accommodate movement of the camera through apartment

 2. Furniture mounted on rollers to make it moveable

 a) PROBLEMS

 (1) Everything moved back to previous position in time to be seen again when camera moved so that the moved objects were again visible

 (2) The sound was all recorded directly; therefore everything had to be moved silently

III. CAMERA MOVEMENT IN *Rope*

 A. CINEMATOGRAPHY and INTERPRETATION

 1. The film was based on a stage play

 2. Lack of editing and use of camera movement attempted to duplicate stage's containment and restriction

 3. The film is able to do more than the play, however

 a) Camera movement begins very fluid, with a sense of freedom that mirrors the sense of freedom felt by at least the dominant of the two homosexual lovers

 b) By end of film, camera much more restricted

 (1) The sense of entrapment has become dominant, replacing the earlier sense of freedom

 (2) The space covered by the camera has become much more limited, again reflecting the sense of claustrophobia felt by the killers

 B. THE INITIAL CUT and MOVEMENT

 1. Film begins (with credits) outside of apartment, in the street

 2. The camera moves toward the apartment, and here we get one of the few cuts in the film

 3. Therefore, we have gotten the most unrestricted moment, the "free-est" moment of the film at this point

 a) Don't think that the rest of the film is completely restricted (it may seem to be)

 b) Think of Prof. Rupert Cadell planting his cigarette case on the chest

C. CAMERA MOVEMENT *vs.* EDITING

1. A helpful way to understand how film style works is to imagine alternatives; how would the effect of a shot (or a scene or even a film) be different if it were made differently?

2. SCENE: Brandon takes rope into kitchen, puts it in a drawer

 a) Long take lets us see Brandon's confident, arrogant walk

 (1) This tells us about him and how he feels

 (2) How else could this have been achieved?

 (a) A close-up

 (b) What would have been the effect? (too obvious)

 b) Followed by Brandon putting rope in kitchen drawer

 c) How does Hitchcock duplicate editing?

 (1) Door swings shut, then opens to show us Brandon dropping the rope into the drawer

 (2) This isolates the action, much in the way a separate shot would

 (3) But what is the difference?

 (a) The long take version is more interesting

 (b) It gives us Philip's POV

 (i) We feel his nervousness and fear

 (ii) We are not meant to *feel* (or *share*) Brandon's confidence and smug sense of superiority

 (iii) Instead, we are meant to *see* (or *observe*) it

 d) What expectations do we have because of this scene and its style?

 (1) They will be caught

 (2) It will be because of Brandon's arrogance, Philip's fear and the rope

3. SCENE: After dinner, housekeeper clears dishes off chest, carrying them from the living room to the dining room

 a) Each time she returns, brings some books back to chest

b) Camera positioned to show her trips back and forth, with the guests and hosts offscreen right

c) What are our expectations at this point?

 (1) She will try to open the chest

 (2) If so, this is how the killers will be caught

d) The editing alternative

 (1) Show Brandon's and Philip's faces in close-ups

 (2) Cut back to the housekeeper

 (3) Cut to Rupert watching Brandon and Philip, etc.

 (4) The difference

 (a) We would know that Brandon and Philip think the housekeeper will open the chest

 (b) This would kill some of the suspense

D. THE DEVELOPMENT OF THE NARRATIVE and CAMERA MOVEMENT

1. The action becomes more and more confined to the living room, whereas it earlier had taken place in other rooms also

2. Camera becomes confined to living room, closer and closer to chest

3. Camera movements become more closely associated with Rupert

a) They become more probing

b) At the same time, more abrupt, smaller, and tense

4. Think about how the plot has made us switch our loyalties, without us really being aware of it

a) Initially, we do not want Brandon and Philip to get caught; we share their fear

b) By the last third of the film, we want Rupert to find the body

 (1) This is the result of "star power," in part (after all, he *is* Jimmy Stewart)

 (2) But Hitchcock also uses style - primarily camera movement - to make us switch our identification

E. THE END OF THE FILM

1. Rupert finally opens the window to fire the gun

2. Sense of claustrophobia broken; the room, and the space, have been
 opened up after relentlessly increasing confinement

3. We feel the relief of Rupert, and Brandon and Philip also

CINEMATOGRAPHY

Nosferatu (F.W. Murnau, 1922)

Directed by F. W. Murnau

Written by Henrik Galeen

Cinematography by Fritz Arno Wagner and Gunther Krampf

Produced by Enrico Dieckmann and Albin Grau

Produced and Distributed by Jofa-Atelier Berlin-Johannisthal and Prana-Film GmbH

Cast

Max Schreck…Graf Orlok

Gustav von Wangenheim…Hutter

Greta Schroder…Ellen Hutter

Alexander Granach…Knock

Georg H. Schnell…Harding

Ruth Landshoff…Ruth

John Gottowt…Professor Bulwer

STUDY QUESTIONS

1. In what ways is the cinematography in *Nosferatu* somewhat unusual?

2. The use of on- and offscreen space is especially effective in this film. In ways are they used? How are these uses different from most films, either silent or more recent?

3. *Nosferatu* also uses altered speed of motion, as well as pixilation. What are the narrative functions of these uses of cinematography?

4. How are cinematography and mise-en-scène used to increase the sense of movement without the use of the moving camera?

CINEMATOGRAPHY in *Nosferatu* (F.W. Murnau, 1922)

I. INTRODUCTION

 A. F.W. Murnau's *Nosferatu* offers a number of examples of the (often unusual) use of cinematography

 B. We will first look at some of these unusual uses of cinematography and their effects

 C. We will then look at how Murnau used cinematography and mise-en-scène to solve a particular problem he faced in making this film

II. CINEMATOGRAPHY in *Nosferatu*

 A. SCREEN FORMAT

 1. Made in the old Academy standard aspect ratio, 1:1:33

 2. The IRIS is also used extensively to alter the screen format

 a) The iris is a round, moving mask

 b) Either closing (iris-in) to end a scene or emphasize a detail, or opening (iris-out) to begin a scene or reveal more space around a detail

 B. OFFSCREEN SPACE: Onscreen and offscreen space are also aspects of framing that are used effectively in the film

 1. Onscreen space often implies offscreen space, as when a character looks offscreen and obviously sees something that we can not see

 2. The offscreen space behind the set is often used for dramatic effect, as when characters disappear behind objects or suddenly appear from behind them (the vampire rising out of the ship's hold, etc.)

 3. Shadows often suggest objects or characters offscreen, especially the vampire, who is often seen only as a shadow

 C. CAMERA POSITION

1. CAMERA ANGLE, LEVEL, and HEIGHT are generally fairly "normal" (straight-on, parallel to the horizon, and about the height of an average man)

2. Often, however, camera position is altered for specific effects

 a) For example, we cut from a straight-on shot of a crowd looking offscreen up and right, to a shot from a low angle looking up at Renfield on the roof of a building

 b) Because we do not get a high-angle shot, we see the scene more-or-less from the POV of the crowd, not that of Renfield

3. CAMERA DISTANCE; is varied extensively throughout the film; close-ups are often used:

 a) To convey important information and give us details (such as Harker's bleeding thumb)

 b) To create surprise and shock (the close-up of the vampire's face in the coffin)

D. THE PHOTOGRAPHIC QUALITIES

 1. SPEED OF MOTION is also varied throughout the film

 a) Most of the film is filmed, printed and projected at normal (silent) film speed (16 fps)

 b) FAST MOTION is also used at times for certain effects

 (1) Created through the use of UNDERCRANKING

 (a) This refers to the slowing down of the film as it was exposed in hand-cranked cameras

 (b) It was often used in silent films to create fast motion for comic effects

 (c) It is used in *Nosferatu* to create a supernatural atmosphere as Harker approaches the vampire's castle in the coach

 (2) NEGATIVE PRINTING

<div style="margin-left: 3em;">
(a) This atmosphere is also enhanced by the use of negative film at one point

(b) Gives the impression of "the land of phantoms" as Harker approaches the Count's castle
</div>

 2. PIXILATION

<div style="margin-left: 3em;">
a) Objects in the film are often manipulated through the use of pixilation, or stop-action cinematography

b) This is a frame-by-frame animation process in which objects or subjects are moved between frames

c) Results in the animation of inanimate objects (the coffins, etc.)
</div>

III. CINEMATOGRAPHY and MISE-EN-SCÈNE in *Nosferatu*

 A. THE PROBLEM

<div style="margin-left: 2em;">
1. When F.W. Murnau directed this film in 1922, he was faced with the problem of creating a dynamic film without the use of a mobile camera

2. By 1925, the problem of camera mobility had been solved by the Germans, who then relied on what was known as the "unchained camera"
</div>

 B. THE SOLUTION: Dynamism and depth-filled shots were created by mise-en-scène and cinematography in *Nosferatu* through the use of four principles:

<div style="margin-left: 2em;">
1. UNUSUAL CAMERA POSITION

<div style="margin-left: 2em;">
a) Emphasizes diagonals in the mise-en-scène, such as the shot of Harker and the vampire at the table in the castle

b) The position of the camera emphasizes the diagonal pattern of the floor tiles, which leads the eye of the viewer to the right of the frame, while the characters sit on the left; this makes the eye move, instead of the camera
</div>

2. MOVEMENT WITHIN SHOTS

<div style="margin-left: 2em;">
a) There is much movement toward and away from the camera, as well as in and out of the frame, emphasizing the sense of depth and offscreen space
</div>
</div>

b) Examples include:

 (1) The sailor who enters the frame from the bottom and runs back away from the camera

 (2) The shot of the coffins being carried down the street toward the camera

 (3) The boat entering the harbour from offscreen right

3. LIGHT and SHADOW

 a) Are used to create a sense of depth in the frame

 b) EXAMPLE; the shot of Harker running through the forest, passing through patches of light and shadow; the sense of depth in this shot is also enhanced by the high camera angle looking down on Harker

4. STAGING IN DEPTH (several planes)

 a) Results in a greater sense of depth and more interesting compositions in the frame

 b) EXAMPLE: When the villagers chase Renfield, we see a group of people running in the background from right to left, then a person enters in the middle ground from a doorway, left to right in the frame, and finally a person enters from a doorway in the foreground, running right to left

IV. CONCLUSION

 A. Through the use of cinematography, especially special effects, Murnau created a film that gives a feeling of the supernatural

 B. Through the use of cinematography and mise-en-scène, Murnau creates dynamism without the use of the moving camera

CONTINUITY EDITING

Hellraiser (Clive Barker, 1988)

Directed and written by Clive Barker

Produced by Christopher Figg

Original music by Christopher Young

Cinematography by Robin Vidgeon

Film Editing by Richard Marden and Tony Randel

Production by Cinemarque Entertainment BV, Film Futures and New World Pictures

Distributed by New World Pictures

Cast

Andrew Robinson…Larry

Clare Higgins…Julia

Ashley Laurence…Kirsty

Sean Chapman…Frank

Oliver Smith…Frank the Monster

Robert Hines…Steve

Frank Baker…Derelict

Doug Bradley…Pinhead (Lead Cenobite)

Nicholas Vince…Chatterer

Simon Bamford…"Butterball" Cenobite

Grace Kirby…Female Cenobite

STUDY QUESTIONS

1. Clive Barker's *Hellraiser* relies on the continuity system of editing to a great extent; it is essentially a classical Hollywood film. However, it does sometimes violate important principles of continuity editing. In what ways does it do this?

2. Barker claims that he wanted to make an ambiguous film, one that would make the audience think about their own limits: "The line between pleasure and pain, between violence and desire, is so fine, and I find that an interesting ambiguity. What we are trying to do is collide this very strange, dark, forbidden, imagery with really nice pictures." Is Barker successful in this? If so, in what ways?

3. In what ways is this film a mixture of CHC conventions and violations of the CHC? How does it do this narratively? Stylistically?

4. How does editing contribute to this overall structure? In what ways does it present a combination of clear and unclear articulation of time and space?

5. What are some of the more significant motifs in the film?

EDITING in *Hellraiser* (Clive Barker, 1988)

I. INTRODUCTION

 A. Clive Barker's *Hellraiser* relies on the continuity system of editing to a great extent; it is essentially a CHC film

 1. Even when films violate continuity editing principles, the CHC's continuity editing system is used as a "base," against which the alternative has more meaning and impact

 2. Most audiences are familiar with continuity editing, and films that offer an alternative to it run the risk of "losing" the audience without a base of continuity editing

 B. However, *Hellraiser* does sometimes violate important principles of continuity editing; this is one of the aspects that makes the film more interesting than the average horror film

 C. Why did Barker do this?

 1. He claimed that he wanted to make an ambiguous film, one that would make the audience think about their own limits

 a) What is acceptable and not acceptable?

 b) What is beautiful and what is disgusting?

 c) What is really horrifying, and what is just sensational?

 2. "The line between pleasure and pain, between violence and desire, is so fine, and I find that an interesting ambiguity"

 3. "What we are trying to do is collide this very strange, dark, forbidden, imagery with really nice pictures"

 a) Think of the flowers crosscut with blood, the cenobites, etc.

 b) Crosscutting of lovemaking with the nail in the hand

 D. Given this idea behind the film, it is understandable that the film is an odd mixture of the CHC and violations of the CHC

 1. NARRATIVELY

 a) It uses standard horror film clichés

 (1) The girl, Kirstie, threatened by monsters

 (2) The evil stepmother

 (3) The dorky boyfriend

 b) But the film combines them with a weird story of sexual passion and perversion

 c) Although it has a great degree of closure, some things are never explained

 (1) What really happened to Kirstie's mother?

 (2) Who is the tramp who eats crickets and turns into a monster at the end of the film?

 (3) Who or what the hell are the "cenobites" anyway?

 2. STYLISTICALLY

 a) The film plays on the style of the horror movie

 b) It uses sequences that are dreams, but others that are ambiguous

 c) It relies on an odd mixture of the past and present

II. *Hellraiser* and EDITING

 A. The overall structure of the film is a combination of clear and unclear articulation of time and space

 1. TEMPORALLY: Although most of the temporal relations in the film are reasonably clear, there are some important exceptions

 a) When did the events at the beginning of the film (Frank and the box) take place in relation to the rest of the film?

 b) When did the events take place between Frank and Julia in relation to the death of Kirstie's mother's death, the wedding, and the "present"?

 2. SPATIALLY: The relationships between spaces are usually clear, but sometimes are not clearly articulated

 a) Where does this story take place?

 (1) There are hints that it is in England

 (2) But does this really make sense?

 b) Where do the cenobites torture Frank?

 c) Where do the cenobites exist, anyway?

B. A NORMAL SCENE: The first telephone conversation between Larry and his daughter, Kirstie

 1. It is presented in standard CHC crosscutting style

 a) It alternates shots of the characters

 b) They are "facing one another" (does this make sense? No, but it works)

 2. There is some sense of ambiguity, however; where is she in relation to the house?

C. SOME ABNORMAL SCENES

 1. The scene in which Julia remembers her affair with Frank

 a) Displaced diegetic sound creates a sound bridge between the shots (more than once)

 b) Because of this, the arrangement of the mise-en-scène, and eyeline matches, we are initially led to believe Frank is at the door of the present house

 c) What tips us off? Julia's hair is different

 d) When did these events take place?

 e) How much time did they cover?

 (1) Was it a series of events, or did it all happen in one day?

 (2) Because we are seeing the affair as Julia remembered it (it is mentally subjective), we are not sure; maybe she is remembering the "high points" of the affair

 2. The crosscutting scene in which Larry's hand is torn open by the nail

 a) This scene operates more-or-less according to the continuity system, even if in a fairly complicated way; but it also begins to show the idea of perversity in the film

 b) It builds anticipation and tension; we know the nail is there (because the narration is unrestricted and objective) and that Larry is getting close to it

 c) At the same time, Julia is in the room where Frank is, getting turned on by his memory

　　　　(1)　　This is mentally subjective, with some perceptual
　　　　　　　subjectivity and mostly objectivity

　　　　(2)　　We see Julia's memory of having sex with Frank

　d)　Crosscutting makes the connection between the two: sex and
　　　violence

　　　　(1)　　As Julia reaches her climax, Larry reaches the nail

　　　　(2)　　Is this not like sex in some ways? Pleasure so intense
　　　　　　　it is almost painful (or, if you are somewhat kinky, pain
　　　　　　　so intense it is almost pleasurable)

　e)　After the climax, we learn the difference between the brothers,
　　　Larry and Frank

　　　　(1)　　Larry is afraid of blood; he almost faints, thinks he is
　　　　　　　going to be sick

　　　　(2)　　Frank is a stud, and, as we learn later, not at all afraid
　　　　　　　of blood

　　　　(3)　　What about Julia?; She is somewhat disgusted by gross
　　　　　　　things, but she can handle them…maybe even likes
　　　　　　　them

　f)　This sequence also introduces some motifs and plants the causes
　　　for later effects

　　　　(1)　　Motifs

　　　　　　　(a)　　Frank's finger on her lips

　　　　　　　(b)　　The knife

　　　　　　　(c)　　"It's never enough" (think of how he keeps
　　　　　　　　　　telling Julia to get more blood)

　　　　(2)　　Cause and effect

　　　　　　　(a)　　It sets up Julia's sexual desire for Frank

　　　　　　　　　　(i)　　This is needed to explain why she does
　　　　　　　　　　　　　what she does later in the film

　　　　　　　　　　(ii)　　"I'd do anything for you"

　　　　　　　(b)　　"It's never enough"

<div style="margin-left: 2em;">

 (i) This explains why he does things like buy the box

 (ii) It also helps explain why he is into "pleasure and pain"

</div>

 3. THE CLIMAX OF THE FILM

 a) As Frank chases Kirstie through the house, we become disoriented; where are we, especially in relation to "Frank's room"?

 b) The chase establishes an impossible space; as she passes through doors, she enters rooms that can not possibly be connected to those doors

III. CONCLUSION

A. Through the use of all of the elements of film form, Clive Barker has created a horror film that "bothers" us on more than a strictly visual level

B. It disorients us spatially and temporally

 1. We are then more susceptible to its message about the joys of "experience beyond pleasure and pain"

 2. We may begin to question our own sometimes pleasurable reactions to pain...our own and that of others

CONTINUITY EDITING

Frenzy (Alfred Hitchcock, 1972)

Directed by Alfred Hitchcock

Written by Anthony Shaffer

Produced by William Hill and Alfred Hitchcock

Music by Ron Goodwin

Cinematography by Gilbert Taylor and Leonard J. South

Film Editing by John Jympson

Produced and Distributed by Universal Pictures

Cast

Jon Finch…Richard Ian Blaney

Alec McCowen…Chief Inspector Oxford

Barry Foster…Robert Rusk

Billie Whitelaw…Hetty Porter

Anna Massey…Babs Milligan

Barbara Leigh-Hunt…Brenda Margaret Blaney

Bernard Cribbins…Felix Forsythe

Vivien Merchant…Mrs. Oxford

STUDY QUESTIONS

1. Is the range of the narration of *Frenzy* UNRESTRICTED or RESTRICTED? Do we see, hear, and know more than any or all of the characters? Or do we see, hear, and know only what one character in the film experiences?

2. What about the depth of narration? Is it OBJECTIVE, PERCEPTUALLY SUBJECTIVE, or MENTALLY SUBJECTIVE? Examples?

3. Are individual characters causal agents? Do the characters have goals based on some sort of personal desire? What are they? Does opposition to the goals lead to conflicts? Do the characters change because of the conflicts? Is there a strong degree of closure?

4. In terms of editing, are graphics kept similar from shot to shot? Exceptions? Examples?

5. Are the lengths of the takes dependant on camera distance? Are long shots usually on screen longer than closer shots? Exceptions? Examples?

6. Can you give examples of instances of the 180° system? Shot/reverse shot? The eyeline match? Establishment/breakdown/reestablishment? Match on action? The cheat cut?

7. If we conclude that *Frenzy* conforms highly to the continuity editing system, how does this style of editing contribute to the film itself?

CONTINUITY EDITING in *Frenzy* (Alfred Hitchcock, 1972)

I. INTRODUCTION

 A. We are going to discuss, in some depth, editing in Hitchcock's *Frenzy*; But first, it may be helpful to discuss the film in more general terms, dealing with narrative and motifs

 B. NARRATIVE

 1. What is unusual about the narrative of this film?

 a) What is our initial expectation? That Richard Blaney is the "neck-tie murderer"; why?

 (1) The cut from the tie around the strangled woman's neck to Blaney with an identical tie in the pub

 (2) His temperament is established early

 (a) He is a drinker

 (b) He has a violent past, especially in regard to his ex-wife

 (c) He is prone to threats

 (d) His behavior is violent when he is with his ex-wife

 (3) His motives?

 (a) Revenge; how would you describe the behavior of his ex-wife?

 (b) Money; we know he is broke

 b) But what do we discover early in the film?

 (1) The real murderer is, in fact, Bob Rusk

 (2) This is due to the high degree of unrestriction of the narrative

 c) The film's plot follows three storylines:

 (1) Richard Blaney trying to clear himself

 (2) Bob Rusk murdering women and framing Richard

 (3) Inspector Oxford investigating the case

d) Therefore, what we expect, and experience, is more the inevitable capture of a man we know is innocent, rather than an investigation that will reveal the real killer (we already know this)

2. REPETITION and SIMILARITY IN THE NARRATION: RICHARD BLANEY and BOB RUSK AS COMPLEMENTARY CHARACTERS

a) Think of their respective initials: RB and BR

(1) The "R" on the tie pin could stand for either Rusk or Richard

(2) Think of all the "Bs": Bob, Blaney, Brenda, Babs

b) Richard and Bob are complementary in behavior

(1) Richard is hot tempered, and seems capable of violent behavior

(a) What does he say to the man at the Salvation Army? "I'll break your arms."

(b) Think of the broken wine glass; his temper is barely under control, but it *is* under control

(c) He has "normal" sexual preferences

(2) Bob seems even-tempered, but his anger is below the surface

(a) He calls himself "Uncle Bob"

(b) He always offers to help people

(c) Although he doesn't seem to be interested in women, he is actually a pervert (think of the picture of his mother in his room)

(d) He is definitely capable of violence, especially against women

C. MOTIFS: FOOD and SEX

1. One critic calls food, in *Frenzy*, "a basic visual metaphor for the devouring abuses of man-against-man"

2. In this film, food also helps us make comparisons among the various characters

3. FOOD IN GENERAL

 a) Grapes

 (1) Bob gives Richard a box of grapes, which he steps on in anger

 (2) The inspector is served a dinner of quail and grapes (the grapes are bigger than the quail)

 (3) Bob is always eating grapes while he works

 b) Potatoes

 (1) Workmen carry sacks of potatoes around

 (2) Bad potatoes give Bob a way to dispose of Babs's body

 (3) The potato truck becomes an important part of the film

4. More specifically, the film deals with appetites

 a) Some are satisfied

 (1) Brenda feeds Richard a dinner when he is hungry

 (2) The next day, she satisfies Bob's appetite for perversion

 (a) This scene takes place at lunch

 (b) Bob eats before and after killing her

 (c) He comments on her lunch (mostly fruit), suggesting it is inadequate for her (apparently, he could satisfy her appetite)

 (3) Think about Bob's "appetites"

 (a) He always seems to be eating

 (b) He picks his teeth after raping and murdering women

 b) Some of these appetites are not satisfied

 (1) The inspector has to eat simple food for lunch

 (2) His wife, taking a course in "gourmet cooking," gives him disgusting food and/or inadequate amounts of food

 (3) This reflects the quality of his home life

 (4) What does he say in response to her cooking? "Lovely, lovely"

D. Now that we have seen how the film makes connections between characters and uses motifs to advance the narrative, let's look more closely at editing in *Frenzy*

II. EDITING in *Frenzy*

 A. INTRODUCTION

 1. Hitchcock's *Frenzy* is a film that closely follows the CHC's system of continuity editing

 a) The film was made in England, not Hollywood

 b) However, the style of English films, especially in terms of editing, is much like that of the CHC

 2. However, *Frenzy* also violates continuity editing at certain points

 a) These "violations" are used for specific narrative reasons

 b) They stand out because they occur in a film that relies heavily on continuity editing

 3. We will look at both kinds of editing in *Frenzy*

 a) We will discuss the narrative functions of both

 b) And we will discuss the issue of a male-oriented identification in the film

 c) And the difference between the way violent scenes involving women are edited differently than are other scenes

 B. THE RAPE and MURDER SCENE of *Frenzy*

 1. This scene is composed of four segments

 a) The conversation between Rusk and Brenda

 b) The rape

 c) The murder

 d) Rusk's departure

 2. THE CONVERSATION

 a) This segment is shot in conventional CHC style

 b) It begins with an establishing shot, then breaks down the space

 c) It proceeds with a series of shot/reverse shots

3. THE RAPE
 a) As Rusk begins to rape Brenda, we see a series of extremely close shots, fragmenting her body (cf. shower scene in *Psycho*)
 b) Emphasis is placed on her breasts, crotch, and ankles
 c) We also get shots of her head thrown backwards, neck extended and back arched
 (1) This is a typical way to submission in all art forms, and in the animal world
 (2) Cf. *Psycho*, also depictions of sexual satisfaction
 d) Note the lighting in this scene
 (1) It is full on Rusk's face
 (2) It is softer, more diffuse on Brenda, with backlighting providing a halo; this does not happen elsewhere in the film

4. THE MURDER
 a) Unlike the other parts of the film, this is shot largely to give us Rusk's POV
 b) We get many close shots of Brenda's face from a position above her
 c) As Rusk becomes more sexually excited, his face, and the camera get closer
 d) We get a number of shots violating the 180^0 line, from either side of her face
 e)· This segment ends with an extreme close-up of Brenda's eyes darting back and forth

5. THE DEPARTURE
 a) Here we get a return to longer takes, after the series of short takes in the murder scene
 b) This helps us identify with Rusk, with his slowing heart beat, etc.

 c) It also allows us to think about our own reactions to what we have just experienced; we have become excited, maybe even aroused, by something that disgusts us

C. What does this tell us about the representation of violence against women in Hitchcock's, or any, films?

 1. There is some controversy about this

 a) Some scholars say that Hitchcock is trying to make us look at ourselves and question our own attitudes

 b) Others say that Hitchcock, as a male director, can't help but construct scenes that:

 (1) Reflect a male attitude toward women

 (2) Do this in order to make us sympathize with the male, rationalizing abusive treatment of women

 2. Cf. a violent scene in another film, *The Wild One*

 a) In this scene, we have violence between two men

 b) It is shot not to objectify them or fragment them into body parts (no "crotch shots," etc.)

 c) Instead, it gives dynamic, action shots of them, often the entire body, stressing power and strength on the part of both characters

D. THE OTHER MURDER

 1. What is different about the way this is shot, compared to the first murder

 a) It is a long take

 b) It spares us the murder (we're glad)

 c) How do we know there *is* a murder? Repetition of the line, "You're my kind of woman"

III. CONCLUSION: What is the film's final twist?

A. Richard tries to kill Rusk

 1. Initially, what do we think happened?

 2. How do we feel when we find out that the woman is dead already?

B. What does this say about Richard and Bob?

 1. Is Richard just as guilty as Bob?

a) Is he really any less guilty just because the woman was dead already?

b) He cold-bloodily plotted the murder of Rusk for revenge

2. Rusk, on the other hand, kills because he is sick, and "belongs in a hospital, not a prison"

CONTINUITY EDITING

The Locket (John Brahm, 1946)

Directed by John Brahm

Written by Sheridan Gibney

Produced by Bert Granet

Music by Roy Webb

Cinematography by Nicholas Musuraca

Film Editing by J.R. Whittredge

Produced and Distributed by RKO Radio Pictures

Cast

Laraine Day…Nancy

Brian Aherne…Dr. Harry Blair

Robert Mitchum…Norman Clyde

Gene Raymond…John Wilis

Sharyn Moffett…Nancy (age 10)

STUDY QUESTIONS

1. Is the range of the narration of *The Locket* UNRESTRICTED or RESTRICTED? Do we see, hear, and know more than any or all of the characters? Or do we see, hear, and know only what one character in the film experiences?

2. What about the depth of narration? Is it OBJECTIVE, PERCEPTUALLY SUBJECTIVE, or MENTALLY SUBJECTIVE? Examples?

3. Are individual characters causal agents? Do the characters have goals based on some sort of personal desire? What are they? Does opposition to the goals lead to conflicts? Do the characters change because of the conflicts? Is there a strong degree of closure?

4. In terms of editing, are graphics kept similar from shot to shot? Exceptions? Examples?

5. Are the lengths of the takes dependant on camera distance? Are long shots usually on screen longer than closer shots? Exceptions? Examples?

6. Can you give examples of instances of the 180° system? Shot/reverse shot? The eyeline match? Establishment/breakdown/reestablishment? Match on action? The cheat cut?

7. If we conclude that *The Locket* conforms highly to the continuity editing system, how does this style of editing contribute to the film itself? If it deviates in some ways from the system, what are the effects of these deviations?

CONTINUITY EDITING *The Locket* (John Brahm, 1946)

I. INTRODUCTION

 A. Although the Classical Hollywood Cinema (CHC) is often thought of as being monolithic--constricted by rigid rules, convention-bound, etc.--even during the times of the most rigid conformity there has been room for difference

 B. Why is there difference?

 1. Although the CHC needed to produce a consistent product (so consumers would know what to expect for their money), it also needed to differentiate its products to sell them

 2. Conventions of genre and style account for many of these differences; the narrative and visual styles of, say, the Western, were necessarily different from those of the musical, so the audience could recognize and choose them

 3. We must also remember the human or authorial factor involved; this factor was allowed to influence CHC films--within limits--in order to differentiate the product

II. *THE LOCKET* and CONFORMITY TO THE CHC

 A. The NARRATOR

 1. Most obviously the narrator may be a character in the story itself, or may be noncharacter narrator, "telling" us the story as a voice-over commentator; *The Locket* has three character narrators: Dr. Blair, Norman Clyde, and Nancy

 2. Even without this, we understand that we are being told a story: the source of this story is the narrator; in *The Locket* the frame story (the wedding, etc.) is told to us by this more abstract narrator

 B. THE NARRATIVE

 1. RANGE: Options: UNRESTRICTED or RESTRICTED

a. Is the narration UNRESTRICTED (or OMNISCIENT)?

 (1) Do we see, hear, and know more than any or all of the characters?

 (2) If we consider the film as a whole, it is unrestricted

b. Or is the narration RESTRICTED?

 (1) Do we see, hear, and know only what one character in the film experiences? Yes

 (2) However, the individual episodes (flashbacks) tend to be highly restricted

 (3) An exception (not necessarily the only one) occurs during Nancy's flashback when we see her mother find the locket

2. NARRATIVE CONVENTIONS OF THE CHC

 a. Are individual characters causal agents?

 b. Do the characters have goals based on some sort of personal desire?

 c. Does opposition to the goals lead to conflicts?

 d. Do the characters change because of the conflicts?

 e. Is there a strong degree of closure?

C. THE STYLE, especially EDITING

1. Editing is most important to the CHC in terms of style

 a. GRAPHICS

 (1) Kept similar from shot to shot to avoid the disruption that could result from strong graphic clashes

 (2) Lighting, figure placement, etc. are also kept similar shot to shot

 b. RHYTHMIC RELATIONS are not emphasized

 (1) The length of a take is dependant on camera distance

 (2) Long shots usually on screen longer than closer shots

D. ORDER

1. In Hollywood cinema, events are usually presented in chronological order and seen only once

2. Only exception is the flashback (or flashforward; rare)

 a. Signalled by a cut or dissolve

 b. Motivated by the narrative

E. DURATION: often varies

1. What is the plot time? The story time?

2. Where is time omitted?

 a. Time can be omitted within scenes (an interesting example from *The Locket* occurs when Dr. Blair sits in his apartment waiting for Nancy)

 b. However, scenes are often in continuity, with time omitted between scenes; this is indicated by PUNCTUATION or TRANSITION DEVICES

 (1) Includes dissolves, fades, wipes (not cuts)

 (2) Dissolve indicates a brief time lapse, fade indicates a longer one; wipe varies, usually in the middle

III. *THE LOCKET* and (MINOR) DEVIATIONS FROM THE CHC

A. REASONS FOR DEVIATIONS

1. It is part of a genre that was popular in the 1940s known as the "psychological drama"

 a. These films were influenced by "pop psychology," a sort of popular Freudianism that sought to explain everything in terms of some sort of childhood trauma of event (*Citizen Kane* parodies this)

 b. These films often featured psychiatrists, sometimes as villains (how is this played on in the film?)

 c. How will this motivate a particular style of narration?

2. It is also a *film noir*, leading to a number of differences

B. THE NARRATIVE

1. CHALLENGES TO THE CHC
 a. Some observers call film noir "an assault on psychological causality"
 (1) Instead of a strictly goal-oriented protagonist, the protagonist often suffers internal conflict
 (2) This character is often attractive but dangerous, evil, amoral, etc.
 b. It can also be seen in some ways to challenge the prominence of heterosexual romance"
 (1) The *femme noir* is sexually alluring but potentially treacherous
 (2) How does the film deal with romance (and how does it set us up to expect a traditional CHC romance)?
 c. It also challenges the CHC's "happy ending"
 (1) It often ends unhappily
 (2) Happy endings in films noir often seemed forced and not sufficiently motivated

C. THE STYLE
 1. In general, the film noir challenges the "invisibility" of the CHC style
 a. It does this through extensive and obvious low-key lighting (often changing in a shot without realistic motivation)
 b. Extensive voice-over narration
 c. Extensive use of flashbacks
 d. Much use of subjective POV
 e. In general, unusual cinematography (odd angles, unusual tracking shots, etc,)
 2. Although these devices are usually motivated by the narrative (states of mind, etc.), the extent of their use calls attention to them

a. In other words, attention is drawn to the form and style of the film itself, instead of to the narrative

b. This is *overt narration*; calling attention to the telling of the story-- the plot--instead of just to the story itself

CONTINUITY EDITING

The Silence of the Lambs (Jonathan Demme, 1991)

Directed by Jonathan Demme

Written by Thomas Harris and Ted Tally

Cinematography by Tak Fujimoto

Music by Howard Shore

Film Editing by Craig McKay

Produced by Ronald M. Bozman, Edward Saxon and Kenneth Utt

Raymond A. Mendez...moth wrangler

Leanore G. Drogin...assistant moth wrangler

Produced by Orion Pictures

Distributed by Orion Pictures Corporation

Cast

Jodie Foster…Clarice Starling

Lawrence A. Bonney...FBI Instructor

Kasi Lemmons...Ardelia Mapp

Lawrence T. Wrentz...Agent Burroughs

Scott Glenn...Jack Crawford

Anthony Heald...Dr. Frederick Chilton

Don Brockett...Friendly Psychopath

Frank Seals Jr....Brooding Psychopath

Stuart Rudin...Miggs

Raymond A. Mendez...moth wrangler

Leanore G. Drogin...assistant moth wrangler

Anthony Hopkins...Dr. Hannibal "The Cannibal" Lecter

Masha Skorobogatov...Young Clarice

Jeffrey Lane...Clarice's Father

Brooke Smith...Catherine Martin

Ted Levine...Jame Gumb

Diane Baker...Senator Ruth Martin

Roger Corman...FBI Director Hayden Burke

Chris Isaak...SWAT Commander

Lamont Arnold...Flower Delivery Man

STUDY QUESTIONS

1. How does the film let us know where the action is taking place? In what ways is this film edited primarily in the continuity editing style of the classical Hollywood cinema? Why is this done? Did you notice any major violations of continuity editing (violations of the 180 degree rule, etc.)?

2. When, and how, do editing and cinematography mark scenes and/or shots as subjective? From whose point of view (POV) do we see? What is the effect?

3.	What patterns of editing does Demme establish that, while not violations of continuity editing rules, are somewhat unusual? What is odd about the shot/reverse shot sequences in the scenes featuring Hannibal Lecter? Do we see something similar in other scenes?

4.	When, how, and why does Demme use our knowledge and expectations of continuity editing conventions to fool us? Does it work? Why or why not?

5.	What motifs do you notice in this film? Is it typical or atypical of horror/suspense movies?

CONTINUITY EDITING in *The Silence of the Lambs* (Jonathon Demme, 1991)

I. INTRODUCTION
 A. This film relies on the classical Hollywood cinema's CONTINUITY EDITING
 1. It does this both to make sure the story of the film is told as clearly as possible...
 2. And to make sure that the audience understands space clearly in the film (usually)
 B. EXCEPTIONS!!
 1. It also relies on our knowledge of continuity editing to mislead the audience at several points
 2. And it uses some conventions of editing in horror movies to confuse us

II. SPATIAL ARTICULATION
 A. How does the film let us know where the action is taking place?
 1. Through the use of titles to identify locations (what else does this accomplish?)
 a) Examples?
 b) Washington, DC; Belvedere, Ohio; Pittsburgh; Nashville, etc.
 2. Through the use of continuity editing, especially the use of ESTABLISHMENT/BREAKDOWN/RE-ESTABLISHMENT
 a) Examples?
 b) We see Clarice and Hannibal Lecter at his cell, then close-ups of their faces
 B. However, Demme often begins scenes with a close-up, followed by an establishing shot
 1. Examples?
 2. A close-up of Dr. Chilton on the cot, followed by an establishing shot of Lecter's cell (with Lecter in a "face cage")

C. OR...Demme will avoid the establishing shot to create surprise

 1. Examples?

 2. The scene at the training center of the staged car chase; we do not see that Clarice and the instructor are in the same location until they walk into the frame from the right

 3. Another scene at the training center, when Clarice and another trainee burst into the room and she does not see the other agent in the corner (who then puts a gun to her head)

III. VARIATIONS and VIOLATIONS OF CONTINUITY EDITING

A. The examples above are foreshadowing for the more confusing spaces presented later in the film

B. PLAYING WITH CROSS-CUTTING and THE KULESHOV EFFECT

 1. We see an establishing shot of a house, with the caption "Calumet, IL"

 2. This is followed by an interior shot of Jame Gumb, the serial killer, in his house

 3. Soon after, we see a shot of an FBI agent ringing a doorbell

 4. This is followed by a shot of a doorbell ringing in Jame Gumb's house

 5. Why do we assume that they are contiguous spaces?

 a) Because we are accustomed to the CHC's convention of cross cutting, in which the cross cut spaces are spatially related

 b) and because of the CHC's use of cause and effect narration; we assume a narrative, cause and effect relationship between the two objects and spaces

C. AMBIGUOUS SPACE

 1. When Clarice is trying to find Jame Gumb, we are never oriented in the space

 2. We are not given establishing shots in the basement (except in the room with the victim, the senator's daughter); we see only Clarice and a number of rooms and doors

 3. This recalls the scene mentioned above, when Clarice is "killed" by the FBI instructor

D. SUBJECTIVE SPACE (or OBJECTIVE FLASHBACK?)

 1. There are two subjective scenes, both involving Clarice's father

 2. In each of these scenes:

 a) We first see Clarice looking offscreen

 b) Followed by a shot of what she "sees"; we do not yet know it is subjective (camera movement into the space follows Clarice's path in the present)

 c) Followed by another shot of Clarice in the present, still looking offscreen in the same direction

 d) Followed by a shot we now know is either subjective (her memory) or an objective flashback, as she is in the shot as a little girl

E. SHOT/REVERSE SHOT

 1. What is odd about the shot/reverse shot sequences in the scenes featuring Hannibal Lecter?

 2. They are almost always shot from straight in front of the character, as if we are in the place of both Lecter and the person to whom he is talking (why?)

 3. We get a similar use of shot/reverse shot with Jame Gumb and Clarice when they are in the dark

IV. MISCELLANEOUS STUFF

A. MOTIFS

 1. BIRD MOTIF

 a) Clarice "Starling" (as in Marion "Crane"?)

 b) The owl statue in the storage unit

 c) Lecter as "bird of prey"

 (1) "Fly away, little bird"

 (2) He looks down at her (always), as if he were a bird of prey

 d) The murdered cop is strung up like a bird (or angel?)

 e) This pose is echoed later by Jame Gumb as he dances

2.　"SKINNING" MOTIF

 a)　"Buffalo Bill" skins his victims

 b)　Lecter skins the face off the cop to escape (echoed when Jame Gumb puts on the "wig")

3.　MOTH MOTIF

 a)　Why a moth? As Lecter says, it implies transformation and rebirth

 b)　The "death's head" moth is featured in *The Andalusian Dog*, a 1928 avant-garde film by Luis Bunuel and Salvador Dali (seen by film students worldwide, including Demme)

B.　In what ways is this film very typical of horror movies? Think of all the stereotypical "scary things":

1.　Cannibalism, beheadings and the skinning of people

2.　Being stuck in a well

3.　Lost in the dark in an old house with doors that slam shut behind you

4.　Decomposing corpses

5.　Large weird insects

6.　Someone who knows your deepest secrets

7.　Bizarre sexual perversions

C.　In what ways is it atypical?

1.　We have a heroine instead of a hero

2.　Who do we see more than either the heroine or the killer?

3.　We never even see the killer kill anyone

4.　Who is the most sympathetic character in the film (next to Clarice)?

 a)　Why do we like Hannibal Lecter?

 b)　Compare him to the FBI chief, Jack Crawford; both are "father figures," but who do we like more, and why?

CONTINUITY EDITING

His Girl Friday (Howard Hawks, 1940)

Directed by Howard Hawks

Written by Ben Hecht, Charles MacArthur and Charles Lederer

Produced by Howard Hawks

Original music by Sidney Cutner

Cinematography by Joseph Walker

Film Editing by Gene Havlick

Art Direction by Lionel Banks

Costume Design by Robert Kalloch

Produced and Distributed by Columbia Pictures

Cast

Cary Grant…Walter Burns

Rosalind Russell…Hildy Johnson

Ralph Bellamy…Bruce Baldwin

Clarence Kolb…Mayor

John Qualen…Earl Williams

Helen Mack…Molly Malloy

Billy Gilbert…Joe Pettibone

Pat West…Warden Cooley

Edwin Maxwell…Dr. Egelhoffer

STUDY QUESTIONS

1. Is the range of the narration of *His Girl Friday* UNRESTRICTED or RESTRICTED? Do we see, hear, and know more than any or all of the characters? Or do we see, hear, and know only what 1 character in the film experiences?

2. What about the depth of narration? Is it OBJECTIVE, PERCEPTUALLY SUBJECTIVE, or MENTALLY SUBJECTIVE? Examples?

3. Are individual characters causal agents? Do the characters have goals based on some sort of personal desire? What are they? Does opposition to the goals lead to conflicts? Do the characters change because of the conflicts? Is there a strong degree of closure?

4. In terms of editing, are graphics kept similar from shot to shot? Exceptions? Examples?

5. Are the lengths of the takes dependant on camera distance? Are long shots usually on screen longer than closer shots? Exceptions? Examples?

6. Can you give examples of instances of the 180° system? Shot/reverse shot? The eyeline match? Establishment/breakdown/reestablishment? Match on action? The cheat cut?

7. If we conclude that *His Girl Friday* conforms highly to the continuity editing system, how does this style of editing contribute to the film itself?

CONTINUITY EDITING in *His Girl Friday* (Howard Hawks, 1940)

I. INTRODUCTION

 A. *His Girl Friday* is a good example of Hollywood films in the sound era

 1. It relies on the continuity system of editing to a high degree

 2. It is fast, and relies heavily on dialogue for its humor

 3. The narrative is also typical of the CHC:

 a) Unrestricted and objective

 b) Two lines of action (work related and romance related)

 c) Conflict

 d) Changes in the status of the characters

 e) A high degree of closure

 f) It relies on stars

 B. We will break down the film into scenes & segments to see how it works

II. SEGMENTATION

 A. Scene Breakdown:

 1. In the *Morning Post* offices

 a) Who is introduced in this scene?

 b) What are the two lines of action that are presented? What are Walter's goals?

 c) What do we learn of the past?

 d) What kind of character is Walter Burns? How do we know?

 2. The restaurant

 a) What is established in this scene?

 b) What are the obstacles to Walter's goals?

 3. The Criminal Courts pressroom

 a) What do we learn about Hildy in this scene?

 b) What do we learn about the newspaper business?

 c) What do we learn about the case of Earl Williams?

 d) We are introduced to Molly Malloy

4. Walter Burns's office (Walter and Bruce)

5. Earl Williams's cell

 a) What do we learn about Earl Williams?

 b) What do we learn about Hildy?

6. The press room

 a) What makes Hildy decide to tear up the story?

 b) What are our expectations at this point?

7. A precinct jail (What is Bruce picked up for?)

8. The pressroom (Bruce's mother)

9. The sheriff's office (Earl Williams escapes)

10. The pressroom

 a) The longest scene in the movie (33 min)

 b) Each major character appears in this scene

 c) How are the two lines of action resolved in this scene?

 d) What is the closure that is achieved?

 e) Is it typical of the CHC narrative? Does it arrive at this closure in a typical way?

B. What are the various deadlines that are established in the film?

 1. In which scenes are they established?

 2. How do they contribute to the narrative progression?

C. Narrative time is usually omitted between scenes; in this film, however, it is often omitted within scenes

 1. Where does this happen?

 2. Why do we not notice? What does the film do to prevent us from noticing these temporal ellipses?

 3. How are the scenes connected through editing?

 4. Dissolves (except for the transition from 12 to 13)

 a) What do these dissolves indicate?

 b) An example?

 5. What does the cut from 12 to 13 indicate? Why?

D. How are the scenes connected through the narrative?

 1. How do cause and effect lead from one scene to the next?

 2. Some examples of how the end of one scene leads to the next?

 E. What device is used to connect spaces and create narrative relationships among these spaces?

 1. The telephone!

 2. Examples?

III. In what ways is this a rather theatrical film?

 A. Number of locations?

 B. Camera position in each scene?

 C. Most films will mark off scenes and segments with changes of locale

 1. This film is somewhat different

 2. How are scenes and segments divided? Tends to be through character entrances and exits (much like a play)

ALTERNATIVES TO CONTINUITY EDITING

The Battleship Potemkin

(Bronenosets Potyomkin; Sergei Eisenstein, 1925)

Directed by Sergei M. Eisenstein

Written by Sergei M. Eisenstein and Nina Agadzhanova Shutko

Cinematography by Eduard Tisse

Film Editing by Sergei M. Eisenstein

Art Direction by Vasili Rakhals

Produced and Directed by Goskino

Cast

Bobrov...Sailor

Beatrice Vitoldi...Woman with Baby Carriage

N. Poltavseva…Woman with Pince-nez

Julia Eisenstein…Odessa Citizen

Grigori Aleksandrov...Chief Officer Giliarovsky

Aleksandr Antonov…Vakulinchuk

Vladimir Barsky…The Captain

Sergei M. Eisenstein…Ship Chaplain

Mikhail Gomorov…Sailor

Aleksandr Levshin…Petty Officer

STUDY QUESTIONS

1. In what ways is Sergei Eisenstein's *Battleship Potemkin* a clear alternative to the CHC? In what ways is the narrative itself different? Who is the hero?

2. What is the most important stylistic difference between this film and the classical Hollywood film? In what ways does it violate some of the principles of continuity editing? Is the editing of the film completely different from continuity editing?

3. How has Eisenstein built his films on the concept of conflict, not continuity? Between shots and within shots? Screen direction, graphics, rhythm, etc.?

4. In general, how would you go about making this movie into a classical Hollywood movie of the 1930s or 1940s?

ALTERNATIVES TO CONTINUITY EDITING in *The Battleship Potemkin* (Sergei Eisenstein, 1925)

I. EISENSTEIN'S ALTERNATIVE TO CONTINUITY EDITING

 A. Eisenstein did rely on the continuity system of editing to a great extent

 1. In many alternative editing systems, the CHC's continuity editing system is used as a "base," against which the alternative has more meaning and impact

 2. Eisenstein knew that the audience was familiar with continuity editing, and that he might "lose" his audience without a base of continuity editing

 3. EXAMPLE: an eyeline match is "correctly" used to connect the shot of the captain of the ship looking at the men on a lower deck in the next shot

 B. However, he often violates important principles of the system

 1. EXAMPLE: The two shots of the priest with the crucifix

 a) In the first shot, the cross is in the priest's left hand

 b) In the following closer shot it is in his right hand

 2. EXAMPLE: Marines aiming their rifles at the sailors

 a) Screen direction changes from left to right

 b) Makes the point that they are actually fighting themselves by attacking the sailors (Vakulinchuk appeals to them as "brothers," and asks who they are shooting at)

II. EISENSTEIN'S GOAL

 A. Not to achieve Hollywood's "invisible editing," but to use editing to create certain effects in the viewer

 B. To accomplish this, Eisenstein built his films on the concept of CONFLICT, not continuity

 1. Between shots and within shots

 2. Screen direction, graphics, rhythm, etc.

3. This conflict is designed to agitate the viewer

C. Eisenstein based his filmmaking and his particular style of montage on a theory of how the mind works called MATERIALISM

 1. The idea that all feelings and thoughts are produced by the material world and concrete experience

 a) Life itself determines consciousness, attitudes, etc.

 b) Film is a concrete experience, can alter our minds and the way we think and feel

 2. Eisenstein believed that art in general works in a three stage process:

 a) Perception: the audience sees and/or hears an attraction

 b) Emotion: the audience feels an emotion based on the perception

 c) Cognition: the audience understands something, based on the perception and emotion

 3. Thus he attempted to shape the attitudes of his audiences by using montage techniques that would shock the viewer or ATTRACTIONS

 a) The PHYSICAL level was the most basic and created the greatest shock on the level of sheer sensation

 (1) These shocks include the close-up shots of the boy being stepped on, the shot of the woman shot in the eye, etc.

 (2) As well as the overlapping editing of the sailor smashing the plate; in this series of shots, four different takes were combined as eleven shots of four - twelve frames each, resulting in shots of 1/6 - 1/2 second in length

 b) The EMOTIONAL level relied on the juxtaposition of shots to achieve a desired emotional response in the viewer

 (1) As when the rhythmically edited shots of the sailors at work were followed by a shot of the soup (with the maggots) being stirred with the same rhythm

 (2) This was designed to create a feeling of sympathy for the sailors and disgust for the officers

 c) On the INTELLECTUAL level, shots were designed to be combined in the viewer's mind to create cognition, or new thoughts and ideas not inherent in the shots themselves

 (1) EXAMPLE: the priest + the soldier with the sword = the alliance of church and state

 (2) EXAMPLE: the three shots of the lion statues were combined to create in the viewer the idea of something else awakening (the people of Russia)

 (3) Eisenstein referred to this as INTELLECTUAL MONTAGE

III. THE DIALECTIC STRUCTURE OF *The Battleship Potemkin*

 A. Eisenstein used a traditional five act form of tragedy (see handout)

 1. The five Acts

 a) "Men and Maggots"

 b) "The Drama on the Quarterdeck"

 c) "An Appeal From the Dead"

 d) "The Odessa Steps"

 e) "Meeting the Squadron"

 2. Each act is cemented to the others by repetitions

 a) "Brothers" in Act 2 and Act 5

 b) Women kneeling down in Act 3, guns rising up in Act 5

 3. But they are developed thematically: one group to an entire battleship, one battleship to the entire navy, etc.

 B. Each act is divided into two almost equal parts

 1. Each division is divided and emphasized by a pause or break; for example, in Act 4: "SUDDENLY"

 2. These parts are not just different, but are opposites

3. Therefore, the film uses montage on a higher, more structural level- not just at the level of shots

4. This contributes to the film's "explosive action," like an internal combustion engine (NB. the appeal to mechanics, science)

IV. *Battleship Potemkin*'s "ODESSA STEPS" SEQUENCE

A. The sequence operates on a PHYSICAL level

1. The close shots of violence are meant to shock the audience

2. So are the rapid editing of the scene and the oppositional composition of the individual shots themselves

B. This sequence operates on an EMOTIONAL level through Eisenstein's personalization of the event

1. Although the masses are the real protagonists of the film, he earlier introduces the characters who will be killed in the attack on the steps

2. Eisenstein also juxtaposes long shots of the masses with close shots of the effects of the attack on individuals

C. The sequence also operates on an INTELLECTUAL level

1. From the conflict on the level of shots, we understand a conflict between the individual characters

2. From the conflict between the individual characters, we understand a conflict between the groups of characters (soldiers and citizens of Odessa)

3. From the conflict between these groups we understand the conflict between the aristocracy and the Russian people

4. Finally, we should understand an international conflict between the ruling class and the proletariat

D. HOW DOES THE EDITING OF THIS SEQUENCE DIFFER FROM THAT OF THE CONTINUITY EDITING SYSTEM? (In general, based on conflict, not narrative continuity)

1. GRAPHICALLY

a) The "balance" (distribution) of graphic elements (lighting, tonalities, etc.) is not consistent from shot to shot

b) Lines formed by the mise-en-scène often clash from shot to shot, within shots

c) Screen direction of movement of shots often clashes from shot to shot, within shots

2. TEMPORALLY

a) Time is expanded; the scene takes much longer than it would in "real life"

b) Reflects the psychological states of the participants, increases the effect on the audience

3. RHYTHMICALLY

a) Rhythm of the movement of figure behavior in the shots is designed to clash from shot to shot, not to flow as in the CHC

b) Rhythm of the editing is designed to clash with the movement within the shots, and also from shot to shot

4. SPATIALLY

a) Eisenstein cuts freely from one part of the space to another

b) Frequently violates the 180° rule; more often does not establish one to begin with

ALTERNATIVES TO CONTINUITY EDITING

Head (Rafelson, 1968)

Directed by Bob Rafelson

Written by Jack Nicholson, Micky Dolenz, Davy Jones, Michael Nesmith, Bob Rafelson and Peter Tork

Produced by Jack Nicholson, Bob Rafelson and Bert Schneider

Music by Carole King, Michael Nesmith, Ken Thorne, Peter Tork and Harry Nilsson

Cinematography by Michel Hugo

Editing by Michael Pozen

Produced by Raybert Productions

Distributed by Columbia Pictures

Cast

Peter Tork…Peter

Davy Jones…Davy

Micky Dolenz…Micky

Michael Nesmith…Mike

Annette Funicello…Minnie

STUDY QUESTIONS

1. What do you think is the genre of this film? In what ways do you think the genre has affected the construction of the film, and especially the editing?

2. What is the logic of the narrative development of the film? In what ways is the narrative typical or atypical of the classical Hollywood narrative?

3. How does the film attempt to criticize the success of the Monkees? How does it use film form and style to do this? What else does the film criticize?

ALTERNATIVES TO CONTINUITY EDITING in *Head* (Rafelson, 1968)

I. INTRODUCTION

 A. *Head* is part of a sub-genre semi-popular in the late 1960s known as "trip" movies

 B. It was also an effort to deconstruct the myth of the Monkees

 1. The film's director, Bob Rafelson, was the driving force behind the Monkees

 a) He "invented" them

 b) In other words, he got them together for the TV show, and manufactured their image

 c) *Head* was an attempt to destroy the image that Rafelson had built for the band

 d) It was designed to expose the phoniness of the Monkees; but also to cash in on it at the same time

 e) One critic said that the film was an attempt by the Monkees to change their image from pseudo-early Beatles to pseudo-later Beatles

 2. It goes further, to deconstruct the myths of Hollywood, capitalist and imperialist America, and even the hippie movement itself

II. *Head*'s EDITING and its LOGIC (?)

 A. What is the overall structure of the film's editing; what governs it?

 1. It is constructed to duplicate the sort of associations made during an LSD trip

 2. The director claims that the film was "an attempt to find a sort of *acidic* representation, of an acid trip..."

 3. It may be useful for you to think of these associations more as those made during a dream (maybe a nightmare?)

4. The associations are not always clear; but with some thought, it is sometimes possible to make some connections

B. EXAMPLES

1. From the dungeon wall to the bathroom wall

 a) A graphic match (same characters in the same positions)

 b) A thematic connection; the police, etc.

2. Davy Jones's dance number

 a) Based strictly on graphic matches

 b) Black and white alternations; gives a strobe-like effect

3. It often cuts from a character in one location to the same character in another location

 a) Often it is a graphic match; EXAMPLE: The waitress hits Davy, and we cut to him in the same position in the frame being hit by Sonny Liston

 b) Other times there is no attempt to create a graphic match

 (1) EXAMPLE: Cut from the villain saying "Atta boy, Mike" to the Monkees laughing at him, to the villain in another location

 (2) There is a degree of narrative continuity (the conversation continues; he says, "Never make fun of a cripple"), and sound continuity from shot to shot

 (3) But there is spatial discontinuity

4. We always return to the black box

 a) It is like a bad trip; always returning to the place you want to escape

 b) According to Rafelson, "...we were saying that life is a search, you go and search from one [thing] to the other and every time you come out of the box you go back in the box because there *are* no answers."

III. *Head*'s CRITICISM OF THE MONKEES

A. The film makes numerous references to the Monkees and the fact of their "phoniness"

 1. In what way were they "phony" anyway?

 a) Are other bands any less phony?

 b) Do they not all manufacture an image?

 2. What is the reason for this criticism?

 a) What is the result of criticizing yourself?

 b) Is it not an attempt to prevent other people from doing it?

B. EXAMPLES

 1. Reference early in the film to the fact that they were "manufactured"

 2. Frank Zappa's criticism of Davy Jones

 a) He calls his song and dance number "white"

 b) Tells him to work on his music

 3. The guru discusses our inability to distinguish the real from the unreal

 4. Michael Nesmith, looking for the other Monkees, says "If people think we're plastic now, wait until I tell them how we really do it."

 5. They make references to their personas

 a) Peter is "always the dummy"

 b) How do they play on Davy's image?

 6. How are their fans depicted?

 a) Savage, hysterical girls who pull them apart (and they are just mannequins)

 b) Playing a concert is compared to war

IV. *Head*'s CRITICISM OF HOLLYWOOD

A. The film attempts to include Hollywood in its general trashing of American culture

B. EXAMPLES

 1. The girl kissing Davy Jones

 a) Accompanied by "Hollywood" romantic music

　　　　　b)　　　Remember, Davy was the "cute" one

　　2.　　The Western; revealed as a set

　　3.　　James Bond movies (especially with Davy as the macho hero)

　　4.　　Boxing movies (who is the girl?)

　　5.　　Victor Mature, the aging star

　　6.　　*2001* (came out earlier the same year; a "sacred" movie); the black box--
what does it mean?

　C.　　What is hypocritical about this criticism of Hollywood?

V.　　*Head*'s CRITICISM OF CAPITALIST and IMPERIALIST AMERICA

　A.　　TV commercials (bras, dandruff remover, etc.)

　B.　　Coca-Cola

　C.　　The mysterious factory

　　1.　　Manned by lifeless secretaries and depraved employees

　　2.　　Unsafe working conditions

　　3.　　It creates unsafe and unnecessary products

　D.　　The Vietnam War

　　1.　　Tied in with American culture in general

　　　　　a)　　　Football and cheerleading

　　　　　b)　　　The rock concert; screaming and crying girls intercut with
screaming and crying Vietnamese women

　　　　　c)　　　Cartoons; the Bugs Bunny cartoon intercut with the footage from
Vietnam

　　2.　　What is the result of editing in this footage?

VI.　　*HEAD*'S CRITICISM OF THE HIPPIE MOVEMENT

　A.　　The guru

　B.　　Does anyone care about the girl jumping off the building?

　C.　　The birthday party; when Mike is critical of the surprise party and the way all the
people are behaving, they respond by saying "atta boy, Mike"

　D.　　The film is a parody of the "trip film" itself

E. WHAT CLICHÉS DOES THE FILM USE (and SOMETIMES MAYBE CREATE)?

1. Slowly and thoughtfully walking through nature

2. Slow motion, weird colors

3. Running (remember the Beatles?)

4. The movie ends where it began (LSD logic)

ALTERNATIVES TO CONTINUITY EDITING

Stray Dog (Nora inu; Akira Kurosawa, 1949)

Directed by Akira Kurosawa

Written by Ryuzo Kikushima and Akira Kurosawa

Original music by Fumio Hayasaka

Cinematography by Asakazu Nakai

Film Editing by Yoshi Sugihara

Produced by Sojiro Motok

Produced by Toho and Shintoho

Distributed by Toho Company Ltd.

Cast

Keiko Awaji…Harumi

Minoru Chiaki…Girlie-show art director

Ishirô Honda…Fleeing Villain

Isao Kimura…Yuro

Toshirô Mifune…Murakami

Noriko Sengoku…Girl

Takashi Shimura…Sato

Reisaburo Yamamoto…Hondo

STUDY QUESTIONS

1. Kurosawa is generally considered the most "Western" of Japanese film directors, especially by the Japanese themselves. In what ways can we see the influence of Hollywood films (and American popular culture in general) in *Stray Dog*?

2. In what ways is *Stray Dog* different from similar Hollywood films? In what ways is the narrative similar to and/or different from similar Hollywood films (esp. crime movies, either recent or from the 1940s)? In terms of the characters and characterizations? In terms of cause and effect; do we always know what is happening and why?

3. In what ways is the mise-en-scène similar to and/or different from similar Hollywood films? Are settings and costumes used in ways like that of Hollywood movies? Lighting? Is figure behavior much different from that of Hollywood movies? In what ways is the cinematography similar to and/or different from similar Hollywood films?

4. In what ways is the editing similar to and/or different from similar Hollywood films? Are the shots graphically continuous or discontinuous? What about the rhythm of the editing? Is there anything different about the pace of the film? Does it use the Hollywood system of establishment – breakdown – reestablishment? Are the shots spatially continuous? Does it use crosscutting? Are you ever confused about where you are or where the characters are, especially in relation to one another? Does it follow the 180° system?

5. Are there ambiguities created? How?

6. Is the film similar in some ways to other Asian films? Does the pace, especially, seem similar to other Asian films you have seen? Which ones? Is there something about Asian culture that may help to explain the differences between at least some Asian films and those of Hollywood?

ALTERNATIVES TO CONTINUITY EDITING in *Stray Dog* (Akira Kurosawa, 1949)

I. Introduction

 A. Kurosawa's *Stray Dog* is not really radically different from classical Hollywood cinema

 1. Most of it is shot in continuity editing, if somewhat differently from Hollywood films of the time

 2. Kurosawa is generally considered the most "Western" of Japanese film directors (especially by the Japanese themselves)

 3. However, *Stray Dog* is also distinctly Japanese (and Asian)

 B. It is this juxtaposition of Hollywood and Japanese stylistic features that make the film interesting

 1. Kurosawa was heavily influenced by Hollywood films

 2. Many of his films are very obviously influenced by Hollywood genre films, especially

 a. Westerns influenced his samurai films (which in turn influenced Westerns!)

 b. He made a number of films based on or inspired by American crime and detective novels (including *Stray Dog*)

 3. However, the ways in which he made his films are not quite the same as the ways in which Hollywood made similar films

II. In what ways is *Stray Dog* different from similar Hollywood films?

 A. In what ways is the narrative similar to and/or different from similar Hollywood films (especially crime movies, either recent or from the 1940s)?

 1. In terms of the characters and characterizations

 a. What about the protagonist; is he typical of Hollywood detectives?

 b. Does he have the same kinds of goals that we find in Hollywood protagonists?

2. In terms of cause and effect; do we always know what is happening and why?

 a. In Hollywood films, the causal relationships are always clear

 b. Is that true of *Stray Dog*? Do we always know what is going on, and why? Is the narrative progression similar to that of a Hollywood detective film?

B. In what ways is the mise-en-scène similar to and/or different from similar Hollywood films?

 1. Are settings and/or costumes used in ways like that of Hollywood movies?

 2. Is lighting used in ways that are similar to the ways in which Hollywood lighting functions?

 3. What about figure behavior

 a. Is it much different from that of Hollywood movies?

 b. Does the acting style seem typical of Hollywood films of the same genre?

C. In what ways is the cinematography similar to and/or different from similar Hollywood films?

 1. Is the look of the film (film stock, etc.) different from that of Hollywood films?

 2. What about camera distance (shot scale)? Anything unusual?

 3. Japanese films often feature unusual camera angles; in what ways do we see this in *Stray Dog*?

D. In what ways is the editing similar to and/or different from similar Hollywood films?

 1. Are the shots graphically continuous or discontinuous? Anything obvious?

 2. What about the rhythm of the editing?

 a. Is there anything different about the pace of the film?

 b. Does it use the Hollywood system of establishment – breakdown – reestablishment?

3.	Are the shots spatially continuous?

 a.	Does it use crosscutting?

 b.	Are you ever confused about where you are or where the characters are, especially in relation to one another?

 c.	Are there ambiguities created? How?

 d.	Does it follow the 180° system?

 (1)	Examples (especially shot/reverse shot)?

 (2)	Exceptions (violations)? Why?

4.	Are the shots temporally continuous?

 a.	If so, what creates the continuity?

 b.	If not, what creates the discontinuity?

 c.	Japanese films often create patterns of editing that function independently of the narrative; is that true of *Stray Dog*?

III.	How Can We Account For Differences?

A.	How can we account for the differences between this film and similar Hollywood films?

B.	Is the film similar in some ways to other Kurosawa films? Can we account for some of the differences by looking at the auteur?

C.	Is the film similar in some ways to other Asian films?

1.	Does the pace, especially, seem similar to other Asian films you have seen?

 a.	Which Asian films have a similar pace?

 b.	If you are familiar with Chinese Fifth Generation films, do you seem any similarity with these films?

2.	Is there something about Asian culture that may help to explain the differences between at least some Asian films and those of Hollywood?

ALTERNATIVES TO CONTINUITY EDITING

Good Morning (Ohayo; Yasujiro Ozu, 1959)

Directed by Yasujiro Ozu

Written by Kôgo Noda and Yasujiro Ozu

Original music by Toshirô Mayuzumi

Cinematography by Yuharu Atsuta

Film Editing by Yoshiyasu Hamamura

Distributed by Shochiku Films, Ltd.

Cast

Masuo Fujiki…Zen

Yoshiki Kuga…Setsuko Arita

Kuniko Miyake…Tamiko

Eiko Miyoshi…Grandma Haraguchi

Teruko Nagaoka…Mrs. Tomizawa

Chishu Ryu…Keitaro Hayashi

Keiji Sada…Heichiro Fukui

Koji Shigaragi…Minoru

Masahiko Shimazu…Isamu

Hajime Shirata…Kozo

Haruko Sugimura…Kikue Haraguchi

Toyoko Takahashi…Shige Okubo

Haruo Tanaka…Haraguchi

Eijirô Tono…Tomizawa

STUDY QUESTIONS

1. Ozu is generally considered the most "Japanese" of Japanese film directors, especially by the Japanese themselves. However, he was familiar with, and admired, Hollywood films. In what ways can we see the influence of Hollywood films (and American popular culture in general) in *Good Morning*?

2. In what ways is *Good Morning* different from similar Hollywood films? In what ways is the narrative similar to and/or different from similar Hollywood films (especially comedies, past or present)? In terms of the characters and characterizations? In terms of cause and effect; do we always know what is happening and why?

3. In what ways is the mise-en-scène similar to and/or different from similar Hollywood films? Are settings and costumes used in ways like that of Hollywood movies? Lighting? Is figure behavior much different from that of Hollywood movies? In what ways is the cinematography similar to and/or different from similar Hollywood films?

4. In what ways is the editing similar to and/or different from similar Hollywood films? Are the shots graphically continuous or discontinuous? What about the rhythm of the editing? Is there anything different about the pace of the film? Does it use the Hollywood system of establishment – breakdown – reestablishment? Are the shots spatially continuous? Does it use crosscutting? Are you ever confused about where you are or where the characters are, especially in relation to one another? Does it follow the 180° system?

5. Are ambiguities created? How?

6. Is the film similar in some ways to other Asian films? Does the pace, especially, seem similar to other Asian films you have seen? Which ones? Is there something about Asian culture that may help to explain the differences between at least some Asian films and those of Hollywood?

ALTERNATIVES IN CONTINUITY EDITING in *Good Morning* (Ohayo; Yasujiro Ozu, 1959)

I. INTRODUCTION

 A. Japanese prefer to be aware of the artistic process (and their part in it)

 1. Often reject identification with the characters

 2. Are not swallowed up by the narrative

 3. Enjoy abstract qualities of film, patterns of editing, etc.

 B. The Japanese do not reject continuity editing entirely

 1. Add touches that are considered "wrong" by Western filmmakers

 2. Often for decorative purposes, to create formal and stylistic patterns

II. OZU

 A. 360° SPACE

 1. Conceives of space as a circle

 2. Camera may be placed on any spot on circumference

 3. OR the center of the circle

 B. GRAPHIC EDITING

 1. Cuts from shot to shot matching graphically according to arrangement of characters or objects

 2. Uses matching colors as a basis for shot changes

III. *Ohayo*

 A. 360° SPACE

 1. IN CONVERSATIONS: Camera placed on any spot on circumference or the center of the circle

 2. AMBIGUOUS SPACE

 a) Ozu tends to cut from space to space in and around the neighbourhood

 b) Although we often can not situate ourselves in relation to the surrounding shots, Ozu usually has an electrical tower in the background (but it does not help; it is usually more confusing)

 c) Sometimes, he shoots one house through the doorway of another, adding to the confusion (and he makes a joke about it when Mr. Tomizawa comes home to the wrong house)

B. GRAPHIC EDITING

 1. Ozu cuts from a hanging light and clock in one shot to another hanging light and clock in another locale

 2. He cuts from a shot of a laundry line with a red shirt in the upper left corner of the shot to one with a red lamp shade in the same space in the frame, but another location, a living room

 3. FROM CHARACTER TO CHARACTER

 a) Often, Ozu will cut from one character to another with the two occupying similar spaces on the screen; OR…

 b) Especially at the beginning, Ozu uses characters to lead to other characters

 (1) Characters talk to one another, then leave, taking the camera and narration with them

 (2) They are not especially important in themselves, but move us to other spaces and characters

C. THE STRUCTURE OF *Ohayo*

 1. The film is divided into six distinct days, Wednesday to Monday

 2. Each new day is introduced with similar shots

 a) The first day

 (1) Begins with a shot of the neighbourhood with the electrical tower in the foreground

 (2) A shot of the houses and fence

 (3) Between the rows of houses, hill in the background

 (4) Closer to the hill

 (5) The boys on the hill

 b) The second day

 (1) Repetition of shot 3 (but the shadows tell us it is afternoon, not morning as in shot 3)

 (2) Repetition of shot 4

 (3) Repetition of shot 5

 c) The third day

 (1) Repetition of shot 4

 (2) Repetition of shot 5

 d) The fourth day: Repetition of shot 5

 e) The fifth day: Repetition of shot 2

 f) The sixth day

 (1) Repetition of shot 5

 (2) Repetition of shot 3

 g) At the end of the sixth day

 (1) Repetition of shot 4

 (2) The underwear on the laundry line

 (3) Repetition of shot 1, but from the opposite angle (electrical tower in the background)

IV. NARRATIVE SUBTLETY OF *Ohayo*

 A. THE SALESMEN and THEIR SCAM

 1. The salesmen work as a team

 2. One makes a nuisance of himself, other sells the "salesman alarm"

 B. THE "FALSE" RESOLUTION

 1. Admission of the grandmother that she forgot the money seems to end the subplot about the missing Women's Association dues

2. However, this becomes interrelated with the silence subplot when Mrs. Haraguchi thinks that Mrs. Hayashi told her kids, Minoru and Isamu, not to talk to her

C. FUKUI and SETSUKO

1. Fukui tells his mother how important "small talk" is as a "social lubricant;" she tells him he just can't tell Setsuko he loves her

2. When Fukui and Setsuko meet at the train station, this is proven correct; the boys were right, also

D. THE LANGUAGE and FARTING COMPARISON

1. Language and farting are compared in the film; both have limitations and social uses

2. Mr. Okubo is good at farting (he works at the gas company); his wife thinks he is calling her

3. Minoru farts when Fukui asks him to translate and pokes him in the head

4. Farting forms part of both male bonding (among both boys and men) and the language the boys use; it is not sufficient, just as spoken language is insufficient at times

FILM SOUND

The Conversation (Francis Coppola, 1974)

Directed by Francis Coppola

Written by Francis Coppola

Produced by Francis Coppola

Cinematography by Bill Butler

Film Editing by Richard Chew

Production Company: American Zoetrope

Cast

Gene Hackman…Harry Caul

John Cazale…Stan

Allen Garfield…William P. 'Bernie' Moran

Frederic Forrest…Mark

Cindy Williams…Ann

Michael Higgins…Paul

Elizabeth MacRae…Meredith

Terri Garr…Amy Fredericks

Harrison Ford…Martin Stett

Mark Wheeler…Receptionist

Robert Shields…The Mime

Phoebe Alexander…Lurleen

STUDY QUESTIONS

1. What is this film about? What is the theme of the film?

2. Consider range and depth of narration. Is the film's narration restricted or unrestricted in range? If restricted, to whom is it restricted? What is the depth of the narration? What seems to mark the film's narration as objective, perceptually subjective or mentally subjective?

3. How does sound work with the other elements of style in the film? How does sound affect the narrative meaning of the film?

4. Which sounds in the film are diegetic and which are non-diegetic? Which are objective and which are mentally subjective?

5. In what ways is this film similar to and/or different from the other films we have seen?

FILM SOUND in *The Conversation* (Francis Coppola, 1974)

I. INTRODUCTION: We can interpret this film on a number of levels

 A. On one level, it is a thriller

 1. Harry is tricked into getting "the director" to the hotel so he can be murdered

 2. Like any good thriller, it gives us a surprise ending

 B. On a more abstract level, it is about Harry's guilt

 1. Harry has caused the deaths of three people in the past, and is afraid that he will cause the deaths of two more due to his tapes

 2. He retreats into paranoid secrecy and "professionalism"

 C. On an even more abstract level

 1. The film is about this idea of "professionalism" and personal responsibility

 a) Is it possible to "just do one's job," without taking responsibility for the outcome?

 b) Does the American pursuit of success result in this?

 2. It is also about the invasion of privacy

 a) Is it right to invade the privacy of others, just because it is "a job"?

 b) What about the mime? Why do we hate the mime?

 3. Is it not in some ways about what we do when we watch movies?

 a) We invade the privacy of others without becoming personally involved; the characters do not know that we are there

 b) We can enjoy sex and violence, etc., without taking any responsibility for its effects

 c) Harry is our stand-in

 (1) Like him, our interpretation of the film (both its meaning and just what is actually happening) is based on expectations and our experience of the elements of film form

(2) We make sense out of the elements of film style; we reconstruct a story from the plot

D. Finally, on an even more abstract level, the film is about former President Richard Nixon (more on this later; think about it)

II. HOW DOES SOUND WORK WITH THE OTHER ELEMENTS OF STYLE IN THE FILM?

A. How does sound affect the narrative meaning of the film?

1. The film creates expectations that alter our interpretation of the meaning of the message on the tape

a) Our initial impression of the tape is that it is an "innocent" conversation between two illicit lovers

b) This impression is altered by the director's assistant's warning that "These tapes are dangerous. Someone may get hurt." We think there must be something more that we missed

c) Harry electronically alters the tape to reveal something new: "He'd *kill* us if he got the chance."

d) Harry listens to this new version and makes an interpretation: He says to Meredith, "Listen; she's frightened." This creates an interpretation on our part, that the director and his assistant are trying to kill the couple

e) After the murder, Harry "hears" it differently (subjectively)

(1) "*He'd* kill *us* if he got the chance."

(2) The tape is not even playing at the time; it is in his mind

2. But what exactly do we hear? Is it not subjective?

a) The film is very restricted (we never leave Harry), and is mentally subjective

b) We see and hear what Harry hears, and the way he sees and hears it

(1) Many point of view shots

(2) When Harry plays the tapes, we often see what he is remembering (the couple at the square)

258

 (3) The dream sequence

 (4) Sound, especially, is subjective

 (a) We hear the tapes as Harry hears them

 (b) The elevator scene; it becomes louder as Harry becomes more nervous

B. IN WHAT OTHER WAYS DOES SOUND INTERACT WITH THE OTHER ELEMENTS OF STYLE?

 1. Harry and his horn: the combination of live sound, recorded sound, and the image

 a) Harry is a person who interacts with recordings better than with real people

 b) When he relaxes, he plays his trumpet with a record of a live performance; when the audience applauds, he almost takes a bow

 2. Harry and Meredith (the prostitute): again, the combination of sound and image

 a) They listen to the tape while they make love

 b) He is lying on the bed while the woman on the tape mentions the bum on the park bench, who once had a family and parents who loved him, etc.

 c) Meredith wipes away a tear from Harry's eye at the same time the woman did it on the tape (we remember the image; there is no sound)

C. HOW DOES THE FILM USE ALL THE ELEMENTS OF FILM STYLE TO MAKE CONNECTIONS BETWEEN CHARACTERS?

 1. How is Amy (Harry's girlfriend, Terri Garr) like the wife of the director?

 a) Both sing "The Red Red Robin"

 b) They are both victims of Harry's bugging

 c) They both know it!

 2. How is Harry like the mime?

 a) Eavesdrops on people, even during intimate moments

b) They both "bug" people, in their own ways

3. How is Harry like Bernie Moran?

 a) Both are buggers, proud of their expertise (think of the pun on "buggers")

 b) Both intrude on people's private moments (at the party, Bernie bugs Harry)

 c) Bernie is crude; is Harry really like that?

4. How is Harry like the priest?

 a) Both listen, but do not become involved; "professional integrity"

 b) The priest has his confessional booth, Harry has his cage at his workplace; he goes into it when people start asking him questions

 c) The priest has his robe, Harry has his raincoat

 d) Think of the religious subtext in the film

 (1) Christmas trees, cookies (from the director's assistant, made them himself)

 (2) "Gift wrapping;" Harry's victims, in both cases

 (3) Harry finally destroys both his statue of Mary and his stereo, the only two things he believed in

5. How is Harry like Meredith, the prostitute?

 a) They both work for money, becoming involved with people intimately without the intimacy

 b) Listening to the tapes, she says to him "It's only a trick." (think of the double meanings here)

 c) She says, "It's just a job. You're not supposed to feel anything; you just do it."

 d) He says (about the murders in NY), "I'm not responsible; I just turned in the tapes."

D. How is Harry like the director?

1. Both are fooled by the director's wife, her lover, and the director's assistant

2. Both end up "gift wrapped," Harry in his raincoat and the director in a clear plastic shower curtain

3. Both are victims; Harry is also a murderer, like the wife's lover, dressed in plastic in the murder scene (or is it in Harry's mind?)

III. THE NIXON SUBTEXT

A. The film was made in 1972-73, and released in 1974, after the Watergate break-in but before it became a scandal

B. Obviously, the film is about bugging, and the greater issue of invasion of privacy and responsibility for one's actions ("I take the responsibility, but not the blame.")

C. Bernie mentions that he bugged the losing Presidential candidate "twelve years ago;" that would make it 1960, when Nixon was the loser

D. Therefore, Bernie "bugged the bugger," just as he is doing to Harry; and just as Nixon's tapes led to his downfall

E. In Harry's room at the hotel, we hear a news story about Nixon on the TV

F. The film was ahead of its time; Harry, like Nixon, ends up a total paranoid, destroying everything around him

FILM SOUND

Blackmail (Alfred Hitchcock, 1929)

Directed by Alfred Hitchcock

Written by Charles Bennett, Alfred Hitchcock, Benn W. Levy and Michael Powell

Produced by John Maxwell

Cinematography by Jack E. Cox

Editing by Emile de Ruelle

Production Companies: British International Pictures and Gainsborough Pictures

Cast

Anny Ondra…Alice White

Joan Barry…Alice White (voice)

Sara Allgood…Mrs. White

Charles Paton…Mr. White

John Longden…Frank Webber

Donald Calthrop…Tracy

Cyril Ritchard…The Artist

Hannah Jones…The Landlady

Harvey Braban…Chief Inspector

Ex-Det. Sergt. Bishop…Detective Sergeant

Alfred Hitchcock…Man on Subway

STUDY QUESTIONS

1. What is this film about? What is the theme of the film?

2. Consider range and depth of narration in *Blackmail*. Is the film's narration restricted or unrestricted in range? If restricted, to whom is it restricted? What is the depth of the narration? What seems to mark the film's narration as objective, perceptually subjective or mentally subjective?

3. Is sound used realistically in this film? In what ways is sound used expressively, and not necessarily realistically? How do technical deficiencies seem to affect the film and our perception of it?

4. Which sounds in the film are diegetic and which are non-diegetic? Which are objective and which are mentally subjective?

5. In what ways is this film similar to and/or different from other Hitchcock films with which we are familiar?

FILM SOUND in *Blackmail* (Alfred Hitchcock, 1929)

I. INTRODUCTION

 A. Hitchcock's *Blackmail* was made when Hitchcock still lived and worked in England, and is the first sound film from the British film industry

 B. It started as a silent film

 1. The scenes that had not been shot already were shot with direct sound

 2. All of the shots with the Alice White character were re-shot to record the sound

 3. Music and sound effects were added to the rest of the film

 4. Actually, there are two versions that exist

 a) The sound version

 b) And a silent version (that a lot of critics prefer)

 C. PROBLEMS WITH SOUND IN THE FILM

 1. ANNY ONDRA

 a) She played Alice White

 b) She was Czechoslovakian, with a heavy accent

 c) As she pantomimed the words onscreen, the English actress Joan Barry spoke her lines offscreen for recording

 d) This resulted is a certain degree of ASYNCHRONICITY

 (1) Does this add or detract to the story?

 (2) It seems to add to the confusion created in other ways by sound

 2. LACK OF MOBILITY

 a) With the introduction of sound, cameras became much less mobile (temporarily)

 b) This made it difficult to get the camera "in the action," both spatially and psychologically; it constrained the ability to cut freely to POV shots

 c) One of the ways the sense of subjectivity was achieved without this camera freedom was the use of sound

II. WHAT IS THE FILM ABOUT?

 A. This is a film about guilt, and the confusion between good and evil, right and wrong

 1. Is Alice guilty?

 a) She did kill the artist

 b) Was it not in self-defense?

 c) Can we make an argument that she "deserved" it?

 d) More importantly, *she* thinks she is guilty

 2. Should she have confessed?

 a) Is she "better" than the blackmailer?

 b) What would be the point of her confession?

 B. THE POLICE and THE CRIMINALS

 1. How are the police presented?

 a) How do they treat the criminal; what is he to them? (a set of fingerprints)

 b) How does the detective feel about the criminal?

 (1) He shows little interest in the interrogation; it is routine

 (2) He washes his hands afterward; what does this recall?

 2. How is the first criminal presented?

 a) He seems more pitiful than evil

 b) We do not even know what he did

 3. How is the blackmailer presented?

 a) He also seems more pathetic than evil

 b) He is blamed for a crime he did not commit

 c) Essentially, he is framed because of his criminal past

 4. How is Alice presented?

 a) How do the other characters treat her?

 b) How does she feel about herself?

III. NARRATIVE FUNCTIONS OF SOUND IN *Blackmail*

 A. SUBJECTIVITY IN *Blackmail*

1. In what *non-sound* ways is the narration marked as perceptually subjective?

 a) POV shots; especially of the outstretched arms

 b) What does she notice? Signs such as the gin advertisement, "White for Purity"

 c) The laughing jester, pointing at Alice

2. What marks the narration as mentally subjective?

 a) How is her walk through the city, after the murder, presented?

 b) The cocktail shaker becomes a knife

B. Sound in the film tends to be used EXPRESSIVELY, not REALISTICALLY

1. It is not meant to represent an objective reality

2. It often is meant to reflect the subjective feelings of Alice White

3. At other times it manipulates the viewer in ways that are not realistic

C. The confusion and conflict of the sound reflects the confusion of right and wrong in the film

D. GENERAL EXAMPLES OF EXPRESSIVE SOUND

1. Sounds often offer just minimal cues, as in radio

 a) How are sound effects used to describe the police?

 (1) Their routine is accompanied by a few minimal representative sound cues or effects

 (2) Their discussions are unrecognizable mumblings

 b) How are sound effects used to denote crowds?

 (1) Just a few people offscreen mumbling

 (2) This gives the scenes a general, non-specific quality

 c) What sort of sounds do we hear during the chase scene?

 (1) Some typical "police" sounds: whistles, etc.

 (2) Sounds of footsteps, but oddly divorced from the actual mise-en-scène

 d) In all of these cases, both nondiegetic sound and sound effects seem to contribute to a stylized presentation of the police, the chase, and London in general

2. The overlapping of Alice's scream with that of the landlady when she discovers the body (a SOUND BRIDGE)

E. EXAMPLES OF SUBJECTIVE SOUND

1. PERCEPTUALLY SUBJECTIVE

 a) We often see Alice onscreen, watching her reactions to what she hears from offscreen

 b) When Frank and the blackmailer discuss what they are going to do; she is onscreen, they are offscreen

2. MENTALLY SUBJECTIVE SOUND

 a) The loud bird sounds in Alice's bedroom (birds?)

 b) The loud bell of the shop every time someone enters

 c) The word "knife" repeated in the otherwise distorted conversation of the neighbor

IV. CONCLUSION

A. Who is guilty? Is everybody?

B. Can we tie this in with the other Hitchcock films we have seen?

FILM SOUND

The Innocents (Jack Clayton, 1961)

Directed and Produced by Jack Clayton

Written by William Archibald and Truman Capote

Music by Georges Auric

Cinematography by Freddie Francis

Editing by James B. Clark

Art Direction by Wilfred Shingleton

Production Company: 20th Century Fox

Cast

Deborah Kerr…Miss Giddens

Peter Wyngarde…Peter Quint

Megs Jenkins…Mrs. Grose

Michael Redgrave…The Uncle

Martin Stephens…Miles

Pamela Franklin…Flora

Clytie Jessop…Miss Jessel

Isla Cameron…Anna

STUDY QUESTIONS

1. Consider range and depth of narration in *The Innocents*. Is it as an objective or perceptually subjective narrative about two ghosts who haunt a house, possess two children, and torment an innocent woman? Or is it a mentally subjective narrative about the unhealthy imagination of a sexually repressed woman who torments two innocent children?

2. Is the film's narration restricted or unrestricted in range? If restricted, to whom is it restricted? What do we see when the narration is unrestricted?

3. What seems to mark the film's narration as objective or perceptually subjective? How does the plot suggest that the children see the ghosts? How does expectation affect our reading of the images? Is there a physical manifestation of the presence of the ghosts?

4. How can we make a case that the narration of *The Innocents* is actually mentally subjective? What stylistic elements (especially sound) mark the narration as potentially mentally subjective? How do cinematography and mise-en-scène signal potentially mentally subjective sequences?

5. What narrative clues are given that Miss Giddens is imagining all this? What is her background? Does she have an active imagination? Does she seem attracted to the uncle?

6. Can alternative interpretations explain some of the ambiguous stuff?

FILM SOUND in *The Innocents* (Jack Clayton, 1961)

I. INTRODUCTION

 A. The Innocents is a "thinking person's ghost story" in more ways than one

 B. It requires more imagination on the part of the audience than do modern horror films; it is more challenging

 1. It is also about the imagination and thought, and what they can do

 C. Our discussion will revolve around two opposing interpretations

 1. The film is an objective or perceptually subjective narrative about two ghosts who haunt a house, possess two children, and torment an innocent woman; OR…

 2. The film is a mentally subjective narrative about the unhealthy imagination of a sexually repressed woman who torments two innocent children

 3. Is the film's narration restricted or unrestricted in range?

 a) It is mostly restricted to Miss Giddens

 b) In the rare moments of unrestriction, what do we see? Usually, one of the children smiling

II. *The Innocents* AS OBJECTIVE (OR PERCEPTUALLY SUBJECTIVE) NARRATIVE

 A. Miss Giddens is innocent, and the children are not; they are possessed

 B. What seems to mark the narration as objective?

 1. How does the plot suggest that the children see the ghosts?

 a) Eyeline matches seem to indicate that they do

 b) The expressions on their faces indicate this also

 c) But what does that really prove?

 d) How does expectation affect our reading of the images?

 2. Is there a physical manifestation of the presence of the ghosts?

 a) The tear on the chalkboard

 b) But again…what does it prove?

 c) Do we see a real tear, or just what Miss Giddens "sees"?

III. *The Innocents* AS MENTALLY SUBJECTIVE NARRATIVE

 A. In this case, the children are innocent, and Miss Giddens is not

 1. She is possessed by her own sexual fantasies

 2. Does the film's title seem to support this interpretation?

 a) The fact that it is plural?

 b) Unless it is meant to be ironic; and does not Miss Giddens say it that way?

 3. If, in fact, she is imagining all this, what does she do to the innocent children?

 a) She drives Flora crazy

 b) She kills Miles

 4. What stylistic elements mark the narration as mentally subjective?

 5. How does sound signal potentially mentally subjective sequences?

 a) Nondiegetic sounds often sound appropriately spooky

 (1) Usually before she sees or hears a "ghost" we hear a nondiegetic version of the music box song

 (2) For example, when she first arrives and hears a voice calling "Flora"

 b) Diegetic sounds (the birds, etc.) sometime stop when Miss Giddens sees a ghost

 c) The sounds that we take to be either perceptually or mentally subjective are often distorted

 (1) Does this make it "ghostlike"?

 (2) Or mentally subjective?

 6. How do cinematography and mise-en-scène signal potentially mentally subjective sequences?

 a) The glare on the screen when she sees Quint for the first time (or *was* it Quint?)

 b) After Miss Giddens sees Quint, the camera frames the reflection of Mrs. Gross in the window; maybe Giddens saw her own reflection?

 c) What narrative clues are given that Miss Giddens is imagining all this?

7. What is her background?

 a) Religious, almost Puritan; father was a "country parson"

 b) Only when he was gone would she and her sister play; were they afraid of him?

 c) Think about the way it takes a "religious" person to believe in devils, ghosts, etc.

8. Does she have an active imagination?

 a) The uncle asks her if she does; she says "yes"

 b) What sorts of things does she imagine?

9. Does she seem attracted to the uncle?

 a) How does she look at him during the first scene?

 b) She says she is afraid he will think that she is just trying to get his attention; why? No one else suggests this...

 c) Constant references to how charming and handsome he is, his "swinging bachelor" lifestyle

 d) What about her "moaning and groaning" while sleeping?

 e) Can alternative interpretations explain some of the ambiguous stuff?

10. What would explain the voice she hears calling Flora?

 a) Giddens thinks it is the ghost of Miss Jessel (remember, she already knows that Jessel is dead before she arrives at the house)

 b) Mrs. Gross suggests that it is one of the other servants?

11. What about Miles choking Miss Giddens?

 a) She is already frightened, and has just seen the picture of Quint

 b) Do boys play rough?

12. What explains her seeing Quint after the attic scene?

 a) She has just seen the picture of the locket

 b) She has been thinking (and dreaming?) of the uncle

 c) She finds Quint attractive, as she does the uncle

 d) Does he also look like Miles somewhat?

13. What exactly was the relationship between Quint and Jessel? Quint and Miles? Jessel and Flora?

 a) What does Miss Giddens assume about the relationships?

 b) Does she lead Mrs. Gross with her questions?

14. The kiss Miles gives to Miss Giddens?

 a) Maybe it was just a kiss after all?

 b) Could Giddens's state of mind lead her to infer something more; that he is "possessed" by Quint?

15. The "things" that Miles said at school?

 a) Do we ever know what they are?

 b) Kids say things...

16. Does Miles see Quint at the end?

 a) What suggests that he really does see Quint? The eyeline

 b) But why does he look in that direction?

 c) Could it be a statue that Miss Giddens sees as Quint?

17. The sounds we hear; are they objective, perceptually subjective, or mentally subjective? For example, the sounds of Quint and Jessel "having sex"

 a) "Stop, you're hurting me"

 (1) Is it coming from the ghost of Jessel?

 (2) Is it suggested by Mrs. Gross's story about Quint hitting Jessel?

 (3) Is it Miss Giddens remembering what she said to Miles in the attic, and attributing it to Jessel?

 b) The laughter

 (1) Is it the laughter of ghosts? (perceptually subjective; only she can hear it)

 (2) Is it Miles and Flora (possessed or not)? (objective; anybody could hear it)

 (3) Or is it in the imagination of Miss Giddens? (mentally subjective; she "hears" it only in her mind)

IV. CONCLUSION

 A. The film is capable of being interpreted in either of these two ways

 B. It was designed this way; neither of the explanations can be "proven," but they can be supported by an analysis of the film's style

FILM SOUND

Singin' in the Rain (Gene Kelly and Stanley Donen, 1952)

Directed by Stanley Donen and Gene Kelly

Written by Betty Comden and Adolph Green

Produced by Arthur Freed

Cinematography by Harold Rosson

Music by Nacio Herb Brown and Lennie Hayton

Costume Design by Walter Plunkett

Editing by Adrienne Fazan

Produced by MGM (Metro-Goldwyn-Mayer)

Distributed by MGM (Metro-Goldwyn-Mayer)

Cast

Gene Kelly…Don Lockwood

Donald O'Connor…Cosmo Brown

Debbie Reynolds…Kathy Selden

Jean Hagen…Lina Lamont

Millard Mitchell…R. F. Simpson

Cyd Charisse…Dancer

Douglas Fowley…Roscoe Dexter

Rita Moreno…Zelda Zanders

STUDY QUESTIONS

1. How does sound have an impact on how we interpret what we see on the screen in this movie? For example, do voices affect how we interpret characters?

2. Is this film a *backstage musical* (with a story that revolves around the staging of a "show", with the songs realistically motivated by the narrative) or an *integrated musical* (with the songs incorporated into the narrative, and not always realistically motivated by the narrative)?

3. Is the style of this film basically realistic, or stylized? Why this and what is is the effect?

4. How does sound direct our attention in this film?

5. Does the film play with:
 a. The acoustic properties of sound?
 b. Rhythm?
 c. Fidelity?
 d. Diegetic Sound:
 i. Onscreen/offscreen?
 ii. Internal/external?
 e. Nondiegetic sound?
 f. Synchronization/asynchronization?
 g. Simultaneous/nonsimultaneous sound?

6. Where and how does this film use sound bridges? Dialogue hooks?

FILM SOUND in *Singin' in the Rain* (Gene Kelly and Stanley Donen, 1952)

I. INTRODUCTION

 A. *Singin' in the Rain* is a film *about* sound and film history; therefore, a useful film to discuss in terms of sound in cinema

 B. BUT...SOME HISTORICAL ERRORS

 1. *The Jazz Singer* was *not* the first sound film

 2. No mass panic; studios got together and decided on orderly transition to sound soon after introduction by Warner Bros

 3. However, problems with sound film production are accurate

 C. BACKSTAGE and INTEGRATED MUSICALS

 1. EARLY MUSICALS

 a) Most early musicals were "backstage musicals"

 (1) Stories that revolve around staging of a "show"

 (2) Songs realistically motivated by narrative

 b) Gradually replaced to some degree by "integrated musical"

 2. THE INTEGRATED MUSICAL

 a) Refers to musicals in which the songs are incorporated into narratives

 (1) Songs not always realistically motivated by narrative

 (2) More complex relationship between narratives and musical numbers

 (3) Songs more directly reflect conflicts of story, feelings of characters, etc. (not just songs they happen to be singing for a show)

 (4) Examples from *Singin' in the Rain*?

 (a) Backstage: "Broadway Rhythm" (maybe), "Would You?", "Beautiful Girl"

 (b) Integrated: "Singin' in the Rain", "Good Morning", "You Were Meant For Me"

 b) Audience and its relationship with the integrated musical

 (1) Require more "suspension of disbelief" than do backstage musicals; characters sing in public with no narrative motivation

 (2) Characters operate on two levels:

 (a) In the story, mostly oblivious to film's plot and the audience

 (b) In the plot, often sing to audience, directly addressing the camera and viewer ("Make 'em Laugh")

 (c) Blurring of story and plot challenges the audience and the limits it will accept

 c) STYLE OF THE INTEGRATED MUSICAL

 (1) With foregrounding of narration, integrated musical usually very stylized (as opposed to backstage musical, which aspired to "realism")

 (2) The montage of coming of musicals (segues into "Beautiful Girls"), use of rear projection, etc.

II. FUNDAMENTALS OF FILM SOUND

 A. ACOUSTIC PROPERTIES OF SOUND

 1. LOUDNESS or VOLUME

 a) Radio broadcast

 b) Volume of Lina's voice as she tries to remember where the microphone is

 c) Loudness of some sounds during *The Duelling Cavalier*

 2. PITCH and TIMBRE

 a) How are they used to distinguish different voices (and vocal types)?

 b) Don and Kathy: average, normal Americans, middle class

 c) Lina: obnoxious, whiny, nasal; reveals lower class upbringing (with upper class pretensions)

 d) Cosmo: goofy

e) RF (the producer): authoritative

f) Vocal coaches: stuffy, academic, upper class (sort of)

g) This brings up issues of both class and national identity; many of the talents brought in from the legitimate stage with the coming of sound were British (did not last long)

B. How does sound affect how we interpret what we see on the screen?

1. The voices affect the way we regard the characters

2. How else does sound affect our interpretation of the visuals? Think of the ironic counterpoint of sound and visuals in the flashback (during the radio broadcast)

III. THE DIMENSIONS OF FILM SOUND

A. RHYTHM: How does the rhythm of the sounds interact with the rhythm within the mise-en-scène and/or that of the editing?

1. Matching

a) Movement of crane shots during "Broadway Rhythm" number matches rhythm of music

b) Editing in "Beautiful Girl" number matches rhythm of music (and creates graphic matches)

2. Mismatches?

B. FIDELITY: Much of the humor is the result of the lack of fidelity

1. Lina's voice does not match her screen persona

2. *The Duelling Cavalier* (due to lack of synchronization, when the voices end up with the wrong characters)

3. *The Dancing Cavalier* (because Lina's voice is not her own)

4. Cosmo and Kathy singing "Good Morning"

5. Lina at the premiere singing "Singin' in the Rain" with Kathy behind the curtain

C. SPACE

1. DIEGETIC SOUND

a) ONSCREEN/OFFSCREEN

(1) ONSCREEN: Most of the diegetic sound

 (2) OFFSCREEN: Don Lockwood's offscreen narration during flashback

 b) INTERNAL/EXTERNAL

 (1) EXTERNAL: Most of the diegetic sound (most is onscreen external diegetic)

 (2) INTERNAL: "Broadway Rhythm" number (sounds [and visuals] are what Don is imagining as he tells RF about it [accounts for stylization?])

 2. NONDIEGETIC SOUND

 a) Includes background music; a lot in *Singin' in the Rain*

 b) Often coexists with diegetic sound (especially singing) and even music during musical numbers

D. TIME

 1. SCREEN DURATION or VIEWING TIME

 a) SYNCHRONIZATION: Most of the sound is synchronized

 b) ASYNCHRONIZATION: *The Duelling Cavalier* movie within the movie

 2. PLOT TIME

 a) SIMULTANEOUS/NONSIMULTANEOUS SOUND

 (1) SIMULTANEOUS or SIMPLE DIEGETIC SOUND: Most of the sound

 (2) NONSIMULTANEOUS or DISPLACED DIEGETIC SOUND: During flashback near beginning of film, as Don tells radio audience how he got into film (sound in present, image in past)

IV. SOUND DEVICES FOR CONTINUITY

A. SOUND BRIDGE

 1. "Would You?" bridges scene in which Kathy is recording it and scene of viewing the completed scene after it has been filmed

 2. Is it displaced diegetic sound? Why or why not?

B. DIALOGUE HOOK

1. In RF's office; they talk about making *The Duelling Cavalier* into *The Dancing Cavalier*, then we cut to the actual reshooting of the film

2. After discussion of need for a dialogue coach, a cut to the dialogue coach working with Lina

FILM SOUND

M. Hulot's Holiday

(Les Vacances de M. Hulot; Jacques Tati, 1953)

Directed and Produced by Jacques Tati

Written by Jacques Tati, Henri Marquet, Pierre Aubert and Jacques Lagrange

Music by Alain Romans

Cinematography by Jacques Mercanton and Jean Mousselle

Editing by Suzanne Baron, Charles Bretoneiche and Jacques Grassi

Production Design by Henri Schmitt

Sound by Roger Cosson

Produced by Fred Orain and Jacques Tati

Production Company: Cady Films and Specta Films

Cast

Jacques Tati…M. Hulot

Nathalie Pascaud…Martine

Michèle Rolla…The Aunt

Valentine Camax…Englishwoman

Louis Perrault…Fred

André Dubois…Commandant

Lucien Frégis…Hotel Proprietor

Raymond Carl…Waiter

René Lacourt…Strolling Man

Marguerite Gérard…Strolling Woman

STUDY QUESTIONS

1. Humor in *M. Hulot's Holiday* is created largely through the manipulation of sound and space (especially the relations between foreground and background space). The film plays with all three forms of cinematic sound, including speech, music, and sound effects.

 a. What are some examples of the use of speech to create humor?

 b. What are some examples of the use of music to create humor?

 c. How are sound effects used in the film to create humor?

2. How does the film use the fidelity of sound (or the lack of it) to create humor?

3. How are sound and space used together to create humor in the film? Specifically, how is offscreen sound used? Examples?

4. How is space, more specifically the play of background and foreground relations (and different planes of action in general), also used to create comic effects in the film?

5. How does Tati use cinematography and editing in this film? Are these aspects of style used in any unusual ways?

FILM SOUND in *M. Hulot's Holiday* (Jacques Tati, 1953)

I. INTRODUCTION: Humor in *M. Hulot's Holiday* is created largely through the manipulation of sound and space (especially the relations between foreground and background space)

II. SOUND: This film plays with all three forms of cinematic sound, including speech, music, and sound effects

 A. SPEECH: Some examples of the use of speech to create humor include:

 1. The speech of the Major, describing his march through mud, makes the hotel manager suspect him of tracking in the mud that, in fact, was tracked in by Hulot

 2. As the radio announcer says goodnight to his audience, Hulot turns and tips his hat to the radio in response

 3. Some of the characters (especially the British woman who admires Hulot, and Henry's wife) have funny-sounding voices; this is an example of the use of timbre

 4. The absence of dialogue can also create humor, as when the fat man in shorts stares at the waiter after eating some bad food (chicken)

 B. MUSIC is often an important source of humor in the film; some examples include:

 1. The theme music is used to create a play between diegetic and nondiegetic music

 a) Sometimes it is background music

 b) Other times it is part of the story world (in the woman's room, on the beach, at the ball)

 2. The volume of the music is also manipulated for comic effects

 a) This happens when Hulot plays "Hold That Tiger"

 b) He sits quietly, in contrast to the loud music before it is turned off with the wall switch

C. SOUND EFFECTS are used in two ways in the film:

1. The VOLUME of the sounds is often exaggerated for comic effects

 a) This aspect of the film is signaled at the beginning of the film when the woman slaps her child, and seems as surprised as we are by the loudness of the sound

 b) Other examples include

 (1) The wind blowing in the hotel

 (2) The tow chain which causes Hulot to fall in the water

 (3) The sound of the water from the sprinkler falling in the bucket

 (4) The ping pong ball

 (5) The sounds of Hulot arriving at the hotel each night, etc.

2. FIDELITY of the sounds (what we expect them to sound like based on the source) is also played with; examples include:

 a) The car horn that seems to be speaking to the dog

 b) The horn that sounds like a duck

 c) The air escaping from the tire that sounds as if someone is "passing gas"

 d) The fireworks that sound like machine guns, cannons, etc.

III. SOUND and SPACE are used together to create humor in the film

A. Although all the sound in the film is simple, external diegetic (except for the nondiegetic background music), and there is no internal sound, on and offscreen sound is present

B. Offscreen sound is used in the following examples:

1. As Hulot trips over the suitcase, he falls and we hear the crash offscreen

2. The dogs chasing Hulot and their barking is often offscreen

3. The horse in the shed is heard kicking offscreen

4. The explosion in the Major's hotel room occurs and is heard offscreen

 5. Often when we see the interior of the hotel we hear sounds from the beach and vice versa

IV. Space, or more specifically the play of background and foreground relations (and different planes of action in general), is also used to create comic effects in the film

 A. The scene at the train station depends on the humor of the trains and passengers being on different planes and unable to come together

 B. The taffy on the ice cream vendor's cart is finally caught by a hand that enters from offscreen, and that we could not see

 C. At the ball, we see the annoyed hotel guests in the background as we see Hulot and the woman dancing in the foreground

 D. We often see Henry in the foreground, looking at Hulot either offscreen or in a different plane of the shot's space

V. EDITING and CINEMATOGRAPHY

 A. There are very few close-ups in the film

 1. Many of the gags depend on spatial relations

 2. Therefore, we see many medium and long shots in deep focus

 B. The cuts tend to be 90°, 180°, and lateral cuts:

 C. In general, the action in the background tends to become the foreground in the following shot

 D. There often is little common space from shot to shot, forcing the viewer to search the frame

 E. Sometimes a similar effect is accomplished through figure behavior; a character will move from the background to the foreground or vice versa

VI. NARRATIVE and THEME

 A. The introduction tells us that there is no plot; what does it really mean?

 B. COMPARE and CONTRAST TO HOLLYWOOD FILMS

 1. How is it like or unlike CHC films?

 2. Romance between Matilde and Hulot?

 3. Jokes that do not happen? (little boy and ice cream cone)

C. How are the characters presented?

 1. Most are very regimented, conformists, and do not have fun

 a) The Major

 b) The woman who wants to "get to know people"

 2. Even the businessman and the Communist are very much alike: boring, do not have fun

 3. The masked ball; who is there, and what is the reaction of the other guests?

D. What is Tati trying to tell us? To lighten up a little and have fun

 1. Think of the funeral scene; Hulot makes them laugh in spite of the circumstances

 2. The end of the film?

 a) How do the characters react to the fireworks, music, etc.?

 b) How do they behave as they leave, and who likes Hulot?

 (1) Matilde (think of her laughing at Hulot)

 (2) The little boy (businessman's son)

 (3) The Englishwoman

 (4) Henry

E. Why do these characters like or dislike Hulot?

ANALYZING FILM STYLE

Schindler's List (Steven Spielberg, 1993)

Directed by Steven Spielberg

Written by Thomas Keneally (novel) and Steven Zaillian

Produced by Kathleen Kennedy, Branko Lustig, Gerald R. Molen and Steven Spielberg

Music by John Williams

Cinematography by Janusz Kaminski

Editing by Michael Kahn

Production Companies: Amblin Entertainment and Universal Pictures

Distribution Company: Universal Pictures

Special Effects by Industrial Light and Magic (ILM)

Cast

Liam Neeson…Oskar Schindler

Ben Kingsley…Itzhak Stern

Ralph Fiennes…Amon Goeth

Caroline Goodall…Emilie Schindler

Jonathan Sagall…Poldek Pfefferberg

Embeth Davidtz…Helen Hirsch

Malgoscha Gebel…Victoria Klonowska

Shmulik Levy…Wilek Chilowicz

Mark Ivanir…Marcel Goldberg

STUDY QUESTIONS

1. This film is generally regarded (by critics at least) as Spielberg's first really "grown up" movie. Why do you think that is? What objections do you think critics have had to his earlier (and later) films?

2. How does the film pattern the narrative? Temporal deadline? Journey? Search for information?

3. Which techniques used by the film seem strikingly conspicuous? What aspects of style seem most important, and what ways of using particular techniques seem most important? Are some aspects used in fairly conventional ways, and others used in less conventional ways? Is the use of a particular technique consistent throughout? Does it change? What is the effect?

4. Specifically, is there anything unusual about the cinematography? What about the editing? Are there any unusual combinations of sound and editing in the film?

5. What is the role of style in the film as a whole? How does film style create certain responses in the viewer? How does style shape the meaning we make from watching the film?

FILM STYLE IN *Schindler's List* (Steven Spielberg, 1993)

I. INTRODUCTION

 A. Critics sometimes complain that Spielberg's films consist of "all style and no content"

 1. *Schindler's List* often regarded as Spielberg's 1st truly "good" film; significant subject (Holocaust) and important humanist theme ("Whoever saves one life, saves the world entire")

 2. Style, according to some critics, has been relegated to a supporting role, doesn't "interfere" with the theme of the film

 B. This thinking is wrong on two counts

 1. No such separation of style and content (or theme); the two aspects form a unified work of art

 2. Style doesn't play secondary role in *Schindler's List*; through film style Spielberg explores memory in film, tradition, and life

II. COLOR

 A. Primarily a black and white film, but color appears in five scenes

 1. 1st is scene of Shabbat candle lighting ceremony at beginning

 a) The Scene

 (1) We first see lighting of candles in close-up, with flames in color in a dark mise-en-scène

 (2) Followed by one character in prayer; chanting of the prayer itself heard continuously over next five shots, which are *not* in temporal continuity

 (3) Followed by closer shot of candle flame and child in foreground, rest of characters in background; characters fade out, leaving only the candles

 (4) The following two shots are cut-ins on the candles

 (5) Finally, we see a close-up of one of the candles

 (a) As the prayer ends, the candle burns out

 (b) Camera tilts up to follow candle's smoke before cut to smoke of train in Poland

 (c) This begins the story proper, followed by the creation of first of many lists

 b) First seven shots occur in what we assume is the present

 (1) But not necessarily in the present, no cues given to indicate that it must be the present

 (2) Gives impression of timelessness; ceremony performed today as it was yesterday, last year, and last century (and later in the movie)

 (3) The ceremony exists in not just the present, but also the past...and the future

 (4) First shot, candles with only flames in color, echoed at end of film, during second ceremony

2. Color again appears when Schindler sees the little girl, Genia, wearing a red coat, escape purging of Warsaw ghetto

 a) Red coat makes her stand out from rest of mise-en-scene

 b) She becomes an individual among multitudes, a living person among thousands of names on endless lists

 c) Music we hear during is "Oyf'n Pripetchok", song about memory, children and flames

3. Color red occurs again when we next see this little girl

 a) She is now a corpse

 (1) She escaped the Nazis due to her insignificance, and her body is insignificant, just another among thousands

 (2) Except to anyone who sees her as a real person, who remembers that she was once a living being

b) Nondiegetic music is "Tikkayeno", about memory

c) Remembering, Schindler sees Genia as a real person and this (according to the film) makes him decide to become more active in his efforts to save "his" Jews

 (1) Until this point, primarily wants to keep factory staffed and avoid guilt of being party to genocide

 (2) Nazis (esp. Goeth) irritating, crude and distasteful minor obstacles

 (a) We see his distaste for the Nazis when he watches an officer making a fool of himself in the night club, as Schindler covers his mouth with his hand

 (b) Later talking to Goeth, trying to convince him to pardon people even though he has the "right" to kill them

 (3) Schindler's distaste is changed to a burning desire to save as many lives as possible

4. Next see color near end of film, but still within the past

a) Echoes the beginning of the film

b) During Shabbat prayer, flames of candles are touches of color in an otherwise dark, black and white mise-en-scene

5. Last instance of color occurs at film's end, as past is united with present

a) Freed prisoners, leaving Schindler's factory, march in black and white toward an uncertain future

 (1) Slowly black and white becomes color

 (2) Diegetic figures of past dissolve into nondiegetic figures of present

b) Followed by epilogue, in which each of the "Schindler Jews" who is still living, with actor who played the person, places a stone on Schindler's grave

 c) Last shot of sequence is of red rose that Liam Neeson places on grave, linking scene with the two scenes of little girl in the red coat and two scenes of candle flames, with their small touches of red

B. Last image of film: credits begin over a black and white shot of Jewish gravestones used to pave central road of the prison camp

 1. Conflates the diegetic (Jewish gravestones) with the nondiegetic (Schindler's gravestone) through use of color and black and white

 2. Also through use of the Jewish gravestones themselves, which are both diegetic - they appear in the narrative - and nondiegetic - they exist in the real world

C. Rest of film is in black and white

 1. Black and white cinematography used to make a distinction between past and present?

 a) Could be; often is done for this reason

 b) But color is seen in both past and present

 2. Attempt at a documentary-like feeling?

 a) Black and white film a convention that signals the documentary to only older film viewers

 b) Black and white film probably signals "art" to most audiences (*Manhattan, Raging Bull*).

 3. Evokes instead glamorous look of black and white cinematography of Hollywood's Golden Age

 a) Introduction to Schindler early in the film:

 (1) Number of close-ups, before establishing shot showing us Schindler, his room, etc., show expensive-looking suit, ties, cufflinks, Schindler tying his tie, wad of banknotes, and Nazi Party pin

 (2) Looks not like documentary footage, but Hollywood's Golden Age, and contemporary fashion photography and advertising

 (3) Continues with Schindler and Nazi officers in a night club, has seductive appearance but underneath, emptiness and boredom in Schindler, crudity and cruelty in Nazis

 b) In other parts of the film (esp. the Nachtaktion), black and white footage not used to evoke feeling of glamour

 (1) Closer to classical Hollywood images of WW II than to documentary footage of war (grainy, high contrast)

 (2) Creates tension between appearance of the image (pristine, sparkling, deep focus look) and content (murder and slaughter of the innocent)

4. What is history for Spielberg?

 a) History is movies; for him (and for most of us) the past is inseparable from our images of it

 b) These images often come from films

 c) To say that these images are not "real", or that they are not "realistic", is irrelevant, like saying that words are not really what they represent

 d) Films (and words) convey ideas, not reality

 e) In the film Goeth says that he is not just making history, but changing history; the movie is Spielberg's attempt to reassert this history through images

III. EDITING

 A. Mostly edited according to rules and conventions of continuity editing, but some interesting exceptions

 1. Three different events intercut with one another

 a) Jewish wedding being held inside the prison camp

 b) Goeth's confrontation with his Jewish housekeeper, Helen Hirsch, in his cellar

 (1) Finds himself attracted to Helen - or admits to himself the attraction that is obvious to the audience - although he says that she is "not a person in the strictest sense of the word"

 (2) Later, Goeth tells his superior about the supernatural "power" Jewish women have

 c) Schindler's birthday party

 (1) Celebration begins with a singer; it is the song of this singer that we hear in previous segment as " Goeth staggers to the cellar

 (2) One of the guests is Goeth; contrary to conventions of continuity editing, these intercut scenes are not occurring simultaneously

 d) What links these scenes is not temporal continuity, but both formal and thematic connections

 (1) Series of graphic matches connects singer reaching out for Schindler, Goeth touching face of Helen, and groom lifting veil of his bride

 (2) Breaking of glass at wedding is immediately followed by Goeth's slap across Helen's face, followed by Schindler applauding

 (3) Shots of kisses at the wedding intercut with shots of Schindler kissing singer (and every other woman he can find) and Goeth's beating of Helen

2. Close-ups of Schindler shaving intercut with similar close-ups of Goeth shaving suggest connection between the two

3. Another scene intercuts shots of the one-armed factory worker being shot in the snow with shots of Schindler protesting his execution to a Nazi officer

 a) Dialogue between Schindler and officer continuous over intercut shots, although execution took place earlier

B. Fluidity of temporal progression associated with memory seen during scene in which the Perlmans are rescued

 1. Continual intercutting between the cause (Schindler giving Stern the watch) and the effect (the Perlmans being freed)

 2. Intercutting done in such a manner that it is difficult to differentiate between the shots; where, for instance, does Goldberg's receiving the watch fit in the temporal sequence?

IV. SOUND

A. Relationships between scenes, and between image and sound, further complicated by overlapping sound, or sound bridge

 1. Most common use of sound bridge in Hollywood films is for the sound of a scene to persist for a few seconds into the next scene, which helps to make a smooth transition between the scenes, as the image shows us what the sound is referring to

 2. In *Schindler's List* sound bridges give us sound - most often voice of Schindler - before the image of the next scene

 3. Effect of this is to disorient viewer slightly

 a) We tend to give primacy to the image, become confused when the sound we hear doesn't confirm what we see

B. So, not only are images of different points in time intercut, sounds and images of different times occur simultaneously

 1. In these cases, different events exist simultaneously in the film, as they do in memory

 2. Overlapping editing also serves practical purpose of duplicating the confusion the characters often experience, and suspense of not knowing what is coming next

 a) Prisoners in the cattle cars, hearing what they cannot see, and not knowing where they are going

 b) Women prisoners hearing sound of showers being turned on, but not knowing what will come out

ANALYZING FILM STYLE

Runaway Train (Andrei Konchalovsky, 1985)

Directed by Andrei Konchalovsky

Written by Edward Bunker, Paul Zindel and Djordje Milicevic

Based on a screenplay by Akira Kurosawa

Music by Alan Hume

Editing by Henry Richardson

Produced by Yoram Globus and Menahem Golan

Production Companies: Golan-Globus and Northbrook Films

Distribution Company: Cannon Releasing Corp.

Cast

Jon Voight…Oscar 'Manny' Manheim

Eric Roberts…Buck

Rebecca De Mornay…Sara

Kyle T. Heffner…Frank Barstow

John P. Ryan…Ranken

STUDY QUESTIONS

1. *Runaway Train* is a fairly straightforward movie; does this make it easier or more difficult to analyze? Why?

2. In what ways does the narrative use cause and effect? Is it relatively clear? Do you sometimes have questions about why characters are behaving in particular ways, or are their motivations always fairly easy to figure out?

3. Consider one of the scenes from the film; for example, the end of the film. How could it have been presented differently? Could narrative or stylistic changes have altered the effect of the ending? If so, how does this make it easier to understand why it was constructed the way in which the filmmakers constructed it, instead of some other way?

ANALYZING FILM STYLE in *Runaway Train* (Andrei Konchalovsky, 1985)

I. INTRODUCTION

 A. *Runaway Train* is a fairly straightforward movie in most ways

 1. This may make it more difficult to discuss in terms of style

 2. Uses of style that are unusual are generally more easily noticed than are those that are not as obvious

 B. It *can* be discussed as an action film

 1. However, it is not really like most of today's action films

 2. It is not nearly as bombastic, nor is it meant to be

 a) It is meant to be brutal in a very real, human way

 b) It is more about characters than it is about special effects

II. ANALYZING FILM STYLE

 A. Determine the organizational structure of the film: its narrative or nonnarrative formal system (in this case it is obviously narrative)

 1. How does it use cause and effect?

 a) Pretty straightforward

 b) Examples

 (1) Why does the warden, Frank Barstow, hate Oscar "Manny" Manheim so much?

 (a) Manny has tried to escape twice before

 (b) Manny is a hero to the men

 (c) Manny and the warden are too much alike

 (2) Why do the officials decide to destroy the train? (To save the chemical plant)

 2. How are time and space articulated?

 a) What is the time frame; how much time is covered? (a few days, maybe? Just several hours on the train, probably...)

b) How does the film keep us clear about spatial relationships?

 (1) Confined space on the train

 (2) Map lets us know where the train is in relation to other things like the bridge, tracks, etc.

3. What is the range and depth of narration?

 a) What is the range? (Unrestricted; why? What is the effect?)

 b) What is the depth? (Objective; why? What is the effect?)

4. How does the film pattern the narrative?

 a) A journey from one place to another

 b) But also temporal; a series of deadlines as the train approaches different things

III. Identify the salient ("strikingly conspicuous") techniques used

1. What aspects of style seem most important, and what ways of using particular techniques seem most important?

 a) Cinematography

 (1) Widescreen emphasizes train speeding through the Alaskan wilderness

 (2) Tracking camera (mounted on a moving car or truck) moving with train also emphasizes the speed

 (3) Close-ups of the train alternate with the long shots

 b) Sound

 (1) Diegetic sound

 (a) Loud train sound

 (b) But often decreases in volume to emphasize dialogue (typical of Hollywood films)

 (2) Nondiegetic sound

 (a) Not really very much

 (b) But the choral music, especially at the end, suggests some sort of religious interpretation, especially with Manny "sacrificing" himself and his "crucified" pose at the end; is he dying for the sins of them all?

2. Are some aspects used in less conventional ways?

 a) Editing

 (1) Straightforward for the most part

 (2) Crosscutting among the three different groups of characters (on the train, headquarters, the warden)

 b) Mise-en-scène

 (1) Mostly very dirty, nasty, ugly; very brutal and realistic

 (2) What about the acting styles?

 (a) How are the characters of Manny and Buck articulated? Sara?

 (i) They are all "white trash"

 (ii) However, they are very different kinds of characters, and the acting helps to define them as individuals

 (b) Barstow, the warden, is fairly stereotyped

IV. Trace out patterns of techniques within the whole film

 A. How is the use of techniques patterned?

 1. Is the use of a particular technique consistent throughout?

 2. Does it change? What is the effect?

 B. Bordwell and Thompson in *Film Art* suggest letting your responses guide you; this is very useful

 1. What responses did you have during the film?

 2. Fear, laughter, excitement? Why?

 3. How did the film make you have this particular response?

C. Does the film seem to have an escalating scale of brutality and an increasing pace?

 1. What might that have to do with the narrative?

 2. Does it contribute to the theme? If so, how does it do this?

V. Imagine alternatives!!

A. The end of the film features Manny, after saving Buck and Sara, standing on the engine (with the warden handcuffed inside) with his arms spread open; he fades into the snow-filled frame, with the choral music on the soundtrack

B. How could this have been presented differently?

C. What would be the difference in the effect achieve?

D. Would it alter a pattern established in the film? If so, what would be the effect of that?

E. Would it alter the way in which we take the scene? Alter our expectations? Change the meaning?

ANALYZING FILM STYLE

Psycho (Alfred Hitchcock, 1960)

Directed by Alfred Hitchcock

Written by Joseph Stefano

Produced by Alfred Hitchcock

Cinematography by John L. Russell

Music by Bernard Herrmann

Editing by George Tomasini

Production Company: Shamley Productions

Distributed by Paramount Pictures

Cast

Anthony Perkins…Norman Bates

Vera Miles…Lila Crane

John Gavin…Sam Loomis

Martin Balsam…Milton Arbogast

John McIntire…Sheriff Chambers

Simon Oakland…Dr. Richmond

Vaughn Taylor...George Lowery

Frank Albertson...Tom Cassidy

Lurene Tuttle...Mrs. Chambers

Patricia Hitchcock...Caroline

John Anderson...California Charlie

Mort Mills...Highway Patrolman

Janet Leigh...Marion Crane

Virginia Gregg...Voice of mother

STUDY QUESTIONS

1. Consider the scene in *Psycho* in which Marion Crane prepares to leave Phoenix to go to Sam in Fairvale. Think of how this scene of the film contributes to the film as a whole, in terms of both narrative and style.

2. What important information is conveyed in this scene? What does it tell us about Marion Crane and the kind of character she is? How does it affect the way we feel about her?

3. What sorts of motifs do we see that are repeated in the rest of the film? Be sure to consider both story elements and stylistic elements.

4. How would the movie as a whole be affected if this scene had been left out?

5. Finally, imagine alternatives to the way in which the scene is presented. How could it have been done differently?

ANALYZING FILM STYLE in *Psycho* (Alfred Hitchcock, 1960)

I. NARRATIVE and FILM FORM

 A. Consider the segment of *Psycho* in which Marion Crane prepares to leave Phoenix to go to Sam in Fairvale

 B. **How does the segment advance the story?**

 1. What important narrative information is provided by the segment?

 a) Marion is at least thinking about taking the money

 b) But how do we know? She is packing her bags, takes her car registration

 c) There is a degree of ambiguity; we are not sure what she will do

 2. What does it tell us about the characters, situation, causes and effects?

 a) We know that she is a sympathetic character, and we feel she is basically good; why?

 b) What are our expectations based on this scene and what we have already seen?

 (1) If she steals the money, something bad will happen

 (2) Why do we think this?

 3. If this segment were taken out of the film, what would be lost?

 a) We would not suspect that she is stealing the money until later in the film

 b) We would lose some of the subjectivity

 C. How and where does the segment fit in with the rest of the film's story and plot?

 1. Has TEMPORAL ORDER been manipulated, and why or why not? No

 2. Does the segment represent part of a PATTERN?

 3. Does it provide something which has been or will be repeated in the plot (MOTIFS)?

 a) Marion in her bra

 b) The shower

D. What is the RANGE of the story information?

 1. RESTRICTED or UNRESTRICTED? Restricted

 2. What is the effect, and why is this done in this segment and/or film?

 a) We begin our identification with Marion

 b) This identification is important to the rest of the film

E. What is the DEPTH of the story information?

 1. OBJECTIVE, PERCEPTUAL SUBJECTIVITY, or MENTAL SUBJECTIVITY?

 a) Sometimes it is objective; the camera is sometimes like an observer in the room, with its presence obvious

 (1) Think of the moving camera shots from the money to the suitcase

 (2) The shots with the shower in the background

 b) At other times, it is perceptually subjective, shots from her POV

 2. What is the effect, and why is this done in this segment and/or film?

 a) As the range becomes more restricted, depth becomes more subjective

 b) This is part of a pattern; we identify more and more with Marion

 c) It is followed by a scene that includes mental subjectivity

II. ELEMENTS OF FILM STYLE

 A. IN GENERAL

 1. How does style make sure we pay attention to the proper pieces of story information? See below

 2. Does style sometimes misdirect our attention, so we tend not to notice something important? No

 3. Are there aspects of style in the segment which do not have story functions? If so, what aspects and why? No

 4. Is the style in the segment "normal" or is some ways unusual? Does it conform to the CHC or not? It seems to conform closely

B. How does MISE-EN-SCÈNE contribute to the segment? Is it relatively "realistic" or stylized to some degree? What does it tell us about the characters, situation, etc.; or does it to some extent exist for its graphic qualities?

 1. SETTING

 a) What does the apartment tell us about Marion?

 (1) It is small and plain

 (2) We know her life is boring, and she does not make much money

 b) Why is this important? Motivation

 2. COSTUME and MAKE-UP; what is Marion wearing at the beginning of the shot?

 a) A black bra; significance?

 b) Cf. to the earlier scene in the hotel room with Sam; what was she wearing?

 3. LIGHTING

 a) Normal; fairly bright and flat

 b) Why?

 (1) It illuminates the rest of the mise-en-scène

 (2) It fits in with the film's comments on evil in daylight, ordinary places, etc.

 4. FIGURE BEHAVIOR

 a) What is Marion doing?

 b) How does Marion behave?

 (1) Does she seem confident and sure of herself?

 (2) How do we know what she is feeling?

C. How does CINEMATOGRAPHY contribute to the segment?

 1. PHOTOGRAPHIC QUALITIES OF THE SHOT

 a) Anything unusual about the look of the image (fuzzy, black-and-white, brightly colored, etc.)?

(1) Fairly standard look, except for black-and-white

(2) Was this normal for the time period? (1960)

(3) What is the effect of this?

b) SPEED OF MOTION: has it been manipulated? Why? No

c) PERSPECTIVE RELATIONS

(1) Unusual use of lens?

(2) Special effects (rear projection, etc.)?

(3) Nothing unusual

2. FRAMING

a) Anything unusual about the size and/or shape of the frame? No

b) How are onscreen and offscreen space used in the segment?

(1) What do we see at the beginning of the scene?

(2) What does the camera show us, and when?

(3) What is the effect?

c) What is the effect of the camera's angle, level, height, and distance?

(1) How is the money shown to us?

(a) From the plot's POV

(b) From Marion's POV

(2) What about the shower?

d) Is the frame mobile? If so (or if not) what is the effect; why is it done?

(1) Mobile framing is used to make the camera obvious

(2) Why is it obvious? Not motivated by POV

(3) What is the effect?

3. Does the segment contain a LONG TAKE? If so, why, and what is the effect? No

D. How does EDITING contribute to the segment?

1. How does the segment handle GRAPHIC and RHYTHMIC relations between shots?

a) Graphics are matched somewhat from the previous scene; More on this to follow

b) The duration of the shots, in general, is dependent on shot distance

2. How is SPACE articulated through editing?

 a) Initially, the camera gives us only a portion of the mise-en-scène

 b) However, it pulls back to give us more details

 c) No real establishing shot per se

 d) Through editing and cinematography, the envelope with the money is established as the center; everything revolves around it

3. How is TIME articulated through editing?

 a) What connects this scene with the previous one?

 b) What connects this shot with the next one?

 c) What do these dissolves mean to the viewer?

4. Does the segment use Hollywood continuity editing or an alternative? Why and how; to achieve what effects?

 a) Continuity editing is played with to a certain degree at the beginning

 (1) What is the effect of the continuation of Marion's walking from one scene to the next?

 (2) Graphically, movement within the mise-en-scène is matched

 (3) But her costume has changed; effect?

 b) Continuity editing--eyeline matches from Marion to the money--creates a coherent space

 (1) But this space is centered on the money

 (2) It is also a highly perceptually subjective scene, due in part to this series of eyeline matches

E. How does SOUND contribute to the segment?

1. How does the segment use the ACOUSTIC PROPERTIES of sound (loudness, pitch, and timbre)?

 a) DIEGETIC

 (1) The volume of the diegetic sounds is amplified somewhat (rustling of papers, clothes hangers, etc.)

 (2) This is just so we can hear

 b) NONDIEGETIC

 (1) How would you describe the acoustic properties of the background music?

 (2) How does it make us feel about what we see?

 (3) Does it form part of a motif?

2. Is the RHYTHM of the sounds (in relation to one another and/or the other elements of film) significant?

 a) The rhythm of the music and that of the cutting and movement within the mise-en-scène are fairly compatible

 b) The rhythm is fairly slow

3. Is sound FIDELITY manipulated; why and how? No

4. How is sound used in relation to SPACE?

 a) Is it DIEGETIC or NONDIEGETIC? Both

 b) Is it ON or OFFSCREEN? Onscreen

 c) Is it INTERNAL or EXTERNAL? External

 d) How is sound used to help define physical aspects of the space? Typical sounds for the space

5. How is sound used in relation to TIME?

 a) Is it SYNCHRONOUS or ASYNCHRONOUS? Synchronous

 b) Is it SIMPLE DIEGETIC or DISPLACED DIEGETIC? Simple diegetic

 c) Does this not change soon?

III. How could the segment have been shot differently, and what would the effect have been?

ANALYZING FILM STYLE

Citizen Kane (Orson Welles, 1941)

Directed by Orson Welles

Produced by Orson Welles

Written by Herman J. Mankiewicz, Orson Welles and John Houseman

Cinematography by Gregg Toland

Music by Bernard Herrmann

Editing by Mark Robson and Robert Wise

Produced by Mercury Productions / RKO Radio Pictures, Inc.

Distributed by RKO Radio Pictures Inc.

Cast

Joseph Cotten...Jedediah Leland/Newsreel Reporter

Dorothy Comingore...Susan Alexander

Agnes Moorehead...Mrs. Kane

Ruth Warrick...Emily Norton

Ray Collins...Boss Jim Gettys

Erskine Sanford...Herbert Carter/Newsreel Reporter

Everett Sloane...Bernstein

William Alland...Jerry Thompson/"News on the March" Narrator

Paul Stewart...Raymond

George Coulouris...Walter P. Thatcher

Fortunio Bonanova...Matiste

Gus Schilling...Headwaiter

Philip Van Zandt...Rawlston

Harry Shannon...Kane senior

Sonny Bupp...Kane III

Orson Welles...Charles Foster Kane

Buddy Swan...Young Charles Foster Kane

Gregg Toland...Interviewer in Newsreel

STUDY QUESTIONS

1. Consider the segment of *Citizen Kane* in which we see a montage sequence covering Susan Kane's career as an opera singer, and her attempted suicide. Whose narration is this? Why is this significant?

2. What significant information do we see in this segment of the film? How does it affect the way in which we understand the rest of the film?

3. What is the RANGE and DEPTH of story information in this segment? How do they affect how we take the sequence?

4. What sort of motifs do we see in this segment of the film? How are they related to the rest of the film?

5. Are there examples of the use of style in this segment that are different from the ways in which style is used in the rest of the film? Why do you think this is? What is the effect?

ANALYZING FILM STYLE in *Citizen Kane* (Orson Wells, 1941)

I. Introduction

 A. We will analyze a segment of *Citizen Kane*: the segment in which we see a montage sequence covering Susan Kane's career as an opera singer, and her attempted suicide

 B. What is the film about?

 1. Charles Foster Kane's obsession with control

 a. He tries to control other people

 b. He does this to a degree by controlling what others "know" or feel

 2. The difficulty of really knowing a person, and the different, often contradictory ideas we have about people and reality itself

 3. Reality is subjective; it depends on who is "doing the talking," or narrating in the case of *Citizen Kane*

II. GENERAL OVERVIEW

 A. Whose narration is this?

 1. Susan's narration

 2. How does this affect the segment? Very subjective:

 a. Many POV shots (Susan's POV); examples?

 b. Is sound subjective?

 B. What important story information is provided?

 1. We learn that her singing career is a flop

 2. We learn that she tries to commit suicide

 C. How is (and/or is not) the film a turning point in the film?

 D. This segment should be dealt with as two smaller segments: the montage sequence and the suicide attempt

III. THE MONTAGE SEQUENCE

 A. What kind of sequence is this?

 1. Montage sequence

2. What is a montage sequence?

3. Why is it used here? What is the effect?

4. Have we seen this before (her career)? How is it different now?

B. How does film style work in the segment?

 1. The combined elements of style (editing, sound, cinematography, and mise-en-scène) are used to give us story information, but also to make us feel a certain way about the story and the characters

 2. This is accomplished to a large degree by manipulating RANGE and DEPTH of story information

 3. How does RANGE and DEPTH of story information affect how we perceive the sequence?

 a. RANGE of story information

 (1) Restricted or unrestricted? Both?

 (2) How are public and private views alternated?

 (a) The contradiction in the sequence

 i) The newspapers: Whose are they? What do they say?

 ii) The audience: What is their reaction?

 (b) In what way does this reflect the film as a whole?

 i) Contradictory views of the same thing or person

 ii) Kane constantly tries to form public opinion; feels that it is perfectly legitimate (even admirable) to fool people into believing "his" reality

 b. DEPTH of story information

 (1) Objective, perceptually subjective, or mentally subjective?

 (2) At least perceptually subjective; probably mentally subjective

 (a) We see and hear what Susan sees and hears

 (b) The *way* in which we see and hear these things reflects her state of mind

 i) The music gets faster and louder

 ii) The editing gets faster and more frantic

 iii) **Especially subjective** is the light burning out at the end of the montage sequence, which also represents Susan herself burning out

C. MISCELLANEOUS COMMENTS ON STYLE IN THE MONTAGE SEQUENCE

 1. MISE-EN-SCÈNE: It is functional in two ways (Remember: elements often have multiple functions)

 a. It lets us know that we are watching an opera (Susan's costume, her acting, the spotlight on her, etc.)

 b. It also ties in with the rest of the segment and the film

 (1) Susan is isolated on the stage; alone in the spotlight (makes sure we see her, indicates her isolation)

 (2) Her figure behaviour is similar to what we have seen previously and will see again; on her knees, especially before Kane

 2. CINEMATOGRAPHY

 a. Susan is often seen from a high height and camera angle

 (1) Does it duplicate how the audience would see her? By Kane, not the rest of the audience

 (2) What is the effect? Reinforces the impression of her isolation, powerlessness before Kane

 b. Shot duration?

 (1) How does the shot duration differ from that of much of the rest of the film?

(2) Does this seem to make the segment stand out from the rest of the segments?

(3) It is followed by a long take, which takes on added significance due to the montage sequence that precedes it

IV. THE SUICIDE ATTEMPT

 A. What do we see and hear, and how do we see and hear it?

 1. We initially see a dark room, with a door in the background

 2. We hear Susan's heaving breathing, and notice a glass, a spoon, and a medicine bottle in the foreground

 3. We are being told important story information through the use of the long take and deep focus photography

 a. It is more subtle than editing to "force" us to look at significant details

 b. It helps create suspense; we do not understand everything immediately

 c. Like the film as a whole, we must try to figure things out; nothing is simple and obvious

 B. RANGE OF STORY INFORMATION

 1. Although Susan is unconscious, it is seen from her POV

 a. The camera is positioned at her height, by the bed, looking at the door in the background as she would if she were conscious

 b. The room dark and cavernous

 (1) Like a tomb (she is dying)

 (2) Like other tomb-like rooms in the film: Thatch Memorial Library, rooms at Xanadu, etc.

 2. How could it have been filmed differently, and what would the effect have been?

 a. Alternative to the long take: editing

330

b. Alternative to perceptual subjectivity: crosscutting from inside of the room to Kane outside of the room

c. What would have been the effect? We would have felt sympathy for Kane

V. CONCLUSION

 A. This **segment deals with Kane**'s obsession with control

 1. He tries to control other people by controlling what they "know" or feel

 2. Even the decision to end Susan's career is his; he controls her

 3. It deals with this issue largely through giving us the POV of one of his "victims," Susan

 B. It also deals with the subjectivity of reality

 1. Kane controls Susan, but seems to be genuinely concerned about her; is he a sympathetic or unsympathetic character?

 2. This segment presents a potential turning point in the film; however, we soon see that Kane has not changed, and continues his domination of Susan

THE CLASSICAL HOLLYWOOD CINEMA

Desperately Seeking Susan (Susan Seidelman, 1985)

Directed by Susan Seidelman

Written by Leora Barish and Floyd Byars

Music by Stephen Bray, Madonna and Thomas Newman

Cinematography by Edward Lachman

Editing by Andrew Mondshein

Cast

Rosanna Arquette…Roberta Glass

Madonna…Susan

Aidan Quinn…Dez

Mark Blum…Gary Glass

Robert Joy…Jim

Laurie Metcalf…Leslie Glass

Anna Levine…Crystal

STUDY QUESTIONS

1. Does *Desperately Seeking Susan* feature individual characters as causal agents? Do the characters have goals based on some sort of personal desire? What are they? Does opposition to the goals lead to conflicts? Do the characters change because of the conflicts? Is there a strong degree of closure?

2. Does this film feature two lines of action? What are they? How do they become interrelated?

3. In terms of editing, are graphics kept similar from shot to shot? Exceptions? Examples?

4. Are the lengths of the takes dependant on camera distance? Are long shots usually on screen longer than closer shots? Exceptions? Examples?

5. Can you give examples of instances of the 180° system? Shot/reverse shot? The eyeline match? Establishment/breakdown/reestablishment? Match on action? The cheat cut?

6. If we conclude that *Desperately Seeking Susan* conforms highly to the continuity editing system, how does this contribute to the film itself?

THE CLASSICAL HOLLYWOOD CINEMA in *Desperately Seeking Susan* (Susan Seidelman, 1985)

I. INTRODUCTION

 A. The 1985 film *Desperately Seeking Susan* was made outside of the Hollywood studio system (distributed by Orion)

 B. However, it still conforms to a high degree to the classical narrative style (as do most Hollywood [and other] movies, even today)

 C. We will look at the ways in which the film conforms to, and deviates from, this style

II. THE NARRATIVE ITSELF

 A. CAUSAL AGENTS

 1. Who, or what, are the causal agents of the action?

 a) They are individual characters (not social, political, or historical forces)

 (1) ROBERTA, the bored New Jersey housewife

 (2) SUSAN, the "free spirit"

 (3) GARY, Roberta's husband

 (4) DEZ, the projectionist who becomes Roberta's boyfriend when she loses her memory

 (5) JIM, Susan's boyfriend

 b) What about GENDER?

 (1) The CHC most often depends on a strong, male protagonist; what about this film?

 (2) Why is a female the lead?

 (a) Think about the genre

 (b) In comedies and melodramas, women are more often allowed to be leads than in other genres

2. These characters have specific GOALS (although not always from the very beginning of the film)

 a) ROBERTA

 (1) Initially, her goal (although a little vague) is to have a more interesting life

 (2) It soon becomes more specifically to find Susan, or at least to see her; a somewhat voyeuristic goal

 (3) Later, her goal is to find her identity and get away from the gangster

 (4) Finally, it is to resolve the conflict between her old identity and her new identity

 b) SUSAN

 (1) She initially is seeking Jim

 (2) Then she is looking for Roberta, who has the key to her locker and her "stuff"

 c) GARY is looking for Roberta

 d) DEZ is looking for Susan/Roberta

 e) JIM is looking for Susan

3. These goals lead to CONFLICTS

 a) ROBERTA

 (1) Her goal of eavesdropping on Susan leads to her confrontation with the gangster

 (2) In a more general way, her goal of living a more exciting life leads to the conflict within her: will she choose the safe life with Gary or a more exciting, but less opulent, life with Dez?

 b) SUSAN

 (1) Her goal of meeting Jim leads to both the missing earrings and Susan's accident

340

(2) Her goal of finding Roberta leads to the conflict with the gangster at the Magic Club

c) GARY: his goal of finding Roberta leads him (and his sister and her boyfriend) to the Magic Club, leading to the confrontation with Dez

d) DEZ: likewise, his search for Susan/Roberta leads to the confrontation with Gary at the Magic Club

e) JIM: his search for Susan leads him and Dez to the Magic Club

4. These conflicts lead to CHANGES in the status of the characters

a) ROBERTA leaves Gary for Dez, and loosens up considerably

b) SUSAN turns a little more "straight," returning the earrings and potentially settling down with Jim

c) GARY loses Roberta, but may loosen up somewhat (he did smoke some pot, after all)

d) DEZ gets Roberta

e) JIM gets Susan, and presumably a more stable life

B. There is typically much ACTION in the CHC

1. There are usually two distinct lines of action

a) One that is often WORK or GOAL-RELATED

(1) What is the most important goal-related line of action in this film?

(2) Is it not Roberta's goal of a more interesting life?

b) One that deals with ROMANCE

(1) What is the most important romance-related line of action in this film?

(2) Is it not between Roberta and Dez?

2. These lines of action are in turn often interrelated

a) Roberta's goal of a more interesting life leads to her romance with Dez

b) This sets up the ultimate conflict in the film; will she choose Dez (and a more interesting life) or Gary (and a more secure but boring life)?

C. CLOSURE is also an important part of this mode

1. Loose ends will be tied up, goals achieved, conflicts resolved, etc.

2. Were there any loose ends left dangling at the end of *Desperately Seeking Susan*?

III. The Style of the Classical Hollywood Cinema

A. RELATIONSHIP BETWEEN STYLE and NARRATIVE

1. The CHC emphasizes the clear transmission of narrative information

2. All elements of the film are motivated by the logic of the narrative

B. EDITING

1. As we know, the most important element of style in the CHC is CONTINUITY EDITING, or "invisible editing;" did you notice any "errors" of continuity in this film?

2. How did the editing further the narrative (in more specific ways?; and note that mise-en-scène is also a part of the effects discussed here)

a) The cut from the missing refrigerator to the present refrigerator

(1) It gives a sense of continuity where there is no strict continuity

(2) It does make a narrative or thematic point, however

(a) Gary can give Roberta material things that Dez can not give her

(b) But these are just material things

b) The cut from the New Jersey side of the bridge to the New York side of the bridge makes a connection between the two characters, but also points out a difference (what do we think of New Jersey and New York, respectively?)

C. MISE-EN-SCÈNE

1. How does the mise-en-scène serve to further the narrative?

 a) It provides clues, or reasons to continue the narrative

 b) Think of the key, the matchbook, the postcard, etc.

2. How does it make connections between Susan and Roberta?

 a) The earrings

 b) The jackets (Roberta wears Susan's, Susan wears Roberta's)

 c) The personal ads and the circles around the ads

 d) The boyfriends (and how are they alike? How does the film point this out to us?)

D. CINEMATOGRAPHY

1. How does the cinematography further the narrative?

 a) Think of the shot of them both walking before the gangster confronts Roberta

 b) Think of the shot of them in the newspaper photo

2. Does it sometimes confuse us?

 a) Perhaps, when Susan meets Gary at the night club, and the camera seems to lose the characters at times

 b) But is there a narrative reason for this? Doesn't it reflect the atmosphere of the club itself?

E. SOUND

1. The various songs "comment" on the action (for example, Marshall Crenshaw's "Someday Someway")

2. How does sound further the narrative? Sound bridges, especially; examples?

F. NARRATION in the CHC (in general!) tends to be objective and unrestricted

1. Is this true in *Desperately Seeking Susan?*

2. Examples?

IV. CONCLUSION

A. *Desperately Seeking Susan* is a film made outside of the Hollywood studio system

1. The breaking up of the studio system was supposed to "free" filmmakers to make new and different films

2. But, in many ways, the CHC has changed very little, as we see in *Desperately Seeking Susan*

B. The film conforms to a great extent to the CHC model

1. Motives for actions are planted ahead, making the narrative flow logically

2. Motifs create a sense of unity

3. It has a great degree of closure

C. The film is also typical in advocating some very common ideas about American life

1. We are all very much alike, despite surface differences (cf. *Something Wild*)

2. A "middle of the road" approach to life is best; avoid extremes (cf. *Something Wild* and *Singin' in the Rain*)

THE CLASSICAL HOLLYWOOD CINEMA

Gigi (Vincente Minelli, 1958)

Directed by Vincente Minelli

Written by Alan Jay Lerner

Music by Frederick Loewe

Cinematography by Joseph Ruttenberg and Ray June

Editing by Adrienne Fazan

Produced by Arthur Freed

Production and Distribution Company: Metro-Goldwyn-Mayer

Cast

Leslie Caron…Gigi

Maurice Chevalier…Honore Lachaille

Louis Jordan…Gaston Lachaille

Hermione Gingold…Madame Alvarez

Eva Gabor…Liane d'Exelmans

Jacques Bergerac…Sandomir

Isabel Jeans…Aunt Alicia

John Abbott…Manuel

STUDY QUESTIONS

1. To what type of film genre does *Gigi* belong? Is it a genre of determinate or indeterminate space? Is it a genre of social order, or one of social integration? How do we know?

2. How is the "social community" introduced to us? Where is the film set, and what kind of place is it? What kinds of characters are introduced to us, and how do we know what kinds of characters they are?

3. What are the conflicts of the story, and how are they set in motion? What intensifies these conflicts? How are they resolved?

4. In what ways is the style of the film "overdetermined"? How does this contribute to the narrative?

5. What are values does this film espouse? Are these values typical of the film's genres? Are they typical of classical Hollywood films?

THE CLASSICAL HOLLYWOOD CINEMA in *Gigi* (Vincente Minelli, 1958)

I. INTRODUCTION

 A. *Gigi* is an example of both the CHC and the genre of the musical

 B. As a musical, it is also a film of indeterminate space

 1. It does not have to take place in a certain locale or setting

 2. It deals with the rites of social integration, not the rites of social order

 3. The conflict is not over control of space, but involved the values of the romantic couple

II. HISTORY OF THE MUSICAL GENRE

 A. Unlike most genres, it is possible to establish a firm date which marks the birth of the film genre of the musical: 1927

 1. This is the year that "talkies" were introduced to the US on a wide scale

 2. It was also the year of the first musical, *The Jazz Singer*

 3. With the coming of sound, Hollywood turned to the New York theater for directors, actors, etc.

 4. This led to the musical genre in movies

 a) These people brought with them the conventions, genres, styles, etc. of the Broadway stage

 b) The musical seemed to be a logical genre for sound movies

 (1) It took advantage of the new technology to do something which could not be accomplished before

 (2) It took advantage of the talents of this new personnel

 B. EARLY MUSICALS

 1. Most early musicals were "backstage musicals"

 a) These presented stories which revolved around the staging of a "show"

 b) Therefore, the songs were realistically motivated by the narrative

 2. These gradually were replaced to some degree by the "integrated musical"

C. THE INTEGRATED MUSICAL

 1. This refers to musicals in which the songs are incorporated into the narratives

 a) The songs are not always realistically motivated by the narrative

 b) These films provide a more complex relationship between the narratives and the musical numbers

 c) The songs more directly reflect the conflicts of the story, the feelings of the characters, etc. (not just songs they happen to be singing)

 2. The audience and its relationship with the integrated musical

 a) These require more of a "suspension of disbelief" than do backstage musicals

 b) Characters sing in public with no narrative motivation;

 c) But the narratives operate on two levels:

 (1) In the story, they are mostly oblivious to the film's plot and the audience

 (2) In the plot, they sing to the audience, directly addressing the camera and the viewer

 (3) This blurring of story and plot challenges the audience and the limits it will accept

 3. STYLE OF THE INTEGRATED MUSICAL

 a) Along with this foregrounding of narration, the integrated musical was usually very stylized (as opposed to the backstage musical, which aspired to "realism")

 b) As Thomas Schatz points out in *Hollywood Genres*, it "sacrificed plausibility for internal narrative logic"

						(1)		In other words, everything in the plot is acceptable *within the context of the film*, even though it is completely unrealistic

(2)		Cf. science fiction, or even Westerns

 c)	Once you accept that characters can break out in song (with musical accompaniment) in public, and that they can look at and sing to the audience, you can accept other formal stylization

(1)		Three-Color Technicolor, which offered bright, unrealistic colors

(2)		Rear projection of obviously fake backgrounds

(3)		"Overdetermined" mise-en-scène (exaggerated to make a point)

(a)		Excessive costume, objects, etc. designed to recreate this idealized world

(b)		Figure behavior which would be out of place in other genres

III.	THE FREED UNIT

A.	The integrated musical reached its highest levels of sophistication at MGM in the 1940s and 1950s

B.	Many of these films were produced by Arthur Freed

1.	He was a former songwriter who became a successful producer at MGM

2.	His films all bear his personal mark; they all display his concern that the musical could only be really successful if it was integrated

C.	Some of the musical's greatest talents worked for Freed

1.	Directors: Vincente Minelli and Stanley Donen

2.	Actors: Fred Astaire, Gene Kelly, Leslie Caron

3.	Films: *Meet Me in St. Louis, Singin' in the Rain, Gigi*

IV.	*Gigi* AS A FILM OF SOCIAL INTEGRATION

A.	HERO: Not an individual male hero, but a romantic couple

B. SETTING

 1. It is indeterminate, so it can take place anywhere

 2. The setting is a civilized space; it is *ideologically stable*

 3. What is the space? Why is this important, what does it add or how does it affect the narrative?

 4. The characters can not alter the space or its ideology, so they must find a solution which will fit in with their values and with those of society

C. VALUES

 1. They are basically feminine

 a) As opposed to those of genres of determinate space, which are masculine (order, action, violence, duty, personal honor, glory, etc.)

 b) These values are maternal, domestic, family-oriented, etc.

 2. What are the values that are in conflict?

 a) Gaston

 (1) He is a "ladies' man"

 (2) He is cruel to women

 (3) He is a man of the world, sophisticated

 (4) He is in fact jaded, and bored to death even with the glamor of the world

 (5) He keeps love and sex separate

 b) Gigi

 (1) She is a child, not interested in sex

 (2) She is spontaneous, she loves even the simple things life has to offer

 (3) She is outspoken, and has a healthy disregard for society and its rules

 (4) She can not separate love and sex

D. THE RESOLUTION

 1. The musical genre ends in social integration

 a) The couple aligns their values with one another

 b) The embrace (or wedding, etc.) symbolizes this integration

 2. In *Gigi*

 a) What is the crisis which leads to the resolution?

 (1) Gigi decides to conform to Gaston's values, becoming his mistress

 (2) Gaston becomes disgusted with himself and what he has created

 b) Gaston conforms to the values of Gigi

 (1) He asks her grandmother for "her hand"

 (2) He accepts domestication and sex with love

 (3) She becomes his wife, not his mistress

 c) But were his values really that different?

 (1) He really loved her and what she represents, all along (how do we know?)

 (2) She has made Gaston accept that what he *really* values, as opposed to what society dictates, is correct

V. CLOSURE

 A. How does the end fit the model of the CHC?

 B. How does it fit the model of the musical genre?

 C. According to Schatz:

 1. "Sexual courtship in the musical invariably is shown as conflict."

 2. "Generally we are given little reason beyond the show itself to believe that the conflicts, which complicated the couple's relationship throughout the film, will magically dissolve once the performance is over."

 3. "Anyway, it is precisely because of the irreconcilable nature of these conflicts that the genre's narrative strategies have developed."

 4. "The musical finale and its celebration of romantic love ultimately prevent us from speculating beyond the film's closing moments."

D.	How do we see this in *Gigi*?

1.	Is there a suggestion that this is an eternal problem?

2.	Does the film end as it began?

3.	What does the film suggest happens after marriage?

THE CLASSICAL HOLLYWOOD CINEMA

Les Girls (George Cukor, 1957)

Directed by George Cukor

Written by John Patrick

Music by Cole Porter

Cinematography by Robert Surtees

Editing by Ferris Webster

Produced by Sol C. Siegel

Production and Distribution Company: Metro-Goldwyn-Mayer

Cast

Gene Kelly…Barry Nichols

Mitzi Gaynor…Joy Henderson

Kay Kendall…Lady Sybil Wren

Taina Elg…Angèle Ducros

Jacques Bergerac…Pierre Ducros

Leslie Phillips…Sir Gerald Wren

Henry Daniell…Judge

Patrick Macnee…Sir Percy

Stephen Vercoe…Mr. Outward

Philip Tonge…Associate Judge

STUDY QUESTIONS

1. To what type of film genre does *Les Girls* belong? Is it a genre of determinate or indeterminate space? Is it a genre of social order, or one of social integration? How do we know?

2. How is the "social community" introduced to us? Where is the film set, and what kind of place is it? What kinds of characters are introduced to us, and how do we know what kinds of characters they are?

3. What are the conflicts of the story, and how are they set in motion? What intensifies these conflicts? How are they resolved?

4. In what ways is the style of the film "overdetermined"? How does this contribute to the narrative?

5. What are the values does this film espouse? Are these values typical of the film's genres? Are they typical of classical Hollywood films?

THE CLASSICAL HOLLYWOOD CINEMA in *Les Girls* (George Cukor, 1957)

I. INTRODUCTION

 A. *Les Girls* is an example of both the CHC and the genre of the musical

 B. As a musical, it is also a film of indeterminate space, as defined by Thomas Schatz in *Hollywood Genres*

 1. It does not have to take place in a certain locale or setting

 2. It deals with the rites of social integration, not the rites of social order

 3. The conflict is not over control of space, but involves the values of the romantic couple

II. HISTORY OF THE MUSICAL GENRE

 A. Unlike most genres, it is possible to establish a firm date that marks the birth of the film genre of the musical: 1927

 1. This is the year that "talkies" were introduced to the US on a wide scale

 2. It was also the year of the first musical, *The Jazz Singer*

 3. With the coming of sound, Hollywood turned to the Broadway for directors, actors, etc.

 4. This led to the musical genre in movies

 a) These people brought with them the conventions, genres, styles, etc. of the Broadway stage

 b) The musical seemed to be a logical genre for sound movies

 (1) It took advantage of the new technology to do something that couldn't be done before

 (2) It took advantage of the talents of this new personnel

 B. EARLY MUSICALS

 1. Most early musicals were "backstage musicals"

 a) These presented stories that revolved around the staging of a "show"

 b) Therefore, the songs were realistically motivated by the narrative

 2. These gradually were replaced to some degree by the "integrated musical"

C. THE INTEGRATED MUSICAL

 1. This refers to musicals in which the songs are incorporated into the narratives

 a) The songs are not always realistically motivated by the narrative

 b) These films provide a more complex relationship between the narratives and the musical numbers

 c) The songs more directly reflect the conflicts of the story, the feelings of the characters, etc. (not just songs they happen to be singing for a show)

 2. The audience and its relationship with the integrated musical

 a) These require more of a "suspension of disbelief" than do backstage musicals

 b) Characters sing in public with no narrative motivation

 c) But the characters in these narratives operate on 2 levels:

 (1) In the story, they are mostly oblivious to the film's plot and the audience

 (2) In the plot, they sing to the audience, directly addressing the camera and the viewer

 (3) This blurring of story and plot challenges the audience and the limits it will accept

 3. STYLE OF THE INTEGRATED MUSICAL

 a) Along with this foregrounding of narration, the integrated musical is usually very stylized (as opposed to the backstage musical, which aspired to "realism")

 b) Plausibility is sacrificed for internal narrative logic

(1) In other words, everything in the plot is acceptable *within the context of the film*, even though it is completely unrealistic

(2) Cf. science fiction, or even Westerns

 c) Once you accept that characters can break out in song (with musical **accompaniment**) in public, and that they can look at and sing to the audience, you can accept other formal stylization

(1) Three-Color Technicolor, which offered bright, unrealistic colors

(2) Rear projection of obviously fake backgrounds

(3) "Overdetermined" mise-en-scene (exaggerated to make a point)

(a) Excessive costume, objects, etc. designed to recreate this idealized world

(b) Figure behavior that would be out of place in other genres

4. The integrated musical reached its highest levels of sophistication at MGM in the 1940s and 1950s

III. *Les Girls* AS A FILM OF SOCIAL INTEGRATION

 A. HERO

1. Not an individual male hero, but a romantic couple

2. In this case, we are in some doubt until near the end of the film

 a) We think it is Barry and Angelle

 b) Then we think it is Barry and Sybil

 c) However, we finally see that the couple consists of Barry and Joy

 B. SETTING

1. It is indeterminate, so it can take place anywhere

2. The setting is a civilized space; it is *ideologically stable*

3. What is the space? Why is this important, what does it add or how does it affect the narrative?

 a) The space is mostly Paris, but also other exotic locations in Europe

 b) How does this tie in with the narrative?

 (1) What does Barry say is the reason he is there?

 (2) What does this set up?

 (3) Barry and Joy as Americans?

4. The characters can't alter the space or its ideology, so they must find a solution that will fit in with their values and with those of society

C. VALUES

1. They are basically feminine

 a) As opposed to those of genres of determinate space, which are masculine (order, action, violence, duty, personal honor, glory, etc.)

 b) These values are maternal, domestic, family-oriented, etc.

2. What are the values that are in conflict?

 a) Barry

 (1) He is a ladies' man

 (2) He is not always especially sympathetic to "his girls"

 (3) He is a man of the world, sophisticated

 (4) He is dishonest (in all of the flashbacks)

 (5) But is there a difference in the way he is depicted in the three flashbacks?

 (6) But even in his own, he is reluctant to go along with marriage

 b) Joy

 (1) In what ways is she different from the other girls?

 (2) What is it she is interested in?

 (3) She is the CHC's "good woman"

D. THE RESOLUTION

1. The musical genre ends in social integration

 a) The couple aligns their values with one another

 b) The embrace (or wedding, etc.) symbolizes this integration

2. In *Les Girls*

 a) Who conforms to what values?

 (1) Barry realizes that he can only win Joy by marrying her

 (2) What is the situation at the end of the film?

 b) But were his values really that different?

 (1) He really loved her, and what she represents, all along

 (2) She has made Barry accept that what he *really* values, as opposed to what he *thinks* he values, is correct

IV. *Les Girls*, THE MUSICAL, and THE CHC

 A. How does it fit the model of the musical genre?

 1. What sort of conventions of the musical do we see, especially at the beginning?

 2. In some respects, it just skips some of the conventions of the musical

 a) It neglects a long courtship between Barry and Joy

 b) It neglects a final song that resolves the conflict, etc.

 3. It does this because, by 1957, these things were taken for granted by the audience

 B. How does the film fit (or not) the model of the CHC?

 1. How is the first flashback presented?

 2. How is space handled?

 3. What about closure?

 a) Do we know the truth?

 b) What will happen between Barry and Joy?

 4. Why the "violations" of the CHC?

 a) It is an integrated musical; allowed more freedom because it is not realistic

b) It is a comedy; therefore allowed more freedom for this reason

c) Finally, it probably has been influenced to a certain extent by the European Art Cinema

THE CLASSICAL HOLLYWOOD CINEMA

Picnic (Joshua Logan, 1955)

Directed by Joshua Logan

Written by William Inge and Daniel Taradash

Produced by Fred Kohlmar

Original music by George Duning

Cinematography by James Wong Howe

Film Editing by William A. Lyon and Charles Nelson

Production Company: Columbia Pictures Corporation

Cast

William Holden…Hal Carter

Kim Novak…Madge Owens

Rosalind Russell…Rosemary Sidney

Susan Strasberg…Millie Owens

Arthur O'Connell…Howard Bevans

Cliff Robertson…Alan

Betty Field…Flo Owens

Verna Felton…Helen Potts

Reta Shaw…Linda Sue Breckenridge

Nick Adams…Bomber

Phyllis Newman…Juanita Badger

STUDY QUESTIONS

1. To what type of film genre does *Picnic* belong? Is it a genre of determinate or indeterminate space? Is it a genre of social order, or one of social integration? How do we know?

2. How is the "social community" introduced to us? Where is the film set, and what kind of place is it? What kinds of characters are introduced to us, and how do we know what kinds of characters they are?

3. What are the conflicts of the story, and how are they set in motion? What intensifies these conflicts? How are they resolved?

4. Can we say that this film is critical of American society? Does the resolution seem satisfactory? Will Howard and Rosemary be happy? Will Madge and Hal be happy? What is the film's message about "romantic love" and marriage? Are they about passion and sex, or security and a refuge from loneliness?

THE CLASSICAL HOLLYWOOD CINEMA in *Picnic* (Joshua Logan, 1955)

I. THE FAMILY MELODRAMA GENRE

 A. Thomas Schatz, in *Hollywood Genres*: Hollywood has always produced melodramas, movies in which the dramatic situations seem almost stylized, not realistic

 1. Tend to be "over-determined," excessive in style (mise-en-scène, especially), plot and story

 2. The good guys are very good, the bad guys are very bad, the women are very beautiful, etc.

 B. This developed into the conventionalized form of the "melodrama"

 1. "Popular romances that depicted a virtuous individual (usually a woman) or couple (usually lovers)...

 2. ...victimized by repressive and inequitable social circumstances...

 3. ...particularly those involving marriage, occupation, and the nuclear family."

II. GENERAL CHARACTERISTICS OF THE FAMILY MELODRAMA (according to Schatz)

 A. Genre of indeterminate space

 1. No particular setting is necessary

 2. Struggle is not for control of the space; the space is ideologically stable, and can not be changed

 3. Not individual hero, but romantic couple or "doubled hero"

 B. Not a genre of social order, but one of SOCIAL INTEGRATION

 1. Couple is a romantic one, different backgrounds and/or values; or they have values different from those of society

 2. Problem is integration of two systems of values; need to be reconciled with one another and/or society

 C. The resolution involves:

 1. The "embrace": the lovers come together

2. And/or integration or domestication

III. SPECIFIC CHARACTERISTICS OF THE FAMILY MELODRAMA

 A. Compared to romantic comedy

 1. Characters of romantic comedies defy and mock society's rules; in melodrama they are at the mercy of these social conventions

 2. In romantic comedies lovers are integrated as a marital unit distinct from society and its rules; in melodrama resign themselves to social traditions

 B. Schatz: after WW II Hollywood pushed limits of melodrama to show "anxious lovers in a suffocating, highly stylized social environment"

 C. Today, these films (especially of 1950s) seem to portray a society in turmoil

 1. Conservative Eisenhower years, traditional ideas about the role of women and their sexuality, as well as "family values"

 2. At the same time, women beginning to fight restrictions (remember their role in WW II), and we were entering the "space age": women's liberation, 60s, Vietnam, just around the corner

 D. Because these films are so excessive:

 1. Seem to subvert the genre even as they established it

 2. Or, as Shatz puts it, they both celebrate and question the basic values and attitudes of the mass audience

IV. PLOT STRUCTURE OF THE FAMILY MELODRAMA

 A. ESTABLISHMENT

 1. Field of reference and inherent dramatic conflicts accomplished through narrative and iconographic cues

 2. THE NUCLEAR FAMILY

 a) IN GENERAL: It is loaded with icons; family roles are clearly understood by the characters' positions (mother, daughter, etc.)

 b) IN *Picnic*

 (1) It consists of only women

 (2) Where is the man of the house? (deserted the family years ago)

 (3) Clues that a man is needed in the household

 3. THE COMMUNITY

 a) IN GENERAL

 (1) Schatz: family is tied to the larger community

 (2) Family roles are defined by the community

 (3) The family has a clear position in the class structure of the community

 (4) The community (and family) has a "reactionary commitment to fading values and mores"

 b) IN *Picnic*

 (1) How does this work in *Picnic*?

 (2) Who best exemplifies these "fading values" and attitudes?

 4. The "acceptable" lover, Alan

 a) Why is he acceptable and to whom?

 b) What kind of character is he, and how do we know?

 5. The male intruder, Hal

 a) What kind of character is he?

 b) How do we know?

 c) Who likes him (Mrs. Potter); why?

B. ANIMATION

 1. …of the basic conflicts through the actions and attitudes of the genre's characters

 2. What is it that leads to the conflicts involved?

 3. What are the conflicts?

C. INTENSIFICATION

 1. Of the conflict by means of conventional situations and dramatic confrontations until the conflict reaches crisis proportions

 2. What intensifies the conflict?

 3. Attempt to solve these problems leads to the crisis

D. RESOLUTION

 1. Of the crisis in a way that eliminates the threat

2. How is the threat resolved; what constitutes resolution in this film (and genre)?

 a) The embrace; they have embraced and Madge will leave home to be with Hal

 b) Domestication; Hal will settle down and support Madge

 c) Madge admits that she loves Hal and wants a "real man," not security

V. CONCLUSION

A. Can we say that this film is critical of American society?

B. Does the resolution seem satisfactory?

 1. Will Howard and Rosemary (the school teacher) be happy?

 a) What does the film suggest about her?

 b) What does the film suggest about him?

 2. Will Madge and Hal be happy? Why or Why not?

C. If we compare the two "embraces," what is the message about "romantic love" and marriage?

 1. Are they about passion and sex?

 2. Or are they about security and a refuge from loneliness?

THE CLASSICAL HOLLYWOOD CINEMA

Scarface (Howard Hawks, 1932)

Directed by Howard Hawks

Written by Ben Hecht

Cinematography by Lee Garmes and L. William O'Connell

Editing by Edward Curtiss and Lewis Milestone

Produced by Howard Hawks and Howard Hughes

Production Company: The Caddo Company

Distribution Company: United Artists

Cast

Paul Muni…Antonio 'Tony' Camonte

Ann Dvorak…Cesca Camonte

Karen Morley…Poppy

Osgood Perkins…John 'Johnny' Lovo

C. Henry Gordon…Insp. Ben Guarino

George Raft…Guino Rinaldo

Vince Barnett…Angelo

Boris Karloff…Gaffney

STUDY QUESTIONS

1. To what type of film genre does *Scarface* belong? Is it a genre of determinate or indeterminate space? Is it a genre of social order, or one of social integration? How do we know?

2. How is the "social community" introduced to us? Where is the film set, and what kind of place is it? What kinds of characters are introduced to us, and how do we know what kinds of characters they are?

3. What are the conflicts of the story, and how are they set in motion? What intensifies these conflicts? How are they resolved?

4. What kinds of values does the film present to us? Are they essentially masculine or feminine?

5. Is *Scarface* typical, in terms of its narrative and style, of the gangster genre? Is it typical of the classical Hollywood cinema?

THE CLASSICAL HOLLYWOOD CINEMA in *Scarface* (Howard Hawks, 1932)

I. ORIGINS OF THE GANGSTER GENRE

 A. Urban crime films appeared in the early days of silent American film, and grew more popular in the late 1920s

 B. However, they became especially popular in the early 1930s

 1. Gangsters proliferated in American cities (Capone in Chicago, the Purple Gang in Detroit, etc.), and were in the news

 2. This underworld made interesting sounds--violence, jazz, dialogue, etc.-- that added to the appeal of these films

II. CHARACTERISTICS OF THE GANGSTER GENRE (according to Thomas Schatz in *Hollywood Genres*)

 A. It is a genre of DETERMINATE SPACE

 1. It takes place in a particular locale: the American city (in this case, Chicago)

 2. The conflict is one over control of that space

 3. The "hero" enters the space, creates some sort of order, then leaves the space

 B. Therefore it is a genre of SOCIAL ORDER, not SOCIAL INTEGRATION

 1. Involves an individual male hero, not a couple

 2. The conflict is a physically violent one, not emotional

 3. The resolution involves elimination of a threat to the social order, not a romantic embrace

 C. THEMES and VALUES

 1. Mediation between two forces, not integration

 a) On one side is a violent, urban criminal community without morals

b) On the other side is a society with values the hero can not understand or accept

c) He ends up relying on his own sense of morals

 (1) He operates differently from both the cops and the crooks

 (2) Therefore both groups tend to reject his personal style

d) The sometimes restricted narration helps us see this world as Tony Camonte sees it

2. It deals with the theme of the macho code, not feminine or family values

a) He operates the way he does because of "professional integrity"

b) He does not care that much about romance or friendship

c) It deals with value of self-reliance, not cooperation

 (1) He succeeds due to his status as a "loner," rejects cooperation

 (2) Compare this to the Western, in which the "good guy" works alone to save the community

D. HOW DOES THE GANGSTER FILM DIFFER FROM OTHER DETERMINATE GENRES?

1. Unlike the Western, the Gangster film presents a world in which social order has been established but must be maintained

2. There are anarchic forces that seek to destroy this order; these are seen as more natural forces (not civilized), "dog eat dog"

3. The strong, individual Gangster "hero" is a product of these two conflicting forces

a) He is aggressive, determined, keeps his mind on his business; he is not sentimental

b) But he seeks to establish a new kind of social order; ironically, it is one based on anarchy

c) It is this conflict--not strictly a conflict over control of space--that is at the heart of the Gangster film

d) This is why he must leave the space at the end of the film; he does not really fit in with either group, he is too much of an individual

e) How does this conflict lead to his end?

 (1) He has a devotion to duty (his own career), but also to Cesca

 (2) His love for her leads him to kill Little Boy

 (3) Little Boy was one of the reasons for his success

 (4) This unplanned killing leads to his death at the hands of the police

f) It is this contradiction that makes the underworld impossible to maintain as an orderly society (and maybe our civilized society also?)

E. THE FIELD OF REFERENCE OR SOCIAL COMMUNITY

 1. *Scarface* was made during the classical stage of the Gangster genre

 2. Therefore the genre's field of reference was already well established and understood by the audience

 3. ICONS

 a) ACTORS: Paul Muni, George Raft

 b) OBJECTS: Spats, tommy guns, cigarettes, booze, speakeasies, etc.

 c) DIALOGUE

 (1) "You think you're pretty tough, but you'll turn yellow like all the rest."

 (2) "There's only one law: Do it first, do it yourself, and keep on doing it."

 d) MUSIC: Jazz and 1930s "newsreel"-type overly-dramatic music

 4. THE CHARACTERS

 a) THE GANGSTER: Often, as in *Scarface*, crude, but with pretensions to sophistication

 b) THE MOLLS or "loose women": Poppy, Mabel, etc.

 c) THE FAITHFUL SIDEKICK(S): Little Boy, the "secetary"

 d) THE GOOD (or virtuous) WOMAN: Cesca

 e) THE BUMBLING POLICE

 (1) Do they really succeed?

 (2) How do they compare to the gangsters?

 (a) Not as interesting

 (b) Willing to bend the law

III. *Scarface* AS CHC

 A. The CHC's Form and Subject Matter

 1. The CAUSAL AGENTS of the action

 a) Are individual characters

 b) Not historical or social forces; there is no reason provided for Tony's criminal behavior

 2. These characters have specific GOALS

 a) Tony wants to control the Chicago underworld

 b) Cesca wants to find her own life and romance

 3. These goals lead to CONFLICTS

 4. These conflicts lead to CHANGES in the status of the characters; they end up dead

 5. There are two distinct lines of action

 a) One that is WORK-RELATED; Tony's "work" is being a gangster, and he seeks to control the Chicago underworld

 b) The other involves ROMANCE

 (1) It is not his romance with Poppy

 (2) It is his "romance" with Cesca

 c) These lines of action are interrelated; Tony's jealousy leads to his downfall at a time when he seemed unstoppable

 6. CLOSURE is accomplished

 a) Tony and Cesca are killed (along with Tony's "business associates")

 b) According to the movie, Chicago is now free from gangsters (a "new crowd" at City Hall, etc.)

B. The Style of the Classical Hollywood Cinema

 1. *Scarface* relies on the CHC's CONTINUITY EDITING, or "invisible editing"

 2. STYLE and NARRATIVE

 a) Space and time are clearly constructed

 (1) We are never confused about where we are or where the characters are in relation to one another

 (2) We are never confused about when events happen in relation to one another

 b) We are never distracted by the style; there is no attempt to call attention to the graphics of the images or the rhythm of the editing

 3. STYLE and NARRATION

 a) Narration in the CHC (in general!) tends to be external, objective, and unrestricted

 b) *Scarface* usually conforms to this style of narration

 (1) It is generally external and objective

 (2) But it is sometimes restricted to Tony's POV; this is done to allow us to experience the film as he does

IV. CONCLUSION: As we have seen, *Scarface* conforms closely to both the model of the Gangster genre and the model of the CHC

THE CLASSICAL HOLLYWOOD CINEMA

Stagecoach (John Ford, 1939)

Directed by John Ford

Written by Dudley Nichols and Ben Hecht

Music by Gerard Carbonara

Cinematography by Bert Glennon

Editing by Otho Lovering, Dorothy Spencer and Walter Reynolds

Produced by John Ford and Walter Wanger

Production Company: Walter Wanger Productions

Distribution Company: United Artists

Cast

Claire Trevor…Dallas

John Wayne…The Ringo Kid

Andy Devine…Buck

John Carradine…Hatfield

Thomas Mitchell…Doc Boone

Louise Platt…Lucy Mallory

George Bancroft…Marshal Curly Wilcox

Donald Meek…Samuel Peacock

Berton Churchill…Henry Gatewood

Tim Holt…Lt. Blanchard

Tom Tyler…Luke Plummer

STUDY QUESTIONS

1. To what type of film genre does *Stagecoach* belong? Is it a genre of determinate or indeterminate space? Is it a genre of social order, or one of social integration? How do we know?

2. How is the "social community" introduced to us? Where is the film set, and what kind of place is it? What kinds of characters are introduced to us, and how do we know what kinds of characters they are?

3. What are the conflicts of the story, and how are they set in motion? What intensifies these conflicts? How are they resolved?

4. Why, do you think, was the Western such a popular genre, not just in the United States but internationally? What is it about the genre that resonates so profoundly with its audience?

5. In what ways is this film different from more recent Westerns? Have the characteristics and conventions changed, or are they simply presented in different ways?

THE CLASSICAL HOLLYWOOD CINEMA in *Stagecoach* (John Ford, 1939)

I. INTRODUCTION

 A. *Stagecoach* is an example of both the classical Hollywood cinema and the genre of the Western

 B. As a Western, it is also a film of determinate space, as defined by Thomas Schatz in *Hollywood Genres*

 1. It must take place in a certain locale or setting: the American West

 2. It deals with the rites of social order, not the rites of social integration

 3. The conflict is over control of space, not the conflicting values of the romantic couple

II. HISTORY OF THE WESTERN GENRE

 A. THE SILENT ERA

 1. *The Great Train Robbery* (1903)

 a) This film is generally considered to the first Western

 b) Due to its popularity, Westerns continued to be made throughout the silent era

 2. *Covered Wagon* (1923)

 a) This film was the most popular Western of the silent era

 b) It set up many of the concepts and conventions of the Western

 (1) Wagon trains traveling West

 (2) The conflict caused by "sodbusters" moving into the previously open territory, etc.

 B. THE COMING OF SOUND (around 1929)

 1. This brought new popularity to the Western

 2. Along with Western feature films, Western serials were also popular

 a) The consisted of twelve to fifteen episodes of about fifteen minutes each

b) They were cheap to make, encouraging production, esp. by smaller production companies

c) They were shown before the main feature in many theaters

C. THE CLASSICAL PERIOD OF THE WESTERN

1. This occurred between 1930 and 1955

 a) During this time Westerns were very popular

 b) They were made by many of the major Hollywood directors (John Ford, Howard Hawks, etc.)

2. Around 1955, TV took over the Western, and it began to decline as a film genre; however, it is revived periodically

III. THE WESTERN and ITS CHARACTERISTICS

A. WHY WAS IT SO POPULAR?

1. The Western is an intrinsically *American* film genre

 a) Geographically, historically, and culturally, the Western is distinctly American

 b) Despite this, or perhaps because of this, the Western was popular worldwide

2. It deals with attitudes and values that we still admire and to which we still aspire

 a) This is true even though the situations with which these films dealt no longer exist

 b) In fact, they never really did exist; perhaps they are therefore universal?

B. THE CHARACTERISTICS and IDENTIFYING MARKS OF THE WESTERN

1. TIME and HISTORICAL SITUATION

 a) Most Westerns take place in the period 1860-90

 b) This is when the West was opened up by the laying of train tracks, the settling of the land by farmers and sheepherders, etc.

 c) This leads to the specific locale of the Western

2. LOCATION; As a genre of determinate space, the Western must take place in the American West

3. CONFLICT

 a) As a genre of social order, the Western deals with the struggle between *civilization* and *savagery* that resulted from this set of **circumstances**

 b) This struggle is expressed in a variety of *oppositions*:

 (1) East vs. West

 (2) Town vs. wilderness

 (3) Social order vs. anarchy

 (4) Individual vs. community

 (5) Cowboy vs. Indian

 (6) "Schoolmarm" vs. dancehall girl, etc.

IV. *Stagecoach* AS AN EXAMPLE OF THE WESTERN GENRE

 A. THE OPENING OF THE FILM ESTABLISHES THE GENERIC SITUATION

 1. The title and the nondiegetic music signal both the Western genre and the fact that Indians will play a part in the film

 2. The opening shot of Monument Valley

 a) This establishes the location

 b) It also introduces the theme of isolation (two lone riders in the desert)

 3. We see a cut to the next shot

 a) This introduces the theme of the intrusion of civilization, as the screen is filled with tent, soldiers, etc.

 b) The conflict between this civilization and the wilderness is introduced

 (1) The telegraph--representing civilization and technology--goes dead; the link that civilization maintains with the "real world" is a fragile one

(2) The cause of this threat to civilization is made clear; the last word the fort receives is "GERONIMO"

B. HOLLYWOOD'S VERSION OF THE WEST

1. Hollywood's version of the West--not the "real" West--is presented in this film

a) The West is a vast wilderness dotted with occasional civilized locations: towns, forts, etc.

b) These "oases" are linked by society's "tentacles of progress" such as railroads, telegraph, and stagecoaches

2. Each outpost of civilization is also a microcosm of society itself

a) It is threatened by external factors: the harsh environment, Indians, etc.

b) Each is also threatened by internal factors: anarchic and/or socially corrupt members of its own community (gamblers, outlaws, etc.)

C. THE STAGECOACH AS A MICROCOSM

1. It faces the same threats as do the other outposts of society

a) It is threatened externally by Indian attacks

b) It is threatened internally by conflicts within the group itself

2. The passengers represent both the positive and negative aspects of civilization

a) THE "EASTERN" CHARACTERS

(1) PEACOCK (the whiskey drummer)

(a) He represents the East, civilization, and the coming of commerce to the West

(b) But he also represents the problems that come from the civilized world (alcoholism)

(2) GATEWOOD (the bank executive)

(a) He also represents the coming of commerce and order

(b) But he also represents the crime that comes with commerce

(3) LUCY

 (a) She is Eastern-bred and is basically good

 (b) But she also feels superior to the other characters, **and can not understand men like Ringo** or women like Dallas

(4) HATFIELD (the gambler)

 (a) He also has Eastern characteristics; he is polite and somewhat refined (a Southerner)

 (b) But he also is decadent, dishonest, and a little slimy

b) THE "WESTERN" CHARACTERS

(1) RINGO KID

 (a) He is caught between conflicting goals

 (i) He needs to avenge his brother's death

 (ii) But he also wants to obey the law

 (b) Ultimately, he must defy the law to achieve the higher moral goal

 (c) His creed is "A MAN'S GOTTA DO WHAT A MAN'S GOTTA DO"

(2) DALLAS (the prostitute)

 (a) She is clearly a woman of the West (note her name)

 (b) She served a function, but is now rejected by the civilization that has moved West

(3) DOC BOONE

 (a) Like Dallas, he served an important function in the "Old West"

 (b) Now he has fallen victim to the civilization that condemns him

(4) GERONIMO

 (a) He represents the West in its rawest, most anarchic form

 (b) The Indians completely lack either civilization or any higher moral code

 (c) They are just wild and crazy for no apparent reason

c) THE MEDIATING FORCE: THE SHERIFF

 (1) He wants to uphold the law and bring order to the West

 (2) But at heart he is a man of the West; he recognizes both Ringo's plight and his value to society (even if society itself does not recognize this)

 (3) The Sheriff's goal is to satisfy both of these groups

D. DEVELOPMENT OF THE PLOT

1. Once these characters are in place and the conflicts are established, we move on with the development of the plot

2. ANIMATION; the actions and the attitudes of the characters set the conflicts in motion, as values interact and come into opposition

3. INTENSIFICATION; the confrontations of characters over opposing values and attitudes intensify, until they reach a series of crises

4. RESOLUTION; the crises lead to resolution (or closure) of all of the various storylines

 a) GATEWOOD is apprehended

 b) HATFIELD

 (1) He dies, but redeems himself through death

 (2) The West has "cleansed" the Easterner of his decadence

 c) LUCY remains civilized, but now accepts Dallas and Ringo

 d) PEACOCK

 (1) He helps to mediate the conflict within the stagecoach

 (2) He will return to Kansas City (Kansas), but invites Dallas to visit his family

 e) THE SHERIFF

 (1) He maintains law and order

 (2) But he also allows Ringo to achieve his higher moral goal

 f) RINGO KID

 (1) He "does what a man's gotta do" by breaking the law of the East but obeying the law of the West

 (2) He saves the party (and therefore civilization)

 (3) But he can not integrate with that society; it can't accept him or his methods, even though he has made the West safe for the community

 g) DALLAS

 (1) She becomes an "honest woman"

 (2) But society can not accept her either, and she leaves with Ringo

 h) DOC BOONE

 (1) He redeems himself at the birth of Lucy's baby

 (2) He becomes a part of civilization, but remains a critic of it

V. CONCLUSION

 A. The conformity of the East (order, civilization, law, manners, etc.) has come into conflict with the individualism of the West (survival, action, a higher moral code, etc.)

 B. Although the values of the East persevere, we recognize the Western values as superior

 C. Doc Boone's final comment also expresses the Westerner's ambivalent attitude toward the settling of the West: "Well, at least they're saved from the blessing of civilization."

THE CLASSICAL HOLLYWOOD CINEMA

It Happened One Night (Frank Capra, 1934)

Directed by Frank Capra

Written by Samuel Hopkins Adams and Robert Riskin

Produced by Harry Cohn

Original music by Louis Silvers

Cinematography by Joseph Walker

Film Editing by Gene Havlick

Art Direction by Stephen Goosson

Production Company: Columbia Pictures Corporation

Cast

Clark Gable…Peter Warne

Claudette Colbert…Ellie Andrews

Walter Connolly…Alexander Andrews

Roscoe Karns…Oscar Shapeley

Jameson Thomas…King Westley

Alan Hale…Danker

Arthur Hoyt…Zeke

Blanche Frederici…Zeke's Wife

Charles C. Wilson…Joe Gordon

STUDY QUESTIONS

1. *It Happened One Night* is generally considered the first of the screwball comedies. Can you give examples of some of the characteristics of the genre?

 a. Fast-paced with witty dialogue?

 b. Somewhat sexual situations?

 c. Zany, unlikely situations?

 d. A different attitude toward the rich from that of the earlier sound comedies?

2. Is the screwball comedy a genre of determinate or indeterminate space? How do we see this in *It Happened One Night*?

3. Is this film one in which the issue involves social order, or social integration?

4. The screwball comedy has, to a certain extent, a characteristic style. How can we see this in the editing? Cinematography?

5. In what ways does this film celebrate American values?

THE CLASSIC HOLLYWOOD CINEMA in *It Happened One Night* (Frank Capra, 1934)

I. THE SCREWBALL COMEDY

 A. Originated in the early to mid 1930s (during the Depression)

 1. Grew out of early sound comedy; fast-paced, witty dialogue, often about the rich and their faults

 2. *It Happened One Night* (1934) is often considered the film that introduced the genre

 B. General characteristics

 1. Fast-paced with witty dialogue

 a) EXAMPLE: Clark Gable teaching Ellie to dunk doughnuts

 b) EXAMPLE: Discussion of piggyback riding, etc.

 2. Usually deal with somewhat sexual situations

 a) Only mildly titillating, with sexual innuendo

 b) EXAMPLES: The title, "walls of Jericho," the references to unmarried couples spending the night together

 3. Usually deal with zany, unlikely situations

 a) EXAMPLE: Ellie jumping off the boat, etc.

 b) EXAMPLE: King Westley arriving at the wedding in an autogyro

 4. Different attitude toward the rich from that of the earlier sound comedies; not as negative

 a) Most of them just folks like you and me

 b) Most rich Americans are (supposedly) self-made successes, as opposed to European "old-money" (inherited, not earned)

 c) Probably not conscious, but seen as an attempt to deflect criticism away from the rich during a time in which there was a lot of hostility toward the wealthy

II. SPECIFIC CHARACTERISTICS OF THE SCREWBALL COMEDY

A. Screwball comedy is a genre of indeterminate space

 1. No particular setting is necessary

 2. Struggle is not for control of the space

 3. Not an individual hero, but a romantic couple or "doubled hero" (Peter and Ellie)

B. Not a genre of social order, but one of SOCIAL INTEGRATION

 1. Couple is a romantic one, with different backgrounds, values

 a) She is rich, spoiled, but rebellious (Peter calls her "brat")

 b) He is independent, working class, earthy, cynical

 2. The problem is one of integration of the two systems of values; they must be reconciled

C. PROBLEMS IN DISCUSSING THE SCREWBALL COMEDY

 1. There are very few icons, as in the Western, etc.

 2. No particular setting

 3. Therefore gets its identity mostly through narrative situations: sexual situations, courtship between members of different classes, etc.

 4. Also, to an extent, the visual style of the screwball comedy

 a) Editing

 (1) Shot-reverse shot

 (a) It begins confrontationally (stresses the opposition between the two)

 (b) It becomes less confrontational (especially with soft focus on Ellie in the motel room)

 (2) Also emphasis on two-shots of couple

 b) Camera movement

 (1) The camera often pans from one to another of the main characters

 (2) This creates a bond between the couple

 (3) EXAMPLE: The scene where Ellie is at the bus station, and the camera pans over to Peter in the phone booth

 (4) EXAMPLE: When Ellie returns to the bus station to find

 that she has missed the bus, there is a pan to Peter

III. PLOT STRUCTURE OF THE SCREWBALL COMEDY

 A. ESTABLISHMENT

 1. Generic community (field of reference) with its inherent dramatic conflicts

 2. Accomplished through narrative and iconographic cues

 3. Ellie on the boat and at the bus station: dialogue, figure behavior, and camera movement establish the situation and the characters

 B. ANIMATION

 1. Of the basic conflicts through the actions and attitudes of the genre's characters

 2. Ellie thinks Peter is crude, rude, and only wants sex; typical of the working class

 3. He thinks she is spoiled, ungrateful, used to getting her own way; typical of the rich (even before he knows who she is)

 4. Also similarities: both defy authority figures, believe in American values and direct human interaction w/o social restrictions

 C. INTENSIFICATION

 1. Of the conflict by means of conventional situations and dramatic confrontations until the conflict reaches crisis proportions

 2. They fall in love, admit it to themselves (but he does not admit it to her)

 3. This causes problems, as each feels they must change for the other (instead of recognizing the ways in which they are alike)

 a) Ellie wants to be the kind of woman she thinks Peter really wants (the island, etc.)

 b) He thinks he must have money in order to propose to her

 4. Attempt to solve these problems leads to the crisis

 D. RESOLUTION

 1. Of the crisis in a way that eliminates the threat (King Westley)

2. In screwball comedy, leads to embrace; celebrates the well-ordered community

3. Everyone is happy; King Westley receives $100,000; Mr. Andrews is rid of Westley, gains a better son-in-law ("make an old man very happy")

4. Resolution of the conflict between Ellie and Peter leads to broader resolution

 a) Mr. Andrews, self-made millionaire (earned his wealth, as opposed to King Westley, who inherited his wealth), regains his perspective, the qualities that helped make him rich (self reliance, assertiveness, etc.)

 b) Joe Gordan, the editor, is transformed from insensitive tyrant (typical boss) to sympathetic father figure; realizes Peter has fallen in love

IV. *It Happened One Night*

 A. Extremely popular with Depression audiences

 1. Gave them escape from their problems

 2. Broke box-office records nationwide

 3. Won Academy Awards for director, screenwriter, leading actor, leading actress, and best picture of 1934

 B. Celebrates American values

 1. Sanctity of marriage

 a) But must be to the right person

 b) Must be married before sex

 2. Classless society

 a) Reduced hostility toward the rich as a class; redirected at a few members (King Westley; represents "aristocratic," European rich)

 b) Represents more than the marriage of two characters; the union of two classes who have more similarities than differences

 c) These similarities are shared values; marriage, home, family, self reliance, and personal integrity

THE CLASSICAL HOLLYWOOD CINEMA

The Maltese Falcon (John Huston, 1941)

Directed by John Huston

Written by John Huston

Music by Adolph Deutsch

Cinematography by Arthur Edeson

Editing by Thomas Richards

Produced by Henry Blanke and Hal B. Wallis

Production Company and Distribution Company: Warner Bros.

Cast

Humphrey Bogart…Sam Spade

Mary Astor…Brigid O'Shaughnessy

Gladys George…Iva Archer

Peter Lorre…Joel Cairo

Barton MacLane…Det. Lt. Dundy

Lee Patrick…Effie Perine

Sydney Greenstreet…Kasper Gutman

Ward Bond…Det. Tom Polhaus

Jerome Cowan…Miles Archer

Elisha Cook Jr....Wilmer Cook

STUDY QUESTIONS

1. To what type of film genre does *The Maltese Falcon* belong? Is it a genre of determinate or indeterminate space? Is it a genre of social order, or one of social integration? How do we know?

2. How is the "social community" introduced to us? Where is the film set, and what kind of place is it? What kinds of characters are introduced to us, and how do we know what kinds of characters they are?

3. What are the conflicts of the story, and how are they set in motion? What intensifies these conflicts? How are they resolved?

4. What kinds of values does the film present to us? Are they essentially masculine or feminine?

5. Is *The Maltese Falcon* typical, in terms of its narrative and style, of the hardboiled detective genre? Is it typical of the classical Hollywood cinema?

THE CLASSICAL HOLLYWOOD CINEMA in *The Maltese Falcon* (John Huston, 1941)

I. THE HARDBOILED DETECTIVE GENRE

 A. ORIGIN: There were two important influences on the genre

 1. PULP NOVELS: The basic character of the hardboiled detective and his environment were lifted from these

 2. FILM NOIR ("black film" or dark film")

 a) This is a film style (NOT A GENRE) that had its origins in GERMAN EXPRESSIONISM

 b) When German filmmakers left Nazi Germany and came to Hollywood, they brought this style with them (also seen in horror movies of the 1930s and 40s)

 c) Featured:

 (1) Black-and-white film stock, usually high contrast

 (2) Low-key lighting, little use of fill lights, to create a dark, shadowy image (as in *Touch of Evil*)

 (3) Interiors featured cramped, dark, often dingy offices and apartments

 (4) Exteriors usually shot at night (especially with fog, wet streets, etc.), and took place in urban areas (alleys, back streets, etc.)

 B. GENERAL CHARACTERISTICS: The hardboiled detective film took the detective from pulp novels, and depicted him in the style of film noir, resulting in a cynical view of life in American cities in the years just before, during, and after WW II

II. SPECIFIC CHARACTERISTICS OF THE HARDBOILED DETECTIVE GENRE (according to Thomas Schatz in *Hollywood Genres*)

 A. It is a genre of DETERMINATE SPACE

1. It takes place in a particular locale; the American city (usually at night)

2. The hero, Sam Spade, begins in his office, takes a case, enters that space, solves the case, returns to his office

B. Therefore it is a genre of SOCIAL ORDER, not SOCIAL INTEGRATION

1. Involves an individual male hero, not a couple

2. The conflict is a physically violent one, not emotional

3. The resolution involves elimination of a threat, not an embrace

C. THEMES and VALUES

1. Mediation between two forces, not integration

 a) On one side is a violent, urban criminal community without morals; the detective shares their "street smarts," but has a moral code

 b) On the other side is a society with values he can not understand or accept; he is committed to "doing the right thing," and often does not see this commitment in the rest of the society that rejects his style

 c) He relies on his own sense of morals; he operates differently from both the cops and the crooks

 d) The restricted narration helps us see this world as Spade sees it

2. It deals with the theme of the macho code, not feminine or family values

 a) He operates the way he does because of professional integrity; he turns Brigid in because she shot Archer, and he is "supposed" to do something about it

 b) He does not care that much about love (he'll get over it) or friendship (he did not really like Archer, made love to his wife)

 c) It deals with value of self-reliance, not cooperation

 (1) Spade succeeds due to his status as a "loner," rejects the police and their help

(2) Compare this to the Western, in which the "good guy" works alone to save the community

D. THE FIELD OF REFERENCE OR SOCIAL COMMUNITY; *The Maltese Falcon* established the hardboiled detective genre's field of reference

1. ICONS

 a) **Humphrey Bogart**

 b) Trench coats

 c) Guns, cigarettes, booze

2. THE CHARACTERS

 a) THE PRIVATE EYE (Sam Spade, played by Humphrey Bogart)

 b) THE FEMME NOIRE or "dark woman" (Brigid O'Shaughnessy)

 c) THE ATTRACTIVE and DEDICATED SECRETARY with whom the detective has a platonic relationship (Effie Perrine)

 d) THE SOPHISTICATED, WELL-BRED, AMORAL VILLAIN (Kasper Gutman, played by Sidney Greenstreet)

 e) THE EFFEMINATE, DOUBLE-CROSSING CRIMINAL (Joel Cairo, played by Peter Lorre)

 f) THE GUNSEL, obedient and not very bright (Wilmer, played by Elisha Cooke, Jr.)

 g) THE BUMBLING POLICE

III. *THE MALTESE FALCON* AS CLASSICAL HOLLYWOOD CINEMA

A. The CHC's Form and Subject Matter

1. The CAUSAL AGENTS of the action are individual characters

 a) Spade is motivated by professionalism, and the others by greed

 b) Not historical or social forces

2. These characters have specific GOALS

 a) Spade wants to find Archer's murderer

 b) The others want to find the falcon

3. These goals lead to CONFLICTS

4. These conflicts lead to CHANGES in the status of the characters

 a) Spade ends up alone, without a partner or lover, but has avenged the death of Archer

 b) Brigid "takes the fall," goes to prison

5. There are two distinct lines of action

 a) One dealing with ROMANCE: Spade and Brigid

 b) One that is WORK-RELATED: Spade seeks the murderer of Archer

 c) These lines of action are interrelated; Brigid is the murderer, Spade must turn her in even though he loves her

6. CLOSURE is accomplished

 a) Closure here does not involve the falcon; it is merely a plot device

 b) Closure involves the resolution of the romance and the finding of Archer's murderer

 c) Also involves the return of the status quo, with the detective once again alone because of his professional integrity on one hand, and inability to fit in with society on the other

B. The Style of the Classical Hollywood Cinema

1. *The Maltese Falcon* relies on the CHC's CONTINUITY EDITING, or "invisible editing"

2. STYLE and NARRATIVE

 a) Space and time are clearly constructed

 (1) We are never confused about where we are or where the characters are in relation to one another

 (2) We are never confused about when events happen in relation to one another

 b) We are never distracted by the style; there is no attempt to call attention to the graphics of the images or the rhythm of the editing

3. STYLE and NARRATION

a) Narration in the CHC (in general!) tends to be external, objective, and unrestricted

b) As a detective film, *The Maltese Falcon* is an exception

 (1) It is generally external and objective

 (2) But it is highly restricted to Spade's POV; this is done to allow us to experience the investigation as he does

 (3) EXCEPTIONS

 (a) Archer's murder; but, still, we do not see the murderer; and the only witness (Archer) dies

 (b) When Spade enters the elevator, we see (but he does not) Joel Cairo exit the other elevator and walk to Gutman's hotel room

IV. CONCLUSION: As we have seen, *The Maltese Falcon* conforms closely to both the model of the hardboiled detective genre and the model of the CHC

THE ART CINEMA

The Seventh Seal (Ingmar Bergman, 1956)

Directed by Ingmar Bergman

Written by Ingmar Bergman

Music by Erik Nordgren

Cinematography by Gunnar Fischer

Editing by Lennart Wallén

Produced by Allan Ekelund

Production Company: Svensk Filmindustri

Cast

Gunnar Björnstrand…Jöns, the squire

Bengt Ekerot…Death

Nils Poppe…Jof

Max von Sydow…Antonius Block

Bibi Andersson…Mia, Jof's wife

Inga Gill…Lisa, blacksmith's wife

Maud Hansson…Witch

Inga Landgré…Karin, Block's Wife

Gunnel Lindblom…Girl

Bertil Anderberg…Raval

Anders Ek…The Monk

Åke Fridell…Blacksmith Plog

Gunnar Olsson…Church Painter

Erik Strandmark…Jonas Skat

STUDY QUESTIONS

1. In what ways are the subject matter and the story of *The Seventh Seal* typical or atypical of the Art Cinema? How is religion presented in the film differently from the way it was presented at the time in the Classical Hollywood Cinema? What is the theme of the film; would it have been acceptable in a CHC film?

2. Are cause and effect as closely linked as they are in the CHC? Examples? Are the characters different from what we would expect in a CHC film? In what ways are they different? What are their goals and conflicts? Is there closure at the end of this film?

3. Is the narration of the film objective? Are there shots and scenes that are subjective? How do we know? How does the film create ambiguity? What is it ambiguous about?

4. In what ways is it self-reflexive, calling attention to its style and construction?

5. How can we relate this film to Ingmar Bergman's life and his films?

THE ART CINEMA in *The Seventh Seal* (Ingmar Bergman, 1956)

I. Biographical Information

 A. EARLY LIFE

 1. Bergman was born in 1918 in Sweden

 2. His father was a Lutheran minister who eventually became the chaplain to Sweden's royal family

 3. His father was very strict, and young Ingmar was raised under severe discipline and a very rigid ethical code

 a) Ingmar was often imprisoned in dark closets for hours at a time for minor infractions

 b) This upbringing had a profound influence on his films in later life

 4. As a child, he loved the theater, and played with a toy theater, his favorite toy

 B. EDUCATION

 1. Bergman attended the University of Stockholm

 2. He studied theater and art, and was involved in many student productions

 3. After graduation, he served as an intern at a Stockholm theater

 C. EARLY THEATER CAREER

 1. During this time, Bergman wrote a number of short stories, novels, and plays

 2. Very few were published or produced

 D. FILM CAREER

 1. In 1941, Bergman entered the Swedish film industry as a "script doctor"

 2. In 1944, he was assigned a script to write for a well-known Swedish director

 a) This film became *Hets* (in the US, *Torment*)

 b) It became an international success, leading to Bergman's first assignment as a director

II. BERGMAN'S FILM CAREER

 A. THE EARLY FILMS

 1. Although Bergman's early films are usually regarded as artistically insignificant, they are interesting when viewed as part of Bergman's oeuvre

 2. Subject Matter: they often deal with the problems and frustrations of the young, and the generation gap in Swedish society

 3. Themes: they often question the existence of God and the Devil, and the nature of Life and Death

 4. His first important film was *Fangelse* (1949; in the US, *The Devil's Wanton*)

 a) This film was about the suicide of a young prostitute

 b) She is filled with questions about guilt, sin, and the possibilities of redemption

 5. He followed this with *Torst* (1949; *Three Strange Lives*)

 a) This film dealt with the subject matter of the psychology of women and the theme that women have a special introspective inner world; they are in touch with basic truths unavailable to men

 b) These issues would reappear throughout Bergman's films along with the other issues

 B. *The Seventh Seal* (1956) and THE "GOD FILMS"

 1. This film won a number of prizes at the Cannes Film Festival, establishing Bergman as one of the most important of the EAC filmmakers, here and abroad

 2. It is typical of the Bergman films that deal with Man's relationship with God

 3. It was followed by a series of films dealing primarily with this theme

 C. THE "WOMEN'S FILMS"

 1. He returned to films primarily about the psychology of women with *Persona* (1966) and *Cries and Whispers* (1972)

2. These dealt more with the "inner life" of women, less with God (but all deal with the "meaning of life")

3. Bergman began directing theater productions as well as films during this period

D. THE GERMAN FILMS

1. In 1976, while rehearsing at Stockholm's Royal Dramatic Theater, Bergman was arrested by two plainclothes policeman for income-tax fraud

2. He then suffered a nervous breakdown

3. Although later cleared of all charges, he vowed never to work in Sweden again

4. Because Bergman was so prominent and had made Swedish cinema a prestigious as well as commercially important industry, industry executives and the prime minister begged him to stay in Sweden

5. He then made a number of films in Germany and Norway, not all of them successful

E. RETURN TO SWEDEN

1. In 1978, Bergman returned to Sweden, where he resumed directing for the theater, TV, and films

2. In 1983, he made *Fanny and Alexander*, vowing that it would be his last film (he had said this before)

3. He now devotes his time to directing plays for the stage and for TV, claiming it is less physically taxing

III. The Story and Characters of *The Seventh Seal*

A. THE CHARACTERS

1. Antonius Block, the knight

2. Jons, his squire

3. Death

4. Jof and Mia (Joseph and Mary); and their son Mikael

5. Raval

 a) The thief and grave robber

 b) He was a doctor at a theological seminar, sent the Knight to the Crusades

 6. Skat, the actor traveling with Jof and Mia

 7. Plog, the blacksmith

 8. Lisa, Plog's wife

 9. The mute woman

 10. Tyan, the woman who had "fleshly intercourse with the Devil"

 11. Karin, the wife of Antonius

B. The film takes place at the end of the Crusades

 1. Antonius Block and his Jof, his squire, have returned to Sweden after ten years at the Crusades

 2. The Black Plague is ravaging the land

 a) Religious fanatics blame the sins of the people for the plague (cf. AIDS)

 b) The flagellants are punishing themselves in hopes of salvation

IV. *The Seventh Seal* as Art Cinema: SUBJECT MATTER

A. *The Seventh Seal* does not contain nudity or (much) obscene language

B. However, it does deal with sexual situations in ways that were not acceptable to the CHC in the 1950s

 1. The suggestion of sex between Skat and Lisa

 2. The accusation that Tyan has had sex with the Devil

C. The subject matter--a knight returning from the Crusades--would not be unusual for the classical Hollywood cinema

D. But the theme--the doubt over the existence of God--would certainly be forbidden throughout most of the history of the CHC (even today?)

V. *The Seventh Seal* as Art Cinema: FORM

A. Like the films of the CHC, *The Seventh Seal* is a narrative fiction film

 1. However, cause and effect are not as closely linked as they are in the CHC

2. Examples:

 a) Why is Antonius suffering from such doubt?

 b) Why does the mute woman finally speak?

B. Characters and Goals in *The Seventh Seal*

1. The characters in the film have few clearly defined goals

2. Their **character traits are designed** to function symbolically rather than to further the action

 a) Antonius represents the doubt of an intelligent man who wants to believe in God but needs proof

 b) Jof represents the non-believer who lives life for the moment

 c) Jof and Mia represent those who live naturally; do not doubt or blame

3. Conflicts tend to be within a character, rather than between characters

C. CLOSURE

1. Is there closure at the end of this film?

2. What happens to the characters?

 a) They certainly die; in this way there is closure

 b) But do they go to heaven, hell, or to emptiness? We don't know...

VI. *The Seventh Seal* as Art Cinema: STYLE

A. This film uses many of the same techniques as the CHC; Bergman had seen and been influenced by films of the CHC

B. However, *The Seventh Seal* is far more subjective

1. We see a great deal of mental subjectivity in this film

2. These sequences are not always clearly marked by punctuation or the narration; they are ambiguous

3. Examples:

 a) The appearance of Death himself (itself)

 (1) Does he really exist, in human form, in this film?

 (2) The knight sees him; Jof sees him; anyone else?

b) The visions of Jof

 (1) Mary and Jesus

 (2) Death at the end of the film

C. Is the narration of the film overt; does it highlight the construction of the film?

 1. In what ways is it SELF-REFLEXIVE, calling attention to the style and construction of the film?

 2. Examples:

 a) Violations of the 180^0 rule

 (1) We approach death, cut to the opposite side of him

 (2) In the chess sequences, there are a number of cuts from one side to the other

 b) The presentation is often artificial and theatrical

 (1) When Jöns is discussing Lisa, we hear him but Plog does not

 (2) Skat addresses the audience after his "death" scene

D. Because much of what we see in *The Seventh Seal* is difficult to explain in terms of narrative motivation, we tend to consider these as statements or expressions of Bergman himself

VII. *The Seventh Seal* as a Bergman Film

A. How can we relate this film to his life and his films?

B. AUTHOR AS SOURCE

 1. Emphasis on religion in general

 2. Religion as punishment

 3. Fanatical belief is often a cover for doubt; Bergman saw this in his father

C. AUTHOR AS CRITICAL CONSTRUCT

 1. All of Bergman's films conform more-or-less to the style of the EAC; cf. *Persona*

 2. Themes

a) His films often question the existence of God and the Devil, and the meaning of Life and Death

b) His characters are often obsessed with questions about guilt, sin, and the possibilities of redemption

c) Although this is none of his "God films," we can see the beginnings of his concern with the psychology of women

 (1) Do we see a woman who seems to be in touch with basic truths unavailable to men? The mute woman, Karin, maybe Mia...

 (2) In later films, the characteristics of Jof would be more typical of female characters

THE ART CINEMA

Persona (Ingmar Bergman, 1966)

Directed by Ingmar Bergman

Written by Ingmar Bergman

Music by Lars Johan Werle

Cinematography by Sven Nykvist

Editing by Ulla Ryghe

Production Company: Svensk Filmindustri

Cast

Bibi Andersson…Alma, The Nurse

Liv Ullmann…Elisabeth Vogler, The Actress

Margaretha Krook…The Doctor

Gunnar Björnstrand…Mr. Vogler

STUDY QUESTIONS

1. In what ways are the subject matter and the story of *Persona* typical or atypical of the Art Cinema? How is sex presented in the film differently from the way it was presented at the time in the CHC? What is the theme of the film; would it have been acceptable in a CHC film?

2. Are cause and effect as closely linked as they are in the CHC? Examples? Are the characters different from what we would expect in a CHC film? In what ways are they different? What are their goals and conflicts? Is there closure at the end of this film?

3. Is the narration of the film objective? Are there shots and scenes that are subjective? How do we know? How does the film create ambiguity? What is it ambiguous about?

4. In what ways is it self-reflexive, calling attention to its style and construction?

5. How can we relate this film to Ingmar Bergman's life and his films?

THE ART CINEMA in *Persona* (Ingmar Bergman, 1966)

I. Biographical Information

 A. EARLY LIFE

 1. Bergman was born in 1918 in Sweden

 2. His father was a Lutheran minister who eventually became the chaplain to Sweden's royal family

 3. His father was very strict, and young Ingmar was raised under severe discipline and a very rigid ethical code

 a) Ingmar was often imprisoned in dark closets for hours at a time for minor infractions

 b) This upbringing had a profound influence on his films in later life

 4. As a child, he loved the theater, and played with a toy theater, his favorite toy

 B. EDUCATION

 1. Bergman attended the University of Stockholm

 2. He studied theater and art, and was involved in many student productions

 3. After graduation, he served as an intern at a Stockholm theater

 C. EARLY THEATER CAREER

 1. During this time, Bergman wrote a number of short stories, novels, and plays

 2. Very few were published or produced

 D. FILM CAREER

 1. In 1941, Bergman entered the Swedish film industry as a "script doctor"

 2. In 1944, he was assigned a script to write for a well-known Swedish director

 a) This film became *Hets* (in the US, *Torment*)

 b) It became an international success, leading to Bergman's first assignment as a director

II. BERGMAN'S FILM CAREER

 A. THE EARLY FILMS

 1. Although Bergman's early films are usually regarded as artistically insignificant, they are interesting when viewed as part of Bergman's oeuvre

 2. Subject Matter: they often deal with the problems and frustrations of the young, and the generation gap in Swedish society

 3. Themes: they often question the existence of God and the Devil, and the nature of Life and Death

 4. His first important film was *Fangelse* (1949; in the US, *The Devil's Wanton*)

 a) This film was about the suicide of a young prostitute

 b) She is filled with questions about guilt, sin, and the possibilities of redemption

 5. He followed this with *Torst* (1949; *Three Strange Lives*)

 a) This film dealt with the subject matter of the psychology of women and the theme that women have a special introspective inner world; they are in touch with basic truths unavailable to men

 b) These issues would reappear throughout Bergman's films along with the other issues

 B. *The Seventh Seal* (1956) and THE "GOD FILMS"

 1. This film won a number of prizes at the Cannes Film Festival, establishing Bergman as one of the most important of the EAC filmmakers, here and abroad

 2. It is typical of the Bergman films that deal with Man's relationship with God

 3. It was followed by a series of films dealing primarily with this theme

 C. THE "WOMEN'S FILMS"

 1. He returned to films primarily about the psychology of women with *Persona* (1966) and *Cries and Whispers* (1972)

2. These dealt more with the "inner life" of women, less with God (but all deal with the "meaning of life")

3. Bergman began directing theater productions as well as films during this period

D. THE GERMAN FILMS

1. In 1976, while rehearsing at Stockholm's Royal Dramatic Theater, Bergman was arrested by two plainclothes policeman for income-tax fraud

2. He then suffered a nervous breakdown

3. Although later cleared of all charges, he vowed never to work in Sweden again

4. Because Bergman was so prominent and had made Swedish cinema a prestigious as well as commercially important industry, industry executives and the prime minister begged him to stay in Sweden

5. He then made a number of films in Germany and Norway, not all of them successful

E. RETURN TO SWEDEN

1. In 1978, Bergman returned to Sweden, where he resumed directing for the theater, TV, and films

2. In 1983, he made *Fanny and Alexander*, vowing that it would be his last film (he had said this before)

3. He now devotes his time to directing plays for the stage and for TV, claiming it is less physically taxing

III. The Story and Characters of *Persona*

A. THE CHARACTERS

1. Elisabeth Vogel, a famous actress

2. Alma, a nurse assigned to help Elisabeth

B. The film is about the "existential apathy" of Elisabeth, who decides that only by not speaking can she tell only the truth

IV. *Persona* as Art Cinema: SUBJECT MATTER

A. *Persona* does not contain nudity or really obscene language

B. However, it does deal with sexual situations in ways that were not acceptable to the CHC until the late 1960s

 1. Alma's story of her orgy on the beach

 2. Alma's abortion

 3. Alma having sex with Elisabeth's husband

 4. The suggestion of a possible lesbian relationship between Alma and Elisabeth

C. The subject matter--an actress refusing to speak in order to tell nothing but the truth--would be quite unusual for the CHC

D. The theme - that it is impossible to make our words and actions agree with what we are and believe - would certainly be unusual in the CHC

V. *Persona* as Art Cinema: FORM

A. Like the films of the CHC, *Persona* is a narrative fiction film

 1. However, cause and effect are not as closely linked as they are in the CHC

 2. Examples:

 a) Why does Elisabeth refuse to speak?

 b) Why does her husband not know he is making love to someone else?

 c) Why do we see such strange images at the beginning of the film and in the middle?

B. Characters and Goals in *Persona*

 1. The characters in the film have few clearly defined goals

 2. Their character traits are designed to function symbolically rather than to further the action

 a) Elisabeth represents the modern, intelligent and sensitive human being

 (1) She is paralyzed in the face of the reality of existence in today's world

 (2) Therefore, she is an artist; self-centered, attracting attention to herself even as she supposedly tries to hide from the world

 b) Alma represents the sort of person who acts more instinctively (remember the orgy)

 (1) She does not dwell too much on life's problems

 (2) She is a nurse, one who is "other-centered"; she focuses her attention on other people and their needs

 c) They begin to realize how much alike they really are

 (1) Elisabeth is more immature and more emotionally dependent than she would like to admit

 (2) Alma is more calculating, cruel, and self-centered than she would like to believe

 3. Conflicts tend to be within a character, rather than between characters

 a) In this film we get both (sort of)

 b) Elisabeth, especially, has an inner conflict

 c) The conflict between the two women is really an inner conflict between the two parts of the human (or more specifically, female) psyche

C. CLOSURE: Is there closure at the end of this film?

 1. In one way, no; we do not know what happens to the characters (does Elisabeth ever speak?)

 2. In another way, yes; the "film" ends

VI. *Persona* as Art Cinema: STYLE

A. This film uses many of the same techniques as the CHC; Bergman had seen and been influenced by films of the CHC

B. However, *Persona* is far more subjective

 1. There is a great deal of mental subjectivity in this film

2. These sequences are not always clearly marked by punctuation or the narration; they are ambiguous

3. Examples:

 a) Does Elisabeth really speak to Alma?

 b) Does she go to her in night?

4. Is everything real, or could some things be dreams or memories?

5. There are also a lot of things in the film that could be mentally subjective or strictly nondiegetic commentary by Bergman (all of the unmotivated material)

C. Is the narration of the film overt; does it highlight the construction of the film?

1. In what ways is it SELF-REFLEXIVE, calling attention to the style and construction of the film?

2. Examples:

 a) Obviously, the shots of the film, camera, projector, etc.

 b) The scene in which Alma describes Elisabeth's relationship with her son (a joke on shot/reverse shot)

3. What is he trying to say about cinema? It is like language:

 a) You try to say something, in words or on film, about what you are and what you feel

 b) But the result does not say exactly what you want to say, or agree with what you really believe

D. Because much of what we see in *Persona* is difficult to explain in terms of narrative motivation, we tend to consider these as statements or expressions of Bergman himself

VII. *Persona* as a Bergman Film

A. How can we relate this film to his life and his films?

B. AUTHOR AS SOURCE

1. The film is about being an artist (in particular, an artist in film and theater)

2. It is also about the struggle between intellect and instinct, guilt and innocence, etc.; the issues of religion transferred to the realm of art

C. AUTHOR AS BRAND NAME: the film was marketed as a "Bergman film"

D. AUTHOR AS CRITICAL CONSTRUCT

1. All of Bergman's films conform more-or-less to the style of the EAC; cf. *The Seventh Seal*

2. Themes

 a) His films often question the existence of God and the Devil, and the meaning of Life and Death

 b) His characters are often obsessed with questions about guilt, sin, and the possibilities of redemption

 c) *Persona* is one of the films he made dealing with the psychology of women

 d) The reference to the world of cinema and theater is also common to a great number of his films

THE ART CINEMA

Every Man for Himself and God Against All (Werner Herzog, 1974)

Directed by Werner Herzog

Written by Werner Herzog and Jakob Wassermann

Music by Florian Fricke

Cinematography by Jörg Schmidt-Reitwein

Editing by Beate Mainka-Jellinghaus

Production Companies: Filmverlag der Autoren, Cine International, Werner Herzog

Filmproduktion and Zweites Deutsches Fernsehen (ZDF)

Cast

Bruno S....Kaspar Hauser

Walter Ladengast…Professor Daumer

Brigitte Mira…Kathe, Servant

Willy Semmelrogge…Circus director

Michael Kroecher…Lord Stanhope

Hans Musaeus…Unknown Man

STUDY QUESTIONS

1. In what ways are the subject matter and the story of *Every Man for Himself and God Against All* typical or atypical of the Art Cinema? How is the subject matter (philosophy, especially) presented in the film differently from the way it was presented at the time in the CHC? What is the theme of the film; would it have been acceptable in a CHC film?

2. Are cause and effect as closely linked as they are in the CHC? Examples? Are the characters different from what we would expect in a CHC film? In what ways are they different? What are their goals and conflicts? Is there closure at the end of this film?

3. Is the narration of the film objective? Are there shots and scenes that are subjective? How do we know? How does the film create ambiguity? What is it ambiguous about?

4. In what ways is it self-reflexive, calling attention to its style and construction?

5. How can we relate this film to Werner Herzog's life and his films?

THE ART CINEMA in *Every Man for Himself and God Against All* (Werner Herzog, 1974)

I. Biographical Information

 A. EARLY LIFE

 1. Werner Herzog was born in Munich in 1942 during WW II

 2. His parents divorced when he was very young, and he then lived on an impoverished farm in the Bavarian Alps with his mother

 3. He describes himself as a quiet child who had violent outbursts of anger

 4. He saw no films until he was twelve, when he saw documentaries about pygmies and Eskimos

 B. TEENAGE YEARS

 1. As a teenager, he moved back to Munich, where he began making short films, although he had no formal training

 2. He graduated from a college-prep high school in 1961, then attended college in Munich and Pittsburgh, although he never received a degree

 3. He then worked at a TV station in the US

 C. FILM CAREER

 1. After moving back to Germany, Herzog made his first film when he was twenty; it was a documentary about body builders

 2. At twenty-one, he founded a film production company

 3. He is married, has two children, plays soccer, and travels extensively

II. FUNDING: Herzog made twenty-four films (eleven features, thirteen documentaries) in twenty-four years; how has he managed to find funding for these projects?

 A. THE POST-WAR SITUATION

 1. After WW II, the German commercial film industry was in poor shape

 2. The US, occupying West Germany, allowed the industry to become just strong enough to produce propaganda films and light comedies

 3. This allowed US companies to take advantage of the German market by releasing their backlog of films produced during the war

 B. In response to pleas from the German film industry, the German government established two forms of support:

1. The tax on movie tickets was revoked for certain "cultural" films

 a) A government committee made the decisions as to the cultural value of these films

 b) Therefore, these films tended to be politically bland, out of fear of offending government officials

2. Direct subsidies were awarded to certain commercial production companies within the industry

C. In the late 1950s and early 1960s, the government added two more forms of support:

1. Money was supplied for the financing of international film festivals within Germany

2. Prize money and production grants were awarded to the makers of certain short films

D. THE NEW GERMAN CINEMA

1. In 1962, twenty-six young German filmmakers met at the Oberhausen Film Festival

 a) They declared the German commercial film industry to be dead

 b) They demanded more government funding for young independent filmmakers

2. The government agreed, and this resulted in the New German Cinema of 1965-68

 a) Film journalists reviewed film scripts and ideas, and allocated money for production

 b) Because of the lack of unions, it was relatively easy to put together production companies for these films

3. In 1964, when he was twenty-six, Herzog made his first feature film, *Signs of Life*

 a) The script won a prize of $5,000 from a Munich film club

 b) It also won $150,000 from a national film board

 c) The film itself won a festival prize of $175,000

 d) Herzog then used these funds to finance more film production

E. After 1968, government support ended due to:

1. Political changes in Germany

2. And pressure from the commercial film industry

F. The TV industry then began to provide support for the New German Cinema

 1. It accomplished this through its two national networks and its many regional networks

 2. *Every Man for Himself* was financed by the ZDF network

 3. This remains the major source of funds today, and these films are often seen in Germany only on TV, not in theaters

III. HERZOG'S OEUVRE (The term OEUVRE refers to an auteur's body of work, all of the films that he/she has made)

A. HERZOG'S PHILOSOPHICAL POSITION

 1. Herzog may be seen as part of the philosophical movement known as PHENOMONOLOGY

 a) This was especially popular in Europe in the 1940s

 b) Phenomenology, unlike materialism and idealism, stresses that there is a basic link between human consciousness and the material world, but that there is a definite separation between the two

 c) The world exists in its own right, independent of mankind

 d) Man's abstract logic, science and reason get in the way of our perceptual, sensual experience of the world

 2. THE FILM AS A PHYSICAL OBJECT

 a) Herzog has stated that he likes to feel the weight of the film itself

 b) He even likes to operate the clapboard himself

 (1) The clapboard is filmed at the beginning of a take to synchronize sound and image

 (2) In this way, he feels he is the link between the camera and the action

 c) He often starts a film from a location or landscape

 (1) He then figures out his story and characters

(2) This has led him to make films in such diverse locations as Greece, Africa, the Amazon, Australia, and Wisconsin

B. SUBJECT MATTER

1. Herzog often makes films about people who perceive the world differently from the way in which the rest of mankind does

2. He has made films about the conflict between modern medicine and native methods of dealing with illness, the deaf and blind, and dwarves ("the essence of mankind")

3. Herzog stresses the basic dignity in non-human, natural existence apart from "civilized" mankind

4. Thus, animals are often important in his films, as they are in *Every Man for Himself*

 a) The bird Kasper feeds

 b) The hypnotized chicken

 c) The caged bird

 d) The walking cat, etc.

C. THE VIEWER and VIEWING EXPECTATIONS

1. We tend to view Herzog's films on a perceptual and sensual level

 a) We do not watch them as much on a logical level of understanding

 b) Think of the shots in *Every Man for Himself* of nature (wheat fields, rivers, clouds, etc.) that seem to exist more for their intrinsic beauty than for strictly narrative reasons

2. Although many of Herzog's films are narrative films, they are more than *just* narrative films

 a) They celebrate a world apart from man and his concerns

 b) Accordingly, Herzog often makes fun of religion, academia, and bureaucracy, as he does in *Every Man for Himself and God Against All*

IV. *Every Man for Himself* as Art Cinema

A. NARRATIVE and SUBJECT MATTER

1. No sex (by this time, sex was common in Hollywood films)

2. It is a NARRATIVE FICTION FILM

 a) But cause and effect are not closely linked

 b) There are gaps in the narrative:

 (1) How does Kaspar come to live with the older man?

 (2) Why does the man from earlier in the film return to hit Kaspar?

 (3) Who stabbed him?

3. The CHARACTERS are more complex than in the CHC

 a) They have no clearly defined goals

 b) The conflict seems to be within Kaspar; was it better in his prison or in the outside world?

4. CLOSURE

 a) There is closure to some degree: Kaspar dies and the report is finished

 b) But as the clerk says, the report will do because it is the only explanation they have

B. STYLE

 1. It is far more SUBJECTIVE than is the CHC

 a) We see many dream sequences

 b) Often we see what Kaspar is thinking of (the story of the caravan, for example)

 2. SPACE and TIME are not as clearly articulated as in the CHC; there are temporal gaps, especially

V. CONCLUSION

 A. Because we do not always understand what we see in terms of the narrative, we tend to attribute these aspects to the director

 1. He is "trying to tell us something"

 2. EXAMPLES: the shots of wheat, the dream sequences, the story of the caravan, etc.

 B. In order to understand what Herzog is telling us, we are expected to:

1. Watch the film more than once

2. Be familiar with his other films, because he deals with the same issues and ideas in many of his films

THE ART CINEMA

Belle de Jour (Luis Buñuel, 1967)

Directed by Luis Buñuel

Written by Luis Buñuel and Jean-Claude Carrière

Produced by Henri Baum, Raymond Hakim and Robert Hakim

Cinematography by Sacha Vierny

Film Editing by Louisette Hautecoeur

Production Companies: Five Film and Paris Film

Cast

Catherine Deneuve…Séverine Serizy

Jean Sorel…Pierre Serizy

Michel Piccoli…Henri Husson

Geneviève Page…Madame Anais

Pierre Clémenti…Marcel

Françoise Fabian…Charlotte

Macha Méril…Renee

Muni…Pallas

Maria Latour…Mathilde

Claude Cerval and Michel Charrel…Footmen

Iska Khan…Asian client

Bernard Musson…Majordomo

Marcel Charvey…Professor Henri

François Maistre…L'ensignant

Francisco Rabal…Hyppolite

Georges Marchal…Duke

Francis Blanche…Monsieur Adolphe

STUDY QUESTIONS

1. Like the films of the classical Hollywood cinema, *Belle de Jour* is a narrative fiction; however, cause and effect are not as clearly linked as they are in the CHC. What are some examples of unclear cause and effect? What are some of the things we can not explain?

2. Do the characters have clearly defined goals; does Séverine, for example, have any goals? What might explain her behavior, if not in terms of goals?

3. Are conflicts within a character (or characters) rather than between characters? If so, what are these conflicts? Are they resolved?

4. What are some the scenes that seem to be subjective? What marks them as subjective? In what ways are they ambiguous?

5. How does this film handle the issue of sex? Is it similar to the ways in which Hollywood would handle this subject matter? If it is different, in what ways is it different?

6. In what ways can this be seen as a Luis Buñuel film? Are there autobiographical elements in it? Is it similar in some ways to his other films?

THE ART CINEMA in *Belle de Jour* (Luis Buñuel, 1967)

I. INTRODUCTION

 A. Classical Hollywood films are typically oriented towards presenting a clear narrative; Style is subordinate to the narrative and functions to support and advance the narrative as succinctly as possible

 B. *Belle de Jour*, on the other hand, follows the tradition of the EAC

II. *Belle de Jour* as EAC

 A. Subject matter shows the influence of French art films in that *Belle De Jour* centers around emotions

 1. It is possibly also an exploration of the meaning of the erotic

 a) The film studies various images of what is considered erotic

 b) These include rape, S and M, paedophilia, necrophilia, voyeurism, incestuous necrophilia and a hint at lesbianism between Séverine and Mdm Anais

 2. The film studies issues of desire, and the distinction between illusion and reality (discussed later)

 B. Like the CHC, it is a narrative fiction

 1. There is cause and effect construction, but cause and effect are not so clearly linked

 2. Example: Husson gives Séverine the address for the brothel, therefore she is able to visit it, but the viewer is left to decide or deduce why she decides to work there; there is an absence of clear motivating factors

 C. Characters are far more complex than in the CHC

 1. We often do not know much about the characters

 2. Example: Séverine is incapable of sex with her loving husband and yet is able to participate in sex with all the odd characters who come to Mdm Anais's

 a) We do not know enough about her background to be able to deduce why

b) The audience suspects that it is because of her bad experiences as a child (the flashback molestation sequence) but this is complicated by the credibility of her recollection, i.e. is it a flashback of a real event or is it another of her dreams?

D. The characters rarely have clearly defined goals; does Séverine have any goals?

E. Conflicts tend to be within a character rather than between characters (Example: Séverine must decide between the excitement of her lover and the security and gentleness of her husband)

F. There is no clear closure in the film; it is ambiguous and open to interpretation

1. Example: Does Séverine begin to dream because she cannot deal with reality or does the final scene question the entire credibility of the whole preceding narrative?

2. Elaboration:

a) In the opening sequence, the whipping and rape by the coachmen is, in retrospect, recontextualized as a dream when Pierre asks Séverine (in their home) what she is thinking and she replies that she was dreaming about him

b) In the last scene, there are three shots of the blind Pierre in the wheelchair and then a cut to Séverine

c) In the next shot Pierre is sitting in the wheelchair; he takes off his glasses and asks, "What are you thinking, Séverine?" and she replies, "About you Pierre."

d) Does this not question the entire narrative that came before in the similar manner that the opening sequence did?

III. NARRATIVE and STYLE

A. Narrative

1. The narrative is not a clear one; it is ambiguous, raising numerous questions for the viewer

2. The dichotomy between reality and illusion/dream is central to this narrative

3. Using our experience of film viewing, we privilege certain segments as "reality" or "the truth"; we do so because:

a) They establish a linear narrative

b) To some extent, the events form a causal chain

c) They seem logical/explainable or comprehendible

4. Which scenes are NOT part of the present reality?

a) Scenes that are considered outside the scope of the present reality:

(1) The rape of Séverine by the coachmen while Pierre looks on (the opening sequence); the sound bridge of Pierre asking Séverine what she is thinking about and the cut relocates us in the couple's home and bedroom where she admits that she was dreaming

(2) The molestation of a child by a man (the child is deduced to be Séverine by the voice over that calls her) [Pedophilia…is it?]

(3) The same child refusing to receive Holy Communion (the child Séverine is questioned in the voice over as to what is the matter)

(4) The man, talking to his "daughter" in the coffin (incestuous necrophilia)

(5) The cow pasture, where Husson throws mud at Séverine who appears to enjoy it; Pierre looks on

(6) Husson and Séverine in the restaurant; in the background Renée and Pierre look on as the former two crawl under the table; Husson gives Séverine an "envelope and some lily seeds"

(7) Pierre rises from the wheelchair and they look out of the window at the coachmen riding down the autumn lane

b) Why do we consider these outside the scope of "present reality"?

(1) [1]– Recontextualized by Séverine's comments as a dream

(2) Child sequences [2] and [3]– child referred to as Séverine, we *assume* it is possibly a flashback of her actual/real past

(3) Pierre looks on something that is out of the ordinary. [1], [5] and [6] – Out of keeping with the logic of cause and effect as well as with Pierre's character traits; we look for a coherent and dominant view of his character

(4) [4] – Clearly one of the more ambiguous scenes where we are not sure if it is illusion or reality; the sound motif of bells and the same coachmen signal a dream sequence

(5) [7] – Discussed earlier under the section on closure

c) However, it is clear that these are based on our assumptions and expectations as viewers; there is nothing to support or dispute our stand concretely

B. Style

1. We often are not presented with a clear distinction or transition between the different states of dream and reality

a) For example In the CHC, a flashback or a dream is presented with a dissolve or blurring of the scene, etc; some stylistic element helps to make the transition clear to the viewer

b) In contrast, the style of this film tricks us or plays with convention

(1) Example: the false eyeline match; Séverine looks offscreen as she is ascending the stairs to Mdm. Anais's apartment and the next shot is the child refusing to receive Holy Communion; it is a flashback or dream

(2) Example: Both mentally subjective forms of narrative are placed side by side, i.e. the flashback and the dream, without clear indication of their distinction

(3) Example: dual interpretations for the dissolve

(a) The one solitary dissolve in the film (the exterior of their apartment building and the tops of the trees), which takes place after the hospital scene when Pierre is still in a coma initially seems to mark the passing of time

(b) However, in retrospect, it can also be interpreted as the signal for a mentally subjective sequence (the final sequence in their home); this is confirmed by the question that Pierre asks Séverine when he "awakens"

C. At other times the film does not use any particular technique in a standard manner, throughout the entire film in order to cue us to the change between objectivity and mental subjectivity

 1. Example: Paul Sandro (author of *Diversions of Pleasure: Luis Buñuel and the Crises of Desire*) claims that certain sound motifs signal a dream sequence

 a) These include the sound of the coach bells, cowbells, the clinking and crashing of glass and the mention of cats

 b) However, in the scene with the Japanese man, which we assume to be real, he plays with bells; so does that mean that is a dream sequence although it takes place in Mdm. Anais' residence?

IV. EVIDENCE OF THE AUTEUR APPROACH; Various themes and motifs relate this particular film to Buñuel's oeuvre

A. In his book on Buñuel, Paul Sandro "shows how the recurrent theme of disruptive desire often finds a structural counterpart in the viewing experience. As (Buñuel's) films unfold, they produce textual effects that are akin to the ones they thematize: frustrating deferrals of pleasure, disorienting displacements, logical quandaries, seductive dissonance, and conflicts of tone and effect."

B. Religion

 1. Buñuel as a lapsed Catholic, is preoccupied with religious issues and the idea of guilt in his films

 2. Hence the child does not want to receive Holy Communion, which is an indication of the child's feelings of guilt that make receiving the host a sin

C. The box

 1. Present in all his films, and we do not find out what is in the box

 2. In this film, the Japanese man carries the box

D. Others?

V. CONCLUSION

A. Ultimately, it is clear that this film uses its style to play with and thereby question the narrative distinction between illusion and reality

B. The ambiguity that follows allows the film to be interpreted in many different ways; there are no obvious concrete conclusions or interpretations, unlike the films of the CHC

THE ART CINEMA

That Obscure Object of Desire

(Cet Obscur Objet du Désir; Luis Buñuel, 1976)

Directed by Luis Buñuel

Written by Luis Buñuel and Jean-Claude Carrière

Produced by Serge Silberman

Music by Richard Wagner

Cinematography by Edmond Richard

Editing by Hélène Plemiannikov

Production Companies: Greenwich Film Productions, Incine and Les Films Galaxie

Cast

Fernando Rey…Mathieu

Carole Bouquet…Conchita

Ángela Molina…Conchita

Julien Bertheau…Judge

André Weber…Valet

Milena Vukotic…Woman on train

STUDY QUESTIONS

1) In what ways are the subject matter and the story of *That Obscure Object of Desire* typical or atypical of the Art Cinema? How is sex presented in the film differently from the way it was presented at the time in the CHC? What is the theme of the film; would it have been **acceptable in a** CHC film?

2) Are cause and effect as closely linked as they are in the CHC? Examples? Are the characters different from what we would expect in a CHC film? In what ways are they different? What are their goals and conflicts? Is there closure at the end of this film?

3) Is the narration of the film objective? Are there shots and scenes that are subjective? How do we know? How does the film create ambiguity? What is it ambiguous about?

4) In what ways is it self-reflexive, calling attention to its style and construction?

5) How can we relate this film to Luis Buñuel's life and his films?

THE ART CINEMA in *That Obscure Object of Desire* (Luis Buñuel, 1976)

I. *That Obscure Object of Desire* as EAC: FORM and SUBJECT MATTER

 A. Meant to be taken as the personal expressions of the individual artist, in this case Luis Buñuel

 B. Like the rest of the EAC, not subject to Hollywood's moral code

 1. Contains nudity and deals with sexual situations

 2. Although *That Obscure Object of Desire* was made in 1976, when American films also could get away with these things, sex, nudity, etc., remain characteristics of the EAC

 C. Like the films of the CHC, a narrative fiction film; however, cause and effect are not as closely linked as they are in the CHC

 1. *That Obscure Object of Desire* is much closer to the CHC's style than are some other art films

 2. However, it has a looser connection between cause and effect than does the typical CHC film

 a) Why does Conchita look and talk differently from scene to scene, and even sometimes within scenes? What is the cause? Why does Mathieu seem not to notice?

 b) Why does she play with Mathieu in such a cruel way? Does she love him or not?

 c) Why does he sometimes carry a burlap bag; and why do others sometimes carry it?

 D. Characters are more complex than in the CHC; we often do not know much about them

 1. Rarely have clearly defined goals

 a) Mathieu seems to have a simple goal, that of having sex with Conchita; however, he seems obsessed with her, more than just sexual desire for that particular woman

 b) Conchita has no clearly defined goal, except to torture Mathieu; however, she tries to escape him, but then follows him

 2. Conflicts tend to be within the characters, rather than between characters

 a) Conchita seems torn between her love for Mathieu and a need to be free

 b) Mathieu is obsessed with women; he does not seem to understand his obsession himself

E. CLOSURE

 1. What will be the relationship between Mathieu and Conchita? It seems as if the relationship will just continue as it had been (she pulls away from him)

 2. Unless they were killed by the bomb; we do not know

II. *That Obscure Object of Desire* as EAC: STYLE

A. Uses many of the same techniques of the CHC; Buñuel had seen and was influenced by the films of the CHC; in some ways he is playing with the conventions of the CHC

B. But far more subjective than is the CHC

 1. *That Obscure Object of Desire* is constructed largely of flashbacks as Mathieu tells his story

 2. It is his memory of the events

 3. These sequences are not clearly marked by punctuation (just a cut, unlike the dissolve of the CHC); more so by the narration

C. The narration of these films is often overt; they are SELF-REFLEXIVE

 1. This calls attention to their style and construction; this overt narration highlights the presence of a controlling power (the director)

 2. *That Obscure Object of Desire*'s use of two actresses to play the same character calls attention to its construction

D. SPACE and TIME often are not articulated as clearly in as they are in the CHC

 1. Time is unclear in *That Obscure Object of Desire*

 2. The order of events seems clear, but the amount of time omitted between shots is not clear

III. LUIS BUÑUEL AS AUTEUR

 A. Because much of what we see in his films is difficult to explain in terms of the narrative, we tend to consider these as statements or artistic expressions of Buñuel

 B. Some things are explainable only as motifs that occur throughout his films

 1. Insects seem important (the fly)

 2. Dead animals also seem important to Buñuel (the dead mouse)

 C. Obscure symbolism in general is used by Buñuel to deal with some of his artistic interests

 1. Symbols represent "cultural baggage" that restrains us, prevents us from fulfilling our desires; In *That Obscure Object of Desire*, it is the burlap bag that Mathieu carries at times, and we see other people with at other times

 2. Sexual desire and obsession are important themes

 a) In *That Obscure Object of Desire*, Mathieu is obsessed with his "obscure object of desire;" he does not even know who she is, she is not a woman but an ideal for him

 b) The film seems to view sexual relationships as sadomasochistic

 3. Middle-class morality and mentality are important themes

 a) In *That Obscure Object of Desire*, the middle-class passengers on the train sympathize with Mathieu; they fail to see the sexist and classist aspects of the relationship between him and Conchita, in which he feels he "owns" her because of he has given her money

 b) The terrorist bombings are seen by the middle-class as completely arbitrary and without purpose; there is no acknowledgement of the reasons behind them

 c) The bombings are seen by them as much like Conchita's actions

 (1) They both are completely unreasonable and inconvenient

 (2) Sex and terrorism are related by the initials of the terrorist groups; French sexual slang

 4. Religion, and its absurdity, is also an important theme for Buñuel (remember, he was an atheist); In *That Obscure Object of Desire*, one of the groups is the "Revolutionary Army of the Infant Jesus"

D. The film presents a humorous but cynical view of personal and social relationships

 1. On a personal level, we engage in sadomasochistic relationships in which we hurt one another, and deny one another what we really need and want

 2. On a social level, the middle class engages in economic and political dominance of the lower class, which responds with non-constructive and random violence

THE ART CINEMA

Last Year at Marienbad (Alain Resnais, 1961)

Directed by Alain Resnais

Written by Alain Resnais and Alain Robbe-Grillet

Produced by Pierre Courau and Raymond Froment

Music by Francis Seyrig

Cinematography by Sacha Vierny

Editing by Jasmine Chasney and Henri Colpi

Production Companies: Argos Films, Cineriz, Cinétel, Como Film, Cormoran Films, Les Films, Tamara, Precitel, Silver Films, Société Nouvelle des Films and Terra Film

Cast

Delphine Seyrig…A

Giorgio Albertazzi…X

Sacha Pitoëff…M

STUDY QUESTIONS

1. In what ways can we see in *Last Year at Marienbad* aspects of narrative and style that are typical of the films of Alain Resnais?

2. There are a number of ways in which we could interpret this film; what are some of them? How could it be interpreted in a way that would be consistent with the themes and ideas expressed in other films by Resnais?

3. In what ways is this film similar to and different from those of the classical Hollywood cinema? If it were to be remade in Hollywood, how would it be changed?

4. In what ways is this film consistent with the art cinema?

THE ART CINEMA in *Last Year at Marienbad* (Alain Resnais, 1961)

I. ALAIN RESNAIS: BIOGRAPHICAL INFORMATION

 A. Born in France in 1922

 B. Began making 8mm movies at the age of fourteen, but did not make films professionally until he reached his mid-twenties

 C. Between these years, he studied theatre and film directing at the French Cinema School

 D. Drafted into the French Army in 1945, served in a unit that entertained Allied Occupation forces in Germany and Austria

 E. 1946, discharged, began making documentaries, some features; some shown on TV

 1. Worked as a cameraman and editor for other directors

 2. 1956, his reputation as a documentary filmmaker reached a peak with *Night and Fog*

II. Resnais's OEUVRE

 A. The term OEUVRE refers to an auteur's body of work, all of the films that he/she has made

 B. Resnais has made many short documentaries and some feature-length documentaries (some for TV, some for theatrical release), and at least nine feature-length narrative films

 C. THE FILMS; FORM, STYLE, and SUBJECT MATTER

 1. *NIGHT and FOG* (1956)

 a) An unusual documentary investigation of Nazi concentration camps

 b) Established aspects of his approach to filmmaking, continued throughout his career

 c) SUBJECT MATTER: Preoccupation with the theme of memory

d) STYLE: Emphasis on probing and penetrating camera tracking (forward tracking)

e) FORM: disjointed editing, no clear articulation of space or time

2. *HIROSHIMA MON AMOUR* (1959)

 a) The story of a French actress who is making a film in Japan

 b) In the present, she is having an affair with a married Japanese businessman

 c) In the past, she had an affair with a young German soldier during the German occupation of France

 d) The film presents her memories of the affair with the soldier in extensive flashbacks

 (1) They are not signalled by punctuation (editing)

 (2) They are not clearly motivated by the narrative

 (3) They are accompanied by a voice-over narration in the present

3. *LAST YEAR AT MARIENBAD* (1961)

 a) Its narrative structure is based on the recreation of the past as it appears in the memory of the protagonist ("X"; the woman is "A", the "husband" is "M")

 b) Space and time are not articulated clearly

 (1) Events appear in seemingly random order (as in memory)

 (2) Some are repeated, some are repeated differently

 c) Cause and effect are not clear; also many questions as to just what did happen and what is happening (unlike CHC):

 (1) Did they meet the previous year?

 (2) Was the tall thin man her lover? husband?

 (3) Did he kill her?

 (4) Did the protagonist have sex with her? If so, was it rape?

 (5) Did she leave the hotel at the end? If so, with whom? When was it? The previous year, that year, or the next year? Never?

 d) Meaning unclear, ambiguous:

 (1) What is the meaning of the game played with matchsticks?

 (2) **What is so important about the statues and the garden?**

 (3) Why does the play seem to be about the same situation going on in the film?

 (4) What does any of it mean?

III. HOW TO INTERPRET *LAST YEAR AT MARIENBAD*?

 A. The film has always provoked heated discussion

 1. Pauline Kael: The film is silly and pointless

 2. Jonas Mekas: The film is sick, it presents "the abstract, impersonal hell which is the end product of Western Civilization"

 B. INFLUENCE OF THE SCRIPTWRITER

 1. Unlike many other auteurs of the EAC, Resnais prefers not to write his own scripts

 2. Usually works with well known novelists who write screenplays for him (but they do not adapt their novels)

 3. ALAIN ROBBE-GRILLET: scriptwriter for *Last Year at Marienbad*

 a) Important in the movement called the FRENCH NEW NOVEL; Resnais also interested in this movement

 b) French New Novel influenced by films

 c) In films, objects can be shown, not described; with description (as in the novel) usually comes some sort of human importance or interpretation

 d) Characters also can be used as objects can; do not have to be fully described characters with goals, personalities, etc.

e) There is really no past or future tense in film; it is all present tense, must resort to conventions (punctuation) to signal flashbacks and flashforwards

f) Robbe-Grillet sought to eliminate the influence of written literature from both his novels and his screenplay

 (1) Characters have no personalities or even names (the man is "X," the woman is "A," her husband or lover is "M")

 (2) Objects are meant to represent themselves, not ideas or themes (the explanations of the "meaning" of the statues is rejected; they are simply statues)

 (3) The entire film is in the present tense, takes place in the present

 (a) It takes place in the mind of the protagonist as it is remembered

 (b) It is difficult to determine plot time or story time; maybe the same as screen duration

IV. INTERESTS OF ALAIN RESNAIS

 A. MEMORY

 1. What happens when it is repressed? regained? How do we remember things; in what order, accurately, etc.?

 2. In *Marienbad*, we see the memories of X, which can and do change; also those of A, but through the mind of X, who sometimes corrects her memories (she is speaking, recounting her memories, but we see his; or sometimes the other way around [maybe], as when he insists the door was closed)

 B. DIALECTICAL FILM FORM

 1. Tension created by opposing elements that results in a third, different element (cf. Eisenstein)

 2. In *Marienbad*:

a) Alternation of shot locations (interior, exterior)

b) Length of shots (extremely long takes, very short ones; former bore us, latter can not be read easily)

3. Sound and image

a) Music and image (dramatic music with undramatic images; **dramatic** or violent images with no sound)

b) Voice-over and image (voice-over may conform to or contradict the image)

4. THE ROLE OF THE VIEWER

a) Both Resnais and Robbe-Grillet feel that the viewer is the real "author" of a film; we construct it in our minds and give it meaning

b) Robbe-Grillet, in reference to *Last Year at Marienbad*: "These things must be happening in someone's mind. But whose? The narrator-hero's? Or the hypnotized heroine's? Or else, by a constant exchange of images between them, in the minds of both together? It would be better to admit a solution of another order: Just as the only time that matters is that of the film itself, the only important 'character' is the spectator; *in his mind* unfolds the whole story, which is precisely *imagined* by him."

V. CONCLUSION: *Last Year at Marienbad* as EAC

A. FORM and SUBJECT MATTER

1. *Last Year at Marienbad* rejects the cause and effect construction of the CHC

a) Is it therefore more realistic?

b) Maybe, if seen as a series of memories

2. It rejects the idea of characters with clearly defined goals and personalities

3. It rejects closure, preferring ambiguity

4. It invites interpretation as a statement of the author, and we look for clues to the film in the filmmaker's life, statements, interests, etc.

B. STYLE

 1. More subjective than CHC, presents memories of characters without signalling them as subjective

 2. Style calls attention to the film's construction and the director's control over the film

PARAMETRIC CINEMA

M. Hulot's Holiday (Les Vacances de M. Hulot; Jacques Tati, 1953)

Directed and Produced by Jacques Tati

Written by Jacques Tati, Henri Marquet, Pierre Aubert and Jacques Lagrange

Music by Alain Romans

Cinematography by Jacques Mercanton and Jean Mousselle

Editing by Suzanne Baron, Charles Bretoneiche and Jacques Grassi

Production Design by Henri Schmitt

Sound by Roger Cosson

Produced by Fred Orain and Jacques Tati

Production Company: Cady Films and Specta Films

Cast

Jacques Tati…M. Hulot

Nathalie Pascaud…Martine

Michèle Rolla…The Aunt

Valentine Camax…Englishwoman

Louis Perrault…Fred

André Dubois…Commandant

Lucien Frégis…Hotel Proprietor

Raymond Carl…Waiter

René Lacourt…Strolling Man

Marguerite Gérard…Strolling Woman

STUDY QUESTIONS

1. Why, do you think, do film critics and film scholars often regard Tati's films, including *M. Hulot's Holiday*, as art films? In what ways are they similar to and different from art films?

2. Think about the ways in which *M Hulot's Holiday* deals with parameters of film style. Consider especially the ways in which the film uses film sound. In what ways could we regard this use of style to be excessive?

3. *M. Hulot's Holiday* may be regarded as a film built on the concept of perception and perceptual difficulty. Therefore, it contains a variety of types of gags, from conventional comedy bits to those that are so subtle that they are barely there. Can you give examples of these different types of jokes?

4. What seems to be the theme of this film? In what ways does film style contribute to the theme of the film?

PARAMETRIC CINEMA in *M. Hulot's Holiday* (Jacques Tati, 1953)

I. INTRODUCTION

 A. Although often lumped together with art cinema, there exists a group of films that more properly should be thought of as *modernist* or *parametric* films

 B. Parametric narration is narration in which the film's stylistic system creates patterns distinct from the demands of the story

 C. In these films, not only do style and story become equal in importance, they often alternate in importance

II. PARAMETRIC CINEMA

 A. WHAT IS PARAMETRIC CINEMA?

 1. Parametric form is governed by a structuring principle in which "artistic motivation" is systematic and foregrounded

 2. This artistic motivation creates patterns that are as important as or more important than the story structures

 3. Parametric films allow the play of stylistic devices a significant degree of independence from narrative functioning and motivation; they do not only or necessarily serve the narrative

 B. PARAMETRIC FORM and MUSIC

 1. Parametric films are often compared to music, especially serial music, with its repetitive structure of a limited number of notes

 2. But narrative film, depending on the depiction of events, is far different; because the number of choices is unlimited, we need some sort of structural guidelines

 C. WHAT ARE THESE STRUCTURAL GUIDELINES; HOW DO WE READ THESE FILMS?

 1. The story tends to provide a pattern for stylistic variations; it provides a basis for style, gives us an "anchor"

2. Limited numbers of techniques will be used in a given film

 a) Rarely will a director use unlimited variations of unlimited techniques

 b) More often, certain elements of style will be used more specifically *parametrically*: offscreen v. onscreen sound, short takes vs. long takes, etc.

 c) For example, in *M. Hulot's Holiday* Tati limits some parameters:

 (1) In terms of CINEMATOGRAPHY:

 (a) He relies mostly on long and medium-long shots and short tracking movements of the camera

 (b) Neither technique calls attention to itself; they are barely noticeable

 (2) In terms of EDITING, he never uses shot/reverse shot

 (3) These limitations tend to foreground the parameters Tati is more interested in: the dense mise-en-scène, the disorienting uses of editing and sound

3. Parametric films tend to be either unconventionally dense or unconventionally sparse

 a) The dense films will give us cues as to what to look *for* and what to look *at*; or will alternate between narrative and artistic motivation (to prevent viewer burn-out)

 b) The sparse films lead us to look for small differences in the few devices used

D. THEME IN PARAMETRIC FILMS

1. Often, the themes of these films are simple to the point of banality (they tend not to about theme, but about style, anyway)

2. This leads critics to say really banal things about these films

E. DEFLECTION INTO EXCESS

1. THE CHC and EXCESS

a) Excess usually means elements of style that contribute nothing to the narrative or story

b) The CHC seeks to avoid excess; even if a CHC film contains stylistic excess, it is subordinated to the much stronger narrative aspects of the film

c) This "subordinated excess," in fact, is what makes many critics regard some Hollywood directors as "auteurs"

2. PARAMETRIC FILM and EXCESS

a) Parametric films, on the other hand, often deflect attention away from the narrative and toward the excess

b) They do this in part by providing such simple narratives; there is little in the story to distract us from the style (the opposite of the CHC)

c) Unlike the CHC, in which story is most important, and the art cinema, in which there is potentially no excess (even if something is ultimately unexplainable, this may indicate that the director of the film is "trying to say something" about ambiguity and/or meaningless), the parametric film is *about* the excess, its ordering and permutations

3. Because little in M. Hulot's Holiday really contributes to the narrative, a great deal of the film (most of it?) could be regarded as excess

III. *M. Hulot's Holiday* and PARAMETRIC FORM

A. THEME OF THE FILM

1. The theme of the film, on at least the most basic level, is not complicated; it concerns the uniformity of modern life, and the ways in which the characters have learned to pay attention to the "wrong things"

2. On a more interesting level, the film is trying to teach *us*--the audience--to look at things differently, to see in a new way

3. We are forced to look for things in this film; often the funniest or most interesting gags are occurring in the background or edges of the frame, not in the foreground and center

B. PERCEPTUAL DIFFICULTY

1. This is a film built on the concept of perception and perceptual difficulty; contains a variety of types of gags, from conventional comedy bits to those that are so subtle that they are barely there

2. They may be divided into 3 general categories:

 a) Complete gags

 (1) The air escaping from the tire that sounds as if someone is "passing gas"

 (2) The tennis match

 b) Overabundance of gags; especially at the end of the film with the fireworks, the loud music, etc.

 c) Denial of apparent gags; for example, the ice cream cone that does not fall off when the child turns the door knob

3. All of these examples point out why many people dislike Tati's films; they require too much work for jokes that are difficult to understand, do not happen at all, or (some people think) are just not all that funny

IV. CONCLUSION: *M. Hulot's Holiday* and EXCESS

A. Unlike CHC films, deflects attention away from the narrative and toward the excess

1. It does this in part by providing such a simple narrative; there is little in the story to distract us from the style (the opposite of the CHC)

2. The mise-en-scène, although implicated in elaborate gags, does not compete with them by providing a "pretty" or romantic view of the resort

B. WHY DOES THE FILM DO THIS?

1. May seem like a dry, academic attempt at some sort of modernist comedy that is not really all that funny

2. Its project is to make us look at life in another context

3. By refusing to distinguish clearly between what is funny and what is not, the film is trying to get us to see that we should not make that sort of distinction in real life

 a) Life should be enjoyed

 b) It's alright to laugh at life's moments, whether they are "hilarious" or not

PARAMETRIC CINEMA

Play Time (Jacques Tati, 1967)

Directed by Jacques Tati

Written by Art Buchwald, Jacques Lagrange and Jacques Tati

Produced by René Silvera

Original music by James Campbell and Francis Lemarque

Cinematography by Jean Badal and Andréas Winding

Film Editing by Gérard Pollicand

Production Company: Specta Films

Cast

Billy Kearns…Mr. Schultz

Léon Doyen…Doorman

Barbara Dennek…Tourist

Jacques Tati…Monsieur Hulot

STUDY QUESTIONS

1. Why, do you think, do film critics and film scholars often regard *Play Time* as an art film? In what ways is it similar to and different from an art film?

2. Think about the ways in which *Play Time* deals with parameters of film style. How does he use cinematography? What kinds of editing does Tati use? How does he seem to emphasize the mise-en-scène? In what ways is the film style of *Play Time* excessive?

3. *Play Time* may be regarded as a film built on the concept of perception and perceptual difficulty. Therefore, it contains a variety of types of gags, from conventional comedy bits to those that are so subtle that they are barely there. Can you give examples of these different types of jokes?

4. What seems to be the theme of *Play Time*? In what ways does film style contribute to the theme of the film?

PARAMETRIC CINEMA in *Play Time* (Jacques Tati, 1967)

I. *Play Time* and PARAMETRIC FORM

 A. THEME OF THE FILM

 1. The theme of the film, on at least the most basic level, is not complicated

 a) It **concerns the uniformity** of modern life, and the ways in which the characters have learned to pay attention to the "wrong things"

 b) This certainly is supported by the film's style

 (1) What do the tourists look at? What do they miss in Paris?

 (2) It begins very grey and drab, developing to a colorful mise-en-scène by the end of the film, when the tourists have relaxed

 2. On a more interesting level, the film is trying to teach *us*--the audience--to look at things differently, to see in a new way

 3. We are forced to look for things in this film; often the funniest or most interesting gags are occurring in the background or edges of the frame, not in the foreground and center

 a) In the beginning of the film, we are helped by the couple who point out interesting things to look at

 b) After that, we are mostly on our own; it can become very tiring!

 B. PERCEPTUAL DIFFICULTY

 1. *Play Time*, a film built on the concept of perception and perceptual difficulty, contains a variety of types of gags, from conventional comedy bits to those that are so subtle that they are barely there

 2. They may be divided into three general categories:

 a) Complete gags

 b) Overabundance of gags

 c) Denial of apparent gags

 3. First, there are the complete gags

a) Some of these are obvious, resulting from build-ups

 (1) The chairs that breathe

 (2) The repeated seasoning of the fish in the restaurant

b) Some are not so easy to notice, especially on first viewing

 (1) The man who locks the doors and receives a set of horns

 (2) The man who puts the coin in the parking meter, starting the "carousel" of cars and trucks

4. Then there are times when there is an overabundance of gags

a) When Hulot mistakes the Alka-Seltzer for champagne, in the background a man orders dinner by pointing to the stains on the waiter's shirt

b) At the end of the restaurant scene, a multitude of comic bits occur simultaneously

5. Finally, there is the denial of apparent gags, or gags that do not "pay off"

a) When the waiter carries the dessert plate over the head of a dancer, but nothing happens

b) When Hulot puts the sponge on the cheese counter; no one eats it

6. All of these examples point out why many people dislike Tati's films; they require too much work for jokes that are difficult to understand, do not happen at all, or (some people think) are just not all that funny

C. BARING THE DEVICE: *Play Time* often foregrounds, or acknowledges, its perceptual difficulty

1. THE CARDBOARD CUTOUTS

a) Often characters in the background are replaced by life-sized, black-and white photograph cutouts

b) Sometimes he does this with cars, also

c) They are difficult to notice because:

 (1) Often real characters are motionless in the background, also

<div style="margin-left: 2em;">

 (2) The grey mise-en-scène of the first half of the film makes it difficult to pick out the cutouts

 2. THE FALSE HULOTS

 a) The film begins with a number of "false Hulots" (usually audiences expect to see him; he is in all but one of his films, always wearing the same outfit)

 b) This continues with other characters who look like Hulot, confusing us (and the other characters, also)

</div>

II. CONCLUSION: *Play Time* and EXCESS

 A. *Play Time*, unlike CHC films, deflects attention away from the narrative and toward the excess

 1. It does this in part by providing such a simple narrative; there is little in the story to distract us from the style (the opposite of the CHC)

 2. The mise-en-scène, although implicated in elaborate gags, does not compete with them by providing a "pretty" or romantic view of Paris

 B. WHY DOES THE FILM DO THIS?

 1. *Play Time* may seem like a dry, academic attempt at some sort of modernist comedy that is not really all that funny

 2. Its project is to make us look at life in another context

 3. By refusing to distinguish clearly between what is funny and what is not, the film is trying to make us to see that we should not make that sort of distinction in real life

 a) Life should be enjoyed

 b) It's alright to laugh at life's moments, whether they are "hilarious" or not

 c) The end of the film is actually an invitation

 (1) The music continues for several minutes after the image

 (2) This invites us to see the world around us as we have been looking at the film; in other words, lighten up!

PARAMETRIC CINEMA

High and Low (Akira Kurosawa, 1962)

Directed by Akira Kurosawa

Written by Eijirô Hisaita, Ryuzo Kikushima, Akira Kurosawa and Hideo Oguni

Produced by Ryuzo Kikushima, Tomoyuki Tanaka and Akira Kurosawa

Music by Masaru Satô

Cinematography by Asakazu Nakai and Takao Saitô

Production Companies: Kurosawa Production Co. Ltd. and Toho Company Ltd.

Distributed by Toho Company Ltd.

Cast

Toshirô Mifune…Kingo Gondo

Tatsuya Nakadai…Chief Detective Tokura

Kyôko Kagawa…Reiko Gondo

Tatsuya Mihashi…Kawanishi, Gondo's secretary

Isao Kimura…Detective Arai

Kenjiro Ishiyama…Chief Detective 'Bos'n' Taguchi

Takeshi Kato…Detective Nakao

Takashi Shimura…Chief of Investigation Section

STUDY QUESTIONS

1. In *High and Low*, Kurosawa uses a very obvious stylistic device: in the middle of a black-and-white film, he has a small bit of color. What is the effect of this use of color?

2. There are a number of different ways in which we could explain the title of the film; what are some of them?

3. How is the narrative of the film similar to and different from that of a typical classical Hollywood film?

4. In what ways is the film's style similar to and different from that of a typical Hollywood film?

5. Are the narrative and style of this film similar to those of some of the other Kurosawa films you may have seen, even the samurai films?

PARAMETRIC CINEMA in *High and Low* (Akira Kurosawa, 1962)

I. Introduction

 A. To what does the title refer?

 1. Searching high and low

 2. Difference in class and location

 B. Refers to the parametric construction of the film itself: the use of extremes of film style

II. Parametric dramatic structure of *High and Low*

 A. Overall structure of the film

 1. Film is arranged around a pivotal point (pink smoke) that divides the film into two (unequal) parts

 2. Long, tense waiting scenes in the first part; short suspenseful chase scenes in the second part

 a) This creates a sense of obvious structure

 (1) This structure is based on something other than typical Hollywood structuring schemes (journey, search, romance, etc.)

 (2) This calls the attention of the audience to the film's form, not the narrative

 3. Internal structure of the two parts In the first part of the film, Kurosawa reverses the narrative construction of the CHC

 a) The waiting scenes (the "boring stuff" left out in American films) occur onscreen

 b) The action (kidnapping, arrival of police, etc.) occurs offscreen

 4. The second part of the film is in sharp contrast with the first part

 a) The action (looking for the clues, capturing the kidnapper) is onscreen

 b) The waiting is offscreen; this is even more noticeable due to the contrast with the first part of the film

III. Parametric use of technique and style

 A. Kurosawa was familiar with both Hollywood and (obviously) Japanese conventions

 1. He liked to alternate them to create formal oppositions and patterns

 2. For example, in his earlier films, he tended to alternate "correct" eyeline matches with mismatches (as in *The Seven Samurai*)

 3. In *High and Low*, the use of TohoScope (widescreen) eliminates most close-ups

 a) Therefore, not as much emphasis on eyeline matches and mismatches as in earlier films

 b) Instead, more emphasis on the mise-en-scène and its framing, in conjunction with editing, to play with CHC style

 4. The first part of the film (in the house of the shoe manufacturer) is built upon permutations of the characters on the screen from one shot to the next

 a) Alternates "correct" editing (180°) with "incorrect" (360°)

 b) The main object of our attention appears on alternate edges of the frame (parametric use of mise-en-scène)

 c) Through editing and "cheating" with screen positions, the film uses characters as interchangeable units; almost musical in their arrangement (ABCD, DA, etc.)

 d) The main character(s) change positions from shot to shot; sometimes they are onscreen, sometimes they are offscreen

 e) This alternation operates independently of the narrative; it sometimes supports the narrative, sometimes undermines the narrative

 B. Shot transitions

1. Kurosawa uses wipes where most directors would use dissolves; wipes were abandoned by the CHC many years before because they are so obvious

2. As with other techniques Kurosawa alternates these wipes with straight cuts

 a) Thus, the most obvious of all transitional devices is alternated with the least obvious

 b) This calls attention to the pattern Kurosawa is creating; calls attention to the film's form

C. Parametric Use of Color

 1. Pink smoke radically disrupts black-and-white of the rest of the film

 a) Is it an element of mise-en-scène or cinematography?

 b) Remember, color most effective and most obvious in the context of black-and-white

 2. Is the pink smoke narratively necessary?

 a) Why or why not?

 b) The rest of the film could have been in color; or they could have used some other signal

 3. It is formally useful; it serves as an obvious dividing point between the two parts and the two styles of the film

 4. What is the effect of the pink smoke on the audience?

 a) It calls attention to the film's form

 b) Specifically, the parametric structure of the film; it is a film built on the oppositional use of film style

NON-NARRATIVE FILM

Hearts and Minds (Peter Davis, 1974)

Directed by Peter Davis

Cinematography by Richard Pearce

Editing by Lynzee Klingman

Sound by Tom Cohen and Clara Noto

Produced by Henry Lange and Bert Schneider

Production Companies: BBS Productions, Rainbow Releasing and Touchstone Pictures

Distribution Company: Warner Bros.

STUDY QUESTIONS

1. As a rhetorical documentary, *Hearts and Minds* should present a formal argument to convince the audience. Does it do so? If so, what is the argument it is making?

2. Does it deal with a question of fact, or with questions of belief and/or attitudes? What are the facts? Are they in question? If the film is dealing with questions of belief or attitude, what are these beliefs and attitudes?

3. How does the film try to establish credibility? Who is the narrator, and how does he portray himself? What seems to be his attitude? Who are the producer and/or sponsor? Do these factors hurt or enhance the film's credibility? How does the film try to establish a credible style?

4. Does the film make arguments about the subject matter? Does it use a logical, reasoning pattern of organization (problem-solution, cause-effect, etc)? What kinds of evidence does the film present? Does it use specific examples? Statistics?

5. Because it deals with questions of belief, the film should also appeal to emotion as well as reason; does it do this? In what specific ways does it do this? What are the emotions the film is trying to appeal to, and why? What is the purpose?

NON-NARRATIVE FILM in *Hearts and Minds* (Peter Davis, 1974)

I. THE RHETORICAL FORM OF *HEARTS and MINDS*

 A. The four basic attributes of rhetorical form

 1. Does this film seek to convince the viewer to adopt a new intellectual **conviction?**

 a) To oppose future imperialist activities by the US government

 b) To end our emphasis on winning, no matter what the consequences or moral implications

 2. The subject is not a matter of scientific truth (there is no question that the events happened), but is a matter of belief or attitude: the film has a definite ideology (humanist, nonimperialist)

 a) The argument is not so much in favor of one side over the other

 b) The film argues in favor of seeing the Vietnam war from a human (and humanist) point of view rather than a political or nationalistic point of view

 c) The film was made after the war, and is not arguing that we should leave

 d) Instead, it seeks to tell us something about ourselves and our society, as well as about the Vietnamese as human beings

 (1) We tend to see the enemy as something less than human; the film shows us the consequences of our actions on human beings, both the Vietnamese and ourselves

 (2) The film tries to convince us to never let it happen again (think of the children marching at the end of the film)

 3. The film appeals to our emotions

 a) It seeks to make us feel guilty about our complacence and ignorance

 b) It also tries to make us feel angry at the officials who lied to us and caused so much death and destruction

4. Finally, it seeks to persuade the viewer to make a choice that will effect his or her life

 a) Do not let it happen again, do not be blindly obedient, do not see other cultures as less "human" than ours

 b) If we do not change, we may end up killing our fellow human beings or we may be killed ourselves

B. THE THREE TYPES OF ARGUMENTS IN THE FILM

1. Arguments from the source: the film gives the impression of objective reporting

 a) The film uses testimony from three kinds of witnesses; all seem credible

 (1) Gives the opposition opportunities to give their side (government officials, Lt. Coker); they hang themselves

 (2) Uses officials who were in a position to know what was happening; they have changed their ideas, and are against the war

 (3) Uses soldiers who were there

 b) Has a very unobtrusive style

 (1) No voice-over narration

 (2) Uses subtle comparisons to make points, not heavy-handed rhetoric; lets us come to the proper conclusions

 (3) Although it is just as manipulative as any other documentary, does not seem to be

 c) The filmmaker

 (1) Peter Davis, a documentary filmmaker who has worked in both film and TV, directed the film

 (2) Made the film with the backing of a small production company that also made *Easy Rider*

 (3) The company had made a distribution deal with Columbia, who refused to handle it, afraid of bad publicity

 (4) It was finally released by Warner Bros., who did not make much of an effort to sell the film

 (5) Survived legal battles with some of the interviewees in the film; sought to prevent the film from being seen because they did not like the way they appeared in the film

2. Subject-centered arguments; arguments about the subject matter

 a) Supplies much testimony to support its position

 b) Gives historical background about the war and about our attitudes that led to the war (movies, etc.)

 c) Provides examples to support its position

 (1) Americans who do not understand the war but support it anyway

 (2) Americans who believe in our revolution but not the Vietnamese revolution

 (3) Examples of the destruction (both physical [death and injury] and social [prostitution]) caused by our involvement

 d) Provides examples to refute the arguments of the opposition

 (1) The Communist threat; Eisenhower describes the economic reasons for our support of the French

 (2) It refutes Johnson's argument about the Gulf of Tonkin with testimony by Sen. Fulbright, who introduced the bill giving Johnson war powers after the fictitious incident

 (3) The Asian lack of value of human life; the woman who crawls in the grave with her dead son

3. Viewer centered arguments; appeals to the emotions of the audience

a) Withholds the fact that some of the soldiers are crippled until late in the film; this increases the emotional impact

b) The film holds some shots for an unusually long time; will not let us avoid the effects of the war

c) Emphasizes the effects of the war on children; small coffins, injured children, begging in the streets, etc.

II. CONCLUSION

A. *Hearts and Minds* uses the rhetorical documentary form to create a humanist film, an argument meant to appeal to our humanism, and to improve the state of mankind

B. A humanist examination of the film leads to a conclusion that the film seeks to humanize us in two ways

1. By making us see other people as human beings, not just statistics or "targets"

2. By making us look at ourselves and our responsibilities as human beings; as one of the witnesses states in the film, "It's not that we were on the wrong side, we *were* the wrong side"

NON-NARRATIVE FILM

Night and Fog (Alain Resnais, 1955)

Directed by Alain Resnais

Written by Jean Cayrol

Cinematography by Ghislain Cloquet and Sacha Vierny

Film Editing by Alain Resnais

Produced by Anatole Dauman, Samy Halfon and Philippe Lifchitz

Production Companies: Como-Films, Argus-Films and Cocinor

STUDY QUESTIONS

1) As a rhetorical documentary, *Night and Fog* should present a formal argument to convince the audience. Does it do so? If so, what is the argument it is making?

2) Does it deal with a question of fact, or with questions of belief and/or attitudes? What are the facts? Are they in question? If the film is dealing with questions of belief or attitude, what are these beliefs and attitudes?

3) How does the film try to establish credibility? Who is the narrator, what seems to be his attitude? How does the film try to establish a credible style?

4) Does the film make arguments about the subject matter? Does it use a logical, reasoning pattern of organization (problem-solution, cause-effect, etc)? What kinds of evidence does the film present? Does it use specific examples? Statistics?

5) Because it deals with questions of belief, the film should also appeal to emotion as well as reason; does it do this? In what specific ways does it do this? What are the emotions the film is trying to appeal to, and why? What is the purpose?

6) What is the overall impact of the film? The film, since its debut, has stirred controversy; why do you think that is?

NON-NARRATIVE FILM in *Night and Fog* (Alain Resnais, 1955)

I. INTRODUCTION

 A. Alain Resnais, director of *Night and Fog*, is best known as a director of art films

 B. He began, however, as a director of documentaries, not narrative films

 C. 1956, his reputation as a documentary filmmaker reached a peak with *Night and Fog*

 1. An unusual documentary investigation of Nazi concentration camps

 2. Established aspects of his approach to filmmaking, continued throughout his career

 D. You see many similarities among *Night and Fog* and his later narrative films (for example, *Last Year at Marienbad* from 1961)

II. NONNARRATIVE FORM and STYLE IN *Night and Fog* (1955)

 A. In what ways does it display attributes of the four types of nonnarrative film? (Remember, nonnarrative films will often mix these forms; they may be rhetorical overall, but will also have elements of the other types of nonnarrative form)

 1. CATEGORICAL

 a) REMEMBER:

 (1) Useful when a filmmaker wants to convey some information to the viewer

 (2) Usually begins with a general category, then introduces subcategories, based on similarities and differences

 b) Examples of the use of categorical form in *Night and Fog*?

 (1) The different styles of the guard houses

 (2) The different features ("surprises") of the various death camps

 (3) The different categories of the prisoners

 (4) The different uses to which the bodies were put, etc.

 2. ABSTRACT FORM

 a) Does *Night and Fog* use the abstract form at all?

 (1) Yes, in a sense; the images of the present are meant to visually clash with the images of the past

 (a) Black and white vs. color

 (b) "Beautiful" images vs. ugly ones, etc.

3. ASSOCIATIONAL FORM

 a) Any examples of the use of associational form?

 b) What about the juxtaposition of past and present?

4. RHETORICAL

 a) The four aspects of the rhetorical form

 (1) Does the film present a formal argument to convince the audience? Yes: Although we would like to believe that the Holocaust is something that happened just once, in the past, in fact it is something that has continued throughout history

 (2) Does it deal with a question of fact, or of belief and/or attitude?

 (a) Yes: There is no question that the events took place (although some still try to deny the Holocaust)

 (b) The film tries to convince viewers to feel a certain way about the events

 (3) Does it appeal to emotion as well as reason?

 (a) It does present facts to support its case

 (b) However, more effective are the images that shock us, images that need no words

 (4) Does it attempt to persuade the viewer to make a decision that will affect his or her life, and possibly move the viewer to action? Yes: We should not let it happen again

 b) The three main types of argument usually used by nonnarrative films using the rhetorical form

 (1) Does the film use arguments from the source?

(a) The use of a credible narrator, credible producer and/or sponsor?

 (i) The text is provided by Jean Cayrol, a well-respected French poet and intellectual

 (ii) The narrator is French actor Michel Bouquet, who Resnais asked to speak in a neutral voice

(b) Credible style (live sound, hand-held cameras, etc., giving the impression of actually having been there without manipulating "reality")?

 (i) Where does the film used come from?

 (a) Found footage from the Nazis themselves

 (b) Allied liberation forces

 (c) Present footage photographed by the filmmakers

 (ii) What is significant about this footage? Is it credible?

(2) Does it use subject-centred arguments (arguments about the subject matter)?

 (a) What is its pattern of organization (problem-solution, cause-effect, etc.)?; Mostly chronological, with some aspects of problem-solution

 (b) Does it present evidence?

 (i) Specific examples? Many visual examples of atrocities

 (ii) Statistics? Many, including nine million dead

 (iii) Expert testimony? Not much

(3) Does the film present viewer-centred arguments (does it appeal to the audience's emotions to make its points)?

 (a) Visually? Of course…

 (b) What about its narration, especially at the end of the film?

5. Does the film also use some aspects of narrative film form?

B. SOME GENERAL COMMENTS ABOUT THE FILM

1. SUBJECT MATTER: Not just about Nazi concentration camps, but also preoccupation with the theme of memory and forgetting

2. STYLE

 a) CINEMATOGRAPHY: Emphasis on probing and penetrating camera tracking (forward tracking)

 b) EDITING: Disjointed editing, no clear articulation of space or time

 c) In many ways, this film is very much like Resnais's narrative films

NON-NARRATIVE FILM

Who Killed Vincent Chin? (Christine Choy and Renee Tajima-Pena, 1988)

Directed by Christine Choy and Renee Tajima-Pena

Produced by Christine Choy & Renee Tajima-Pena

Sound by Ira Spiegel

STUDY QUESTIONS

1. Should we consider *Who Killed Vincent Chin?* a rhetorical documentary? If so, does it present a formal argument to convince the audience? If so, what is the argument it is making?

2. Does this film use the three main types of argument usually used by non-narrative films using the rhetorical form?

 a. Arguments from the source? Does this film try to establish credibility? How does it do this? Who do we never see in this film?

 b. Subject-centered arguments? Does this film make arguments about the subject matter? Does it present evidence, such as specific examples, statistics, or expert testimony?

c. Viewer-centered arguments? Does this film appeal to the audience's emotions to make its points? If so, how does it do this?

3. What are the salient techniques used in this film? How does Choy use environment and context in this film? What do we see and know about where these people live?

4. How is the entire film structured? Are there really three levels of time and four "lines of action"? What are they?

NON-NARRATIVE FILM in *Who Killed Vincent Chin?* (Christine Choy Renee Tajima-Pena, 1988)

I. INTRODUCTION

 A. David Bordwell and Kristin Thompson, in *Film Art*, offer four general steps in analyzing film style

 B. We will use these to analyze Christine Choy's 1988 documentary film, *Who Killed Vincent Chin?*

II. DETERMINE THE ORGANIZATIONAL STRUCTURE OF THE FILM, ITS NARRATIVE OR NONNARRATIVE FORMAL SYSTEM

 A. Does the film have a narrative or nonnarrative structure?

 1. It has a nonnarrative structure

 2. How do we know this? What indicates to us that it is a nonnarrative film?

 B. Which nonnarrative formal system does the film use?

 1. CATEGORICAL

 a) Remember, this is useful when a filmmaker wants to convey some information to the viewer; is that what Choy wants to do?

 b) Does the film divide its information or images into groups to help us understand the subject matter?

 c) Does the film begin with a general category, and then introduce subcategories?

 2. ABSTRACT

 a) The audience's attention is drawn to the abstract visual and sonic qualities of the things shown

 b) We do not look for logical or narrative connections between shots and images

 c) Is this film organized around abstract principles, such as color, shape, rhythm, and size?

 3. ASSOCIATIONAL

a) Suggests expressive qualities and concepts by juxtaposing seemingly unlike things

b) Does this film do this? Is it associating seemingly unlike things?

4. RHETORICAL

 a) Is Choy presenting a persuasive argument?

 b) Is she trying to do more than give the audience information about a subject?

 c) Does this film use the three main types of argument usually used by nonnarrative films using the rhetorical form?

 (1) ARGUMENTS FROM THE SOURCE

 (a) Does this film try to establish credibility?

 (i) Is Choy a credible filmmaker?

 (ii) Does it use a credible style?

 (b) How does the film try to make us "buy" its argument?

 (c) Who do we never see in this film?

 (i) Do we see the narrator?

 (ii) Do we see Vincent Chin?

 (2) SUBJECT-CENTERED ARGUMENTS

 (a) Does this film make arguments about the subject matter?

 (i) What is the argument that the film is trying to make?

 (a) That Vincent Chin's death was racially motivated?

 (b) That no matter the motivation, justice was not served in this case?

 (ii) If we can determine the argument, how can we describe the method by which Choy seeks to convince us?

(b) Does it present evidence, such as specific examples, statistics, or expert testimony?

(i) Much of the testimony is not by an "expert," but by the killers themselves; what is the effect of this?

(ii) Much of the evidence is supplied by TV and newspaper reports; do we consider them to be reliable?

(3) VIEWER-CENTERED ARGUMENTS

(a) Does this film appeal to the audience's emotions to make its points?

(b) If so, how does it do this?

(c) What role does Vincent's mother play in this effort to appeal to the emotions?

III. IDENTIFY THE SALIENT TECHNIQUES USED

A. MISE-EN-SCÈNE

1. How does Choy use environment and context in this film?

2. What do we see and know about where these people live?

a) Where did this murder take place?

b) Detroit; what is our attitude toward Detroit? What kinds of preconceptions do we have about it?

c) The United States

(1) Do we feel that these kinds of things could occur here?

(2) How do Vincent's mother and friends feel about the United States?

3. How do we feel about this?

B. CINEMATOGRAPHY

1. How does Choy use cinematography (camera work) in this film?

a) Distinguish between the "found" footage (TV footage, etc) and that taken by Choy and her crew

 b) Is there a difference?

 2. Does the use of cinematography make any difference to how we take this film?

 C. EDITING

 1. Does Choy use editing in any salient or unusual way?

 2. What seems to guide the shot-to-shot relationships?

 3. How are time and space articulated in this film; do you feel that editing has manipulated you and affected the way in which you take the events depicted?

 D. SOUND

 1. How does sound contribute to the film?

 2. Who do we never hear?

 a) Vincent himself

 b) Why not?

IV. TRACE OUT PATTERNS OF TECHNIQUES WITHIN THE WHOLE FILM

 A. How is the entire film structured?

 B. Are there really three levels of time and four "lines of action"?

 1. The interviews are taking place in the "present"

 2. Two lines of action deal directly with the case of Vincent Chin

 a) One line of action deals with the night of the murder of Vincent Chin (the past)

 b) The other deals with the trials of the murderer (the more recent past)

 3. Likewise, there are two "histories" related (and headed for a collision)

 a) The history of the Chinese coming to America

 b) The history of the Detroit auto industry and its workers

V. PROPOSE FUNCTIONS FOR THE SALIENT TECHNIQUES and THE PATTERNS THEY FORM

 A. How does style enhance the *emotional* aspects of the film?

B. How does style shape the *meaning* we get from the film?

C. Try to imagine *alternatives* to the way the film was made

 1. Could it have been made more obviously sympathetic to Chin? How?

 2. Could it have been made more obviously sympathetic to Ebens? How?

 3. Could it have been made more as a "straight" documentary?

 a) How? More straightforward temporal structure?

 b) What would have been the result?

 (1) Would it have made it more Ebens's story?

 (2) Would it have made a single person more responsible, instead of seeing this as a broader problem?

D. What is the film really trying to say...who is to blame?

NON-NARRATIVE FILM

Roger & Me (Michael Moore, 1989)

Directed by Michael Moore

Written by Michael Moore

Produced by Michael Moore and Wendy Stanzler

Cinematography by Chris Beaver, John Prusak, Kevin Rafferty and Bruce Schermer

Film Editing by Jennifer Beman and Wendy Stanzler

Sound Department: Jennifer Beman (sound editor) and Judy Irving

Production Company: Dog Eat Dog Films

Distributor: Warner Bros.

STUDY QUESTIONS

1. As a rhetorical documentary, *Roger and Me* should present a formal argument to convince the audience. Does it do so? If so, what is the argument it is making?

2. Does it deal with a question of fact, or with questions of belief and/or attitudes? What are the facts? Are they in question? If the film is dealing with questions of belief or attitude, what are these beliefs and attitudes?

3. How does the film try to establish credibility? Who is the narrator, and how does he portray himself? What seems to be his attitude? Who are the producer and/or sponsor? Do these factors hurt or enhance the film's credibility? How does the film try to establish a credible style? Does it seem "professional"?

4. Does the film make arguments about the subject matter? Does it use a logical, reasoning pattern of organization (problem-solution, cause-effect, etc)? What kinds of evidence does the film present? Does it use specific examples? Statistics?

5. Because it deals with questions of belief, the film should also appeal to emotion as well as reason; does it do this? In what specific ways does it do this? What are the emotions the film is trying to appeal to, and why? What is the purpose?

6. What is the overall impact of the film? Do the film's problems invalidate Moore's point? Do they damage his credibility? What do you think of his use of humor? Does it lessen the impact of the film, or enhance it?

NON-NARRATIVE FILM in *Roger & Me* (Michael Moore, 1989)

I. INTRODUCTION

 A. Michael Moore's 1989 documentary *Roger & Me* uses (primarily) the rhetorical form to create a powerful film that mixes humor and drama to reach the audience

 B. It also has been the subject of controversy surrounding its sequencing of events

II. *Roger & Me* and THE FOUR BASIC ATTRIBUTES OF THE RHETORICAL DOCUMENTARY

 A. It presents a formal argument to convince the audience

 1. What is the argument?

 2. In general:

 a) That a company has a responsibility to the people who made it a success

 b) They are more important than some abstract concept such as "corporate profits"

 3. Some historical background on corporate America

 a) Originally, businesses existed to provide a service or product for the community and a livelihood for the owner and his employees

 b) These businesses grew and became publicly owned

 (1) They came to exist more for the profit of people often outside of the community and a group of executives seeking to preserve their jobs

 (2) They lost their close connections with the communities in which they began

 c) It became easy to justify actions as serving the stockholders

 (1) These stockholders (this often includes executives) became more important than the employees

 (2) Even when employees buy stock themselves, this money is often used to eliminate their jobs!

d) During the Reagan administration, especially, deregulation encouraged corporations to buy or merge with other corporations, further removing them from their roots in the community

e) What is the real answer to international conglomerations?

 (1) International unions

 (2) Workers around the world have been put in competition with one another by these conglomerates

B. In this film, the company is General Motors (personified by Roger Smith, chair of GM), and the people are the citizens of Flint, MI, who worked in that city's auto plants for fifty years

C. It deals not with a question of fact, but of belief and/or attitude

1. The facts are not really in question

a) No one disputes the facts put forth in the film

b) Workers were laid off, factories were opened in Mexico, the crime rate increased, efforts were made to revive Flint, etc.

2. The question is one of belief or attitude about these facts

a) Were these actions justified or wise?

b) Does a company have a responsibility to its employees?

D. Because it deals with questions of belief, the film often appeals to emotion as well as reason; we will discuss this in a few minutes

E. It attempts to persuade the audience to make a decision that will affect his or her life

1. Become active in your own community and company

2. Speak out against what is happening in corporate America

3. Elect candidates who will act in behalf of the working class

4. Will it ever happen?

III. *Roger & Me* and THE THREE TYPES OF ARGUMENT USED BY THE RHETORICAL DOCUMENTARY

A. ARGUMENTS FROM THE SOURCE: How does the film try to establish credibility?

1. THE FILMMAKER

a) Who is the narrator, and how does he portray himself?

 (1) He looks like a slob, and he does not seem especially smart at times; why?

 (a) He wants to be identified with the workers

 (b) He wants to set himself apart from those he is attacking

 (2) What seems to be his attitude?

 (a) He is not angry, or unreasonable; he just wants some simple answers to some simple questions

 (b) He seems to think that if Roger Smith will visit Flint, Smith will see what he has done; is this true?

b) Who are the producer and/or sponsor?

 (1) It is just Moore and his small crew

 (2) They do not officially "represent" anyone

 (a) How does this actually enhance their credibility?

 (b) They appear to represent just ordinary people; GM does not recognize people, only corporate entities

2. How does the film try to establish a credible style?

a) Does it seem "professional"?

b) It uses live sound, hand-held cameras, etc.

c) Moore does not try to "hide" himself or his crew, as often happens in documentaries

d) EDITING

 (1) It is the editing, or sequencing of events in the film, that created some controversy

 (2) What did Moore manipulate?

 (a) He presented events out of their actual chronological order

 (b) He implied that they happened in a much shorter period of time than they actually did

 (3) Why did he do this?

 (a) In order to present an argument in a limited amount of time

 (b) In order to present the events as a narrative; why? (more interesting, easier to follow...)

 (4) IMPLICATIONS OF THIS MANIPULATION

 (a) Does the re-sequencing of events really alter his argument much?

 (b) But what is the effect on the viewer, knowing that this happened?

B. SUBJECT-CENTERED ARGUMENTS; arguments about the subject matter

 1. The film uses a logical, reasoning pattern of organization (cause-effect)

 a) In fact, it may be too logical (see above)

 b) This is another reason for the manipulation of chronology (to enhance the impression of cause and effect)

 2. What kinds of evidence does the film present?

 a) Specific examples

 (1) Workers laid off and unemployed, some turning to crime or selling rabbits

 (2) Shots of the factory in Mexico

 (3) Shots of the devastation in Flint

 (4) Examples of efforts to revive Flint, etc.

 b) Statistics

 (1) 30,000 workers laid off in Flint

 (2) GM made a $5 billion profit in 1986, the year the bulk of the workers were laid off

 (3) Huge amounts of money spent on the Hyatt Regency hotel, AutoWorld, Water St. Pavilion, the new jail, etc.

C. VIEWER-CENTERED ARGUMENTS: The film often appeals to the audience's emotions to make its points

1. The issue itself is treated as an economic one by GM and its spokespersons (which makes it even more ironic that the GM PR man is laid off); by showing the effects of the layoffs in human terms, Moore makes the issue an emotional one

2. EXAMPLES

 a) People being evicted on Christmas Eve while Smith babbles on about "the dignity of man"

 b) The Rabbit Lady

 c) The laid-off auto worker being shot in the street

 d) The callous behavior of Flint's upper class

 (1) Hiring the unemployed to be "human statues"

 (2) Playing golf and complaining that people are lazy

 (3) Having a party in the new jail

IV. USE OF OTHER FORMS?

A. Categorical?

B. Abstract?

C. Associational?

D. Narrative?

V. CONCLUSION

A. PROBLEMS WITH THE FILM

 1. The changed chronology

 2. Some cheap shots

 a) Bob Eubanks

 b) Miss Michigan

 c) What do they really have to do with Flint's problems?

B. WHAT IS THE OVERALL IMPACT OF THE FILM?

 1. Do the problems invalidate Moore's point?

 2. Do they damage his credibility?

 3. What do you think of his use of humor? Does it lessen the impact of the film?

ANIMATION

Lady and the Tramp

(Hamilton Luske, Clyde Geronimi and Wilfred Jackson, 1955)

Directed by Hamilton Luske, Clyde Geronimi and Wilfred Jackson

Written by Ward Greene and Erdman Penner

Produced by Walt Disney and Erdman Penner

Original music by Sonny Burke, Peggy Lee and Oliver Wallace

Film Editing by Donald Halliday

Production Company: Walt Disney Productions

Distributor: Buena Vista Pictures

Voice Cast

Peggy Lee…Darling/Si/Am/Peg

Barbara Luddy…Lady

Larry Roberts…Tramp

Bill Thompson…Jock/Bull/Dachsie/Joe

Bill Baucon…Trusty

Stan Freberg…Beaver

Verna Felton…Aunt Sarah

Alan Reed…Boris

George Givot…Tony

Dal McKennon…Toughy/Professor

Lee Millar…Jim Dear

STUDY QUESTIONS

1. Despite its technological differences from live-action filmmaking, does *Lady and the Tramp* seem to conform to the model of the Classical Hollywood Cinema? Does the film conform stylistically to the CHC? If so, in what ways does it do this? If not, how does it deviate?

2. In what ways is it ideologically similar to (or different from) live-action CHC films? What values does it seem to be promoting? Are these typical "American" values? Have we seen these values in any other films we have seen this term?

3. Although *Lady and the Tramp* is an animated film, could we argue that it falls within a particular Hollywood genre? If so, which one, and what are the characteristics of the film that seem to put it in this genre?

ANIMATION in *Lady and the Tramp* (Hamilton Luske, Clyde Geronimi and Wilfred Jackson, 1955)

I. INTRODUCTION

 A. Despite its technological differences from live-action filmmaking, *Lady and the Tramp* conforms to a high degree to the model of the Classical Hollywood Cinema

 B. Disney's animation has often been regarded as being much closer to the CHC than are the cartoons of other studios (Warner Bros., MGM, etc.)

 C. In addition, it fits in quite well with the types of films being made in Hollywood during the Studio Era

II. *LADY AND THE TRAMP* AND THE CHC

 A. In what ways is the narrative of the film similar and/or different from live-action CHC films?

 1. THE PROTAGONISTS

 a) The agents of cause and effect in the film are individuals: Lady and Tramp

 b) Even though they are animated, and are animals, they have characteristics very similar to those of live-action human protagonists

 2. THE GOALS

 a) The protagonists have goals that drive the narrative

 b) Lady: She wants to get home, and then to prove that Tramp did not threaten the baby

 c) Tramp: He also wants to clear his name (and to win Lady)

 3. THE TWO LINES OF ACTION

 a) Work-related line of action: Lady and Tramp try to protect the baby, and clear Tramp's name

 b) Romance-related line of action: Tramp and Lady are in love, but can not be together because Lady's owners think Tramp attacked the baby

4. CLOSURE

 a) Lady and Tramp prove that Tramp did not seek to harm the baby

 b) Overcoming the obstacles leads to changes in the status of the characters:

 (1) Lady and Tramp end up together as a "married" couple

 (2) Tramp is domesticated, and no longer chases other "women"

 (3) Lady and Tramp have children

B. Does the film conform stylistically to the CHC? If so, in what ways does it do this? If not, how does it deviate?

 1. Again, although Lady and the Tramp is an animated film, its style is very consistent with that of live-action CHC films

 2. Most importantly, it uses continuity editing to maintain spatial and temporal continuity, so that the story is told as clearly as possible

 3. And, as with other CHC films, the style never detracts from, or draws attention from, the narrative; the narrative takes precedence over style

C. Why is the film so similar to live-action CHC films?

 1. Many critics and scholars argue that Disney strove to make his films more like the CHC beginning with *Snow White and the Seven Dwarfs* in 1938, in an effort to make them more realistic

 2. However, the change came about more due to the increase in length of the cartoons from the short form (seven to eight minutes) to feature length

 3. In order to tell a coherent narrative and keep the attention of the audience, Disney looked to the live-action CHC narrative film for a model to use in constructing his feature-length films

 4. The result was a high degree of similarity between the style and narrative of Disney's feature-length animated films and those of the CHC

III. In what ways is it ideologically similar to (or different from) live-action CHC films? What values does it seem to be promoting? Are these typical "American" values?

A. As we have seen, Tramp becomes domesticated and "marries" Lady

1. They form a successful family unit

2. The film suggests that Tramp has a history of promiscuity; when he forms a union with Lady, he gives up "dating" other dogs

3. The film argues that heterosexual relationships are "correct," but must be consummated within monogamous marriage

B. The film also argues that individual effort is most appropriate, and will succeed by overcoming all obstacles (which themselves are created by individuals, for example Aunt Sarah's accusation that Tramp attacked the baby)

C. There is a message about America's class system as well

1. Although Lady and Tramp are of different classes, they ultimately get together and discover they have similar values

2. Note that the values that they "agree" on are essentially feminine and middle class

IV. Although *Lady and the Tramp* is an animated film, could we argue that it falls within a particular Hollywood genre? If so, which one, and what are the characteristics of the film that seem to put it in this genre?

A. *Lady and the Tramp*, as a Disney feature length animation, is also a musical comedy

B. However, it has a number of similarities to the screwball comedy genre (a useful comparison can be made with *It Happened One Night*)

C. SPECIFIC CHARACTERISTICS OF THE SCREWBALL COMEDY

1. Screwball comedy is a genre of indeterminate space

a) No particular setting is necessary

b) Struggle is not for control of the space

c) Not an individual hero, but a romantic couple or "doubled hero" (Lady and Tramp)

2. Not a genre of social order, but one of SOCIAL INTEGRATION

a) Couple is a romantic one, with different backgrounds, values

(1) She is rich and spoiled, but also a little rebellious

(2) He is independent, working class, earthy, cynical

 b) The problem is one of integration of the two systems of values; they must be reconciled

 3. Problems in discussing the screwball comedy

 a) There are very few icons, as in the Western, etc.

 b) No particular setting

 c) Therefore gets its identity mostly through narrative situations: sexual situations, courtship between members of different classes, etc.

 d) Also, to an extent, the visual style of the screwball comedy

 (1) Editing

 (a) Shot-reverse shot

 (i) It begins confrontationally (stresses the opposition between the two)

 (ii) It becomes less confrontational

 (b) Also an emphasis on two-shots of couple

 (2) Camera movement

 (a) The camera often pans from one to another of the main characters

 (b) This creates a bond between the couple

V. CONCLUSION

 A. Again, although Lady and the Tramp is an animated film, it is very similar to live-action CHC films

 B. This is true of both the film's narrative and style

 C. The film also belongs to a CHC genre—the musical comedy—but is also very much like the films of the screwball comedy

ANIMATION

South Park: Bigger Longer & Uncut (Trey Parker, 1999)

Directed by Trey Parker

Written by Trey Parker, Matt Stone and Pam Brady

Film Editing by John Venzon

Original Music by Trey Parker, Matt Stone and Marc Shaiman

Produced by Frank C. Agnone II and Matt Stone

Production Companies: Comedy Central and Comedy Partners

Distributed by Paramount Pictures

Cast

Trey Parker…Stanley Marsh/Eric Theodore Cartman/Satan/Mr. William L. Garrison/Phillip Niles Argyle/Randall "Randy" Marsh/Tom the News Reporter/Midget in Bikini/Ticket Taker/Canadian Ambassador/Bombadeers/Councelor Mackey/Army General/Ned Gerblanski

Matt Stone…Kyle Broslofski/Kenny McCormack/Saddam Hussein/Terrence Henry Stoot/James "Jimbo" Kearn/Gerald "Jerry" Broslofski/Bill Gates

Mary Kay Bergman…Liane Cartman/Sheila Broslofski/Sharon Marsh/Wendy Testeberger/Clitoris

Isaac Hayes…Jerome "Chef" McElroy

George Clooney…Dr. Gouache (a.k.a Dr. Doctor)

Minnie Driver…Brooke Shields

Eric Idle…Dr. Vosknocker

STUDY QUESTIONS

1. How can we describe the style of this film? Does it really use a single style, or does it combine several?

2. In what ways does this film reveal knowledge of film history on the part of its director?

3. In what ways can we see the influence of earlier films, movements, and/or modes on this film?

4. In what ways is this film a classical Hollywood film? Does it have some characteristics of other modes?

5. Consider the fact that this film is animated. How does that affect our expectations while watching the film? What are these expectations, and how do they change? What would be different about the way in which we take the film if it were not animated?

ANIMATION in *South Park: Bigger Longer & Uncut* (Trey Parker, 1999)

I. INTRODUCTION

 A. How can we describe the narrative of this film?

 1. It refers to a number of earlier Hollywood films, as well as to a number of kinds of Hollywood films

 2. Parker and Stone assume that the viewer is familiar with these films (as well as with the "South Park" television show)

 B. How can we describe the style of the film? Does it really use a single style, or does it combine several?

 1. As with the narrative, the film relies on (and refers to) a number of different styles

 2. However, as we will see, it uses primarily computer animation to recreate an earlier style of animation

II. In what ways does this film reveal a knowledge of film (and especially animation) history on the part of its director?

 A. What type of animation is this film (based on the *profilmic event*)?

 1. "South Park" (the television show) began as cut-out animation

 a) This is one of the earliest forms of animation

 b) It features cut-out pieces of paper that form the characters and objects

 c) It can be extremely time-consuming if done meticulously; however, Parker and Stone took little care with the production, resulting in a crude product

 2. *South Park* (the television show and the film) are now computer animated

 a) The production schedule prohibits the kind of time-consuming work that would be required for cut-out animation

 b) However, they use computers to maintain the crude look of their earlier cut-out animation

 c) This crudity fits quite well with the narrative of *South Park*

B. In what ways can we see the influence of earlier films, movements, and/or modes on this film?

 1. *South Park* obviously refers to Hollywood musicals

 a) It features a number of musical numbers, done in a variety of styles

 b) For example, some of the numbers are similar to Broadway-type Hollywood musicals ("Up There," "La Resistance (Medley)"

 2. It also refers to (and parodies) Disney animation (which, after all, is the best example of the modern Hollywood musical)

 a) The opening number, "Mountain Home" is much like similar opening songs in Disney animations

 b) The "Clitoris" is very similar to the talking tree, Grandmother Willow, in *Pocahontas*

 3. The film also is quite aware of its place in animation history

 a) The film (and the television show) are part of the contemporary "aesthetic of ugliness"

 b) Because it is not cost-effective to create the kind of detailed, hand-drawn animation Walt Disney made popular, some animation uses its limited resources to its advantage

 c) "The Simpsons" began this trend; it has continued with "Beavis and Butthead," "Ren and Stimpy," and a variety of other animations, including "South Park"

 d) The film makes a joke about this when Cartman says that animation today sucks, and the characters walk jerkily as in limited animation

III. In what ways is this film a classical Hollywood film? Does it have some characteristics of other modes?

A. Despite the fact that the film is animated (and has a narrative that some would describe as outrageous), it is very much in the mold of the classical Hollywood cinema

B. It features individual protagonists

 1. There is more than one protagonists: Stan, Kyle, Cartman and Kenny

 2. However, they can hardly be described as a "collective"

C. It features two lines of action

 1. Work-related: the boys must prevent Satan from taking over the world

 2. Romance-related: Stan is in love with Wendy

 3. The two become inter-related when Stan searches for "The Clitoris" instead of trying to stop Satan

D. The characters change because of actions that occur due to the opposition to their goals

 1. Stan wins the love of Wendy

 2. Kenny goes to Heaven instead of Hell

 3. Satan dumps Saddam Hussein and returns to Hell

 4. The people of South Park realize that Philip and Terence were not the problem at all; instead they need to listen to their children

IV. VIEWING EXPECTATIONS

A. Consider the fact that this film is animated; how does that affect our expectations while watching the film?

B. What are these expectations, and how do they change?

C. What would be different about the way in which we take the film if it were not animated?

 1. Would we be more offended than we are by the animated film?

 2. Is it easier to accept obscenities, sexual references and violence from animated characters than it would be from live-action characters? Why or why not?

V. CONCLUSION

 A. South Park is a film that has offended a great number of viewers (although many of those most offended have never seen the film)

 B. Regardless of how it has affected viewers, it is safe to say that the film, despite its outlandishness and the fact that it is animated, is safely within the classical Hollywood cinema

 C. South Park as Post-Modernist Text

 1. We can also observe that the film's knowledge of its place in film history, and its references to other films and aspects of popular culture, help to create a post-modern text

 2. This is especially so considering that the film uses a modern technology—computer technology—to create a product that looks like one created by a very old technology—cut-out animation

ANIMATION

Antz (Eric Darnell and Tim Johnson, 1998)

Directed by Eric Darnell and Tim Johnson

Written by Todd Alcott, Chris Weitz and Paul Weitz

Produced by Brad Lewis, Aron Warner and Patty Wooton

Original music by Gavin Greenaway

Edited by Stan Webb

Production Companies: DreamWorks SKG and Pacific Data Images (PDI)

Distributed by DreamWorks Distribution L.L.C.

Cast

Woody Allen…Z-4195

Dan Aykroyd…Chip

Anne Bancroft…Queen

Jane Curtin…Muffy

Danny Glover…Barbatus

Gene Hackman…General Mandible

Jennifer Lopez…Azteca

John Mahoney…Grebs, Drunk Scout

Paul Mazursky…Psychologist

Grant Shaud…Foreman

Sylvester Stallone…Weaver

Sharon Stone…Princess Bala

Christopher Walken…Colonel Cutter

STUDY QUESTIONS

1. Despite its technological differences from live-action filmmaking, does *Antz* seem to conform to the narrative model of the Classical Hollywood Cinema? Does the film conform stylistically to the CHC? If so, in what ways does it do this? If not, how does it deviate?

2. In what ways is it ideologically similar to (or different from) live-action CHC films? What values does it seem to be promoting? Are these typical "American" (or "Hollywood") values? Have we seen these values in any other films we have seen this term?

3. Although *Antz* is an animated film, could we argue that it falls within a particular Hollywood genre? If so, which one, and what are the characteristics of the film that seem to put it in this genre?

4. How does film style contribute to the narrative of *Antz*?

ANIMATION in *Antz* (Eric Darnell and Tim Johnson, 1998)

I. INTRODUCTION: *Antz* is a good example of contemporary film animation

 A. It is a feature film (as opposed to the short cartoon format during the Golden Age of animation, or the thirty minute format of TV animation)

 B. It is designed to appeal to both adults and children

 C. It uses computer animation to achieve what previously would have been done with hand-drawn animation

II. THE CHC STYLE

 A. THE NARRATIVE

 1. Despite the ways in which this movie is not a typical Hollywood film, does it really deviate much from the CHC narrative?

 2. The genre: does the film seem to belong to any Hollywood genre? If so, which one?

 3. The protagonist?

 a) A strong (sort of) male character in Ant Z

 b) He has a goal

 (1) To save the colony

 (2) To get the girl, Princess Bala

 c) He is the agent of cause and effect; he makes things happen

 4. He faces obstacles to his goals

 5. The two lines of action

 a) Work-related: Ant Z must save the colony

 b) Romance-related: Ant Z is in love with Azteca

 c) How do the two lines of action - goal and romance - become intertwined?

 B. THE STYLE

 1. Is there anything unusual at all about the style?

 a) Continuity editing?

(1) Does it conform to or deviate from the CHC continuity style of editing?

(2) Do you ever find yourself confused about spatial or temporal relations in the film?

b) Mise-en-scène?

 (1) Helps to further the narrative (identify places, characters, time of day, etc.)

 (2) Lighting (especially interesting!)

 (a) Is the lighting typical of CHC 3-point lighting? The animators actually thought in terms of this system

 (b) Think of how lighting is used in the typical CHC style: to make objects appear 3-D, specify time of day, indicate diegetic lighting sources, etc

c) Cinematography?

 (1) Anything unusual about camera height and angle?

 (a) Often very low height and low camera height

 (b) But is this motivated by the narrative? We are seeing from the ants' POV

 (2) Special effects are used extensively (the film really is one big special effect); see below

d) Sound?

 (1) Diegetic sound

 (a) Voices identify characters and types

 (b) A great deal of effort went into finding the right vocal types to voice the characters

 (2) Nondiegetic sound

 (a) Background music helps to reinforce the mood

(b) Conventional music was chosen (instead of the synthesizer music typical of computer animated films) to give the film a more traditional, human quality

2. SPECIAL EFFECTS

a) Much was made of the computer graphics in this film

(1) BUT...think about the ways in which the use of computer animation in this film adheres to the ways in which Hollywood adopts new technologies

(2) Hollywood adopts a new technology when it can:

(a) Do what has been done before

(b) Do it more realistically and/or

(c) Do it more efficiently

b) So...what is the "purpose" of computer graphics in *Antz*?

(1) Aren't they used to create what is essentially a fairly standard animated film, but more efficiently?

(2) Aren't computer graphics generally used for creating things in movies that were done before?

(3) How does the film take advantage of computer graphics; how did the filmmakers choose content that would be particularly suited for computer animation? (Ants do not have hair or skin, instead have smooth shells)

ANIMATION

Toy Story (John Lasseter, 1995)

Directed by John Lasseter

Written by John Lasseter, Andrew Stanton, Peter Docter, Joe Ranft, Joss Whedon, Andrew Stanton, Joel Cohen and Alec Sokolow

Produced by Bonnie Arnold, Ed Catmull, Ralph Guggenheim and Steve Jobs

Film Editing by Robert Gordon and Lee Unkrich

Original music by Randy Newman

Production Company: Pixar Animation Studios and Walt Disney Pictures

Distribution Company: Buena Vista Pictures

Cast

Tom Hanks…Woody

Tim Allen…Buzz Lightyear

Don Rickles…Mr. Potato Head

Jim Varney…Slinky Dog

Wallace Shawn…Rex

John Ratzenberger…Hamm

Annie Potts…Bo Peep

John Morris…Andy Davis

Erik von Detten…Sid Phillips

Laurie Metcalf…Andy's Mom

R. Lee Ermey…Sarge

STUDY QUESTIONS

1. In what ways is *Toy Story* such a good example of the continuity of Hollywood filmmaking over the past 80 years?

2. In terms of its narrative, is *Toy Story* typical or atypical of the classical Hollywood cinema? In exactly what ways is it typical or atypical?

3. In terms of its style, is *Toy Story* typical or atypical of the classical Hollywood cinema? In exactly what ways is it typical or atypical?

4. How does *Toy Story* use new technologies? Is it innovative in its use of such technologies? What does it tell us about Hollywood's use of technological innovations?

5. How does Toy Story fit into the history and tradition of American animation? What kinds of influences can we see from other kinds of animation?

ANIMATION in *Toy Story* (John Lasseter, 1995)

I. INTRODUCTION

 A. *Toy Story* is a good example in the continuity of Hollywood filmmaking over the past 80 years (since the CHC style was solidified)

 B. This is true in terms of both content and style

 C. It is an example of package-unit production, which is typical of film production in Hollywood today

 D. It is also a good example of the ways in which Hollywood films are marketed today

II. THE CHC STYLE

 A. THE NARRATIVE

 1. Despite the ways in which this movie is not a typical Hollywood film, does it really deviate much from the CHC narrative?

 2. The genre: it fits in comfortably with both the Disney-type animated musical comedy and the more general contemporary "buddy comedy"

 3. The protagonist?

 a) A strong (sort of) male character in Woody

 b) He has a goal

 (1) Initially, to get rid of Buzz Lightyear so he can once again be Andy's favorite toy

 (2) Then to get back to Andy's house with Buzz and convince the rest of the toys that he did not try to kill Buzz

 c) He is the agent of cause and effect; he makes things happen

 4. He faces obstacles to his goals

 a) Initially, his obstacle is Buzz

 b) Then it becomes Sid

 c) Finally, missing the moving van is the obstacle to Woody and Buzz returning to Andy's house

 5. Romance

a) Bo-Peep, a lamp (really belongs to Andy's little sister), is the love interest

b) How do the two lines of action-goal and romance-related-- become intertwined?

 (1) Bo-Peep is sort of attracted to Buzz

 (2) Woody must prove to her that he did not try to kill Buzz

B. THE STYLE

1. Is there anything unusual at all about the style?

 a) Continuity editing?

 (1) Does it conform to or deviate from the CHC continuity style of editing?

 (2) Do you ever find yourself confused about spatial or temporal relations in the film?

 b) Mise-en-scène?

 (1) Helps to further the narrative (identify places, characters, time of day, etc.)

 (2) Lighting (esp. interesting!)

 (a) Is the lighting typical of CHC three-point lighting? The animators actually thought in terms of this system

 (b) Think of how lighting is used in the typical CHC style: to make objects appear 3-D, specify time of day, indicate diegetic lighting sources, etc.

 c) Cinematography?

 (1) Anything unusual about camera height and angle?

 (a) Often very low height and low camera height

 (b) But is this motivated by the narrative? We are seeing from the toys' POV

 (2) Special effects are used extensively (the film really is one big special effect); see below

d) Sound?

 (1) Diegetic sound

 (a) Voices identify characters and types

 (b) A lot of effort went into finding the right vocal types to voice the characters

 (c) Note: Unlike the animated musicals Disney makes, this one does not feature the characters singing

 (2) Nondiegetic sound

 (a) The songs (by Randy Newman) reinforce the narrative ("You've Got a Friend in Me," "Strange Things," "I Will Go Sailing No More")

 (b) Background music (also by Newman) helps to reinforce the mood

 (c) Conventional music was chosen (instead of the synthesizer music typical of computer animated films) to give the film a more traditional, human quality

2. SPECIAL EFFECTS

 a) A lot is made of the computer graphics in this film; it is the first computer-animated feature film

 (1) BUT...think about the ways in which the use of computer animation in this film adheres to the ways in which Hollywood adopts new technologies

 (2) Hollywood adopts a new technology when it can:

 (a) Do what has been done before

 (b) Do it more realistically and/or

 (c) Do it more efficiently

 b) So...what is the "purpose" of computer graphics in *Toy Story*?

(1) Are they used to create what is essentially a fairly standard animated film, but more efficiently? (John Lasseter: "We're storytellers who happen to use computers.")
(2) Are computer graphics generally used for creating things in movies that were not done before?
(3) How does the film take advantage of computer graphics; how did the filmmakers choose content that would be particularly suited for computer animation? (Lots of plastic, smooth surfaces, etc.)

III. PACKAGE-UNIT PRODUCTION

 A. It was made by Pixar, an independent production company (the first computer animation studio) that has done computer effects for a number of Disney films

 B. Disney distributed and marketed the movie, as well as providing funding and advice (both solicited and unsolicited); part of a three-picture deal between the two companies

 C. Disney provided needed experience in storytelling in animation, as well as the clout to attract the needed talent in voices, music, writing, etc.

IV. MARKETING

 A. How was this film designed to be marketed?

 1. Does the choice of subject matter - toys - seem calculated to create marketing possibilities?

 2. What about product placement?

 a) Who do you think may have contributed "goods and services" (and maybe even some funding!) to the filmmakers?

 b) Notice also how the toys have been selected to appeal to both parents and kids--both older and more modern toys

 3. How is the music designed to be marketed?

 a) Well-known singer (Randy Newman)

 b) Easily-recognized ballads (easy to remember and hum)

 B. So...what products do you know of that were marketed from this film?

1. Soundtrack on CD and cassette

2. Lots of toys: Woody dolls, Buzz "action figures," etc.

3. Videocassettes, laserdiscs and DVDs stuff)

4. Interactive CD-ROMs

5. Clothing: T-shirts, caps, pajamas, etc

6. **Books, coloring books, etc.**

C. Where was the film marketed?

1. In stores, obviously; especially Disney Stores

2. But also through the Internet, from Disney's *Toy Story* web-site